The National Gallery of Ireland

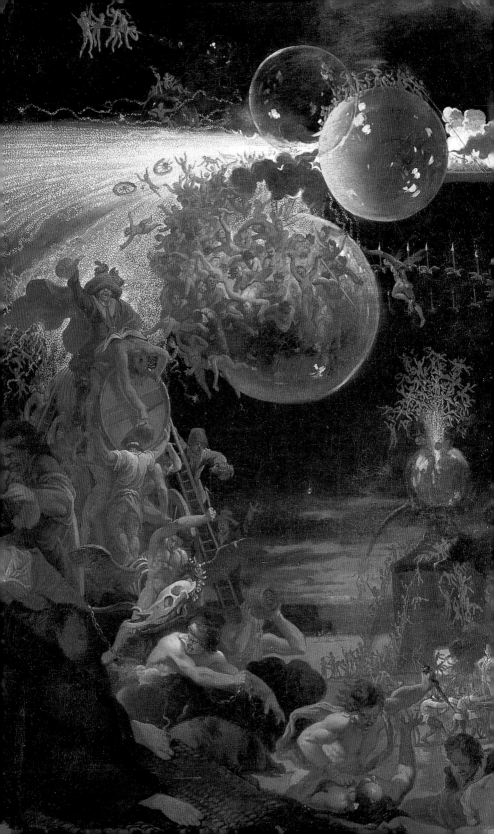

The National Gallery of Ireland: Essential Guide

Scala Publishers, London

SCALA

© 2002 The National Gallery of Ireland in association with Scala Publishers Ltd

First published in 2002 by Scala Publishers Ltd
140a Shaftesbury Avenue London WC2H 8HD

ISBN 1 85759 267 0

Researched by Sergio Benedetti

Edited by Christine Davis

Designed by James Shurmer

Produced by Scala Publishers Ltd

Printed and bound by Conti Tipocolor, Florence, Italy

Front cover: detail from *Party in a Garden*, c.1645–55, by Giovan Battista Passeri

Back cover: François-Marie Poncet, *Adonis*, 1784

Frontispiece: detail from *The Temptation of St Anthony*, 1680s, by Domenicus van Wijn

Contents

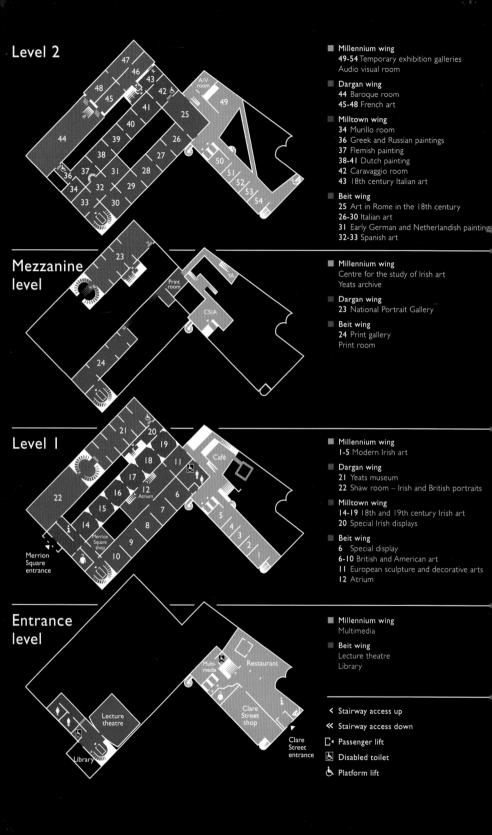

Level 2

■ **Millennium wing**
49-54 Temporary exhibition galleries
Audio visual room

■ **Dargan wing**
44 Baroque room
45-48 French art

■ **Milltown wing**
34 Murillo room
36 Greek and Russian paintings
37 Flemish painting
38-41 Dutch painting
42 Caravaggio room
43 18th century Italian art

■ **Beit wing**
25 Art in Rome in the 18th century
26-30 Italian art
31 Early German and Netherlandish painting
32-33 Spanish art

Mezzanine level

■ **Millennium wing**
Centre for the study of Irish art
Yeats archive

■ **Dargan wing**
23 National Portrait Gallery

■ **Beit wing**
24 Print gallery
Print room

Level 1

■ **Millennium wing**
1-5 Modern Irish art

■ **Dargan wing**
21 Yeats museum
22 Shaw room – Irish and British portraits

■ **Milltown wing**
14-19 18th and 19th century Irish art
20 Special Irish displays

■ **Beit wing**
6 Special display
6-10 British and American art
11 European sculpture and decorative arts
12 Atrium

Entrance level

■ **Millennium wing**
Multimedia

■ **Beit wing**
Lecture theatre
Library

< Stairway access up
≪ Stairway access down
⌐• Passenger lift
♿ Disabled toilet
♿ Platform lift

Foreword

Virtually all museums and galleries by their very nature develop and expand to accommodate the growth of their collections and the needs of their public. As they do so, visitors require more and more support to facilitate their enjoyment and understanding of the exhibits.

Founded in 1854, the National Gallery of Ireland has increased in size four-fold as additional extensions were added over the years, first in 1903, later in 1968, and most recently in 2002. The current complex of buildings presents a far more varied display of European art to its public than was possible way back in 1864, when the Gallery's doors were first open to visitors with some 125 works on show. Today, works range in date from about 1300 to the present day, and cover not only the great masters but also Irish art, prints, drawings, and portraits, as well as a special element dedicated to the work of Jack B. Yeats and the Yeats family.

The present guide has been compiled to provide the visitor with an introduction to the collection, with brief commentaries on many of the most important and popular works, as well as serving as an attractive and informative souvenir which can be taken home and consulted at leisure.

Raymond Keaveney
Director

A Brief History

The opening of the Millennium Wing marks the third major expansion to the National Gallery of Ireland since its establishment by an Act of Parliament in 1854. The antecedents of the institution reach back into the eighteenth century, when there was already a desire to create a public collection for the education of young artists and the enjoyment of the public. In 1765 the Society of Artists in Ireland, a body established the previous year, held its first exhibition in Napper's Great Room in George's Lane. So successful was the venture that a year later they resolved to build a permanent gallery in their new premises in William Street, where they also aspired to create an academy for the study of painting. Whilst paintings by European masters (Mengs and Lely) were offered for the creation of a collection, the project lapsed and the Society itself ceased to exhibit after 1780.

During his term as Lord Lieutenant, 1784–87, the Duke of Rutland gave consideration to the establishment of a public gallery for the display of Old Masters, such a facility to complement an academy to be provided for the education of young artists. As part of this ambitious undertaking, the Flemish artist Pieter de Gree was appointed Keeper of the new Academy. De Gree was already advising the Duke on the purchase of paintings, having previously advised Sir Joshua Reynolds, who had recommended his services. The untimely death of

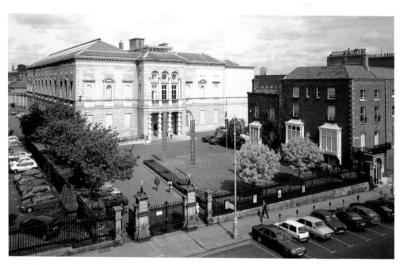

Façade of the historic building from Merrion Square

the Duke, however, undermined the project, which ultimately collapsed.

A further significant attempt to promote the appreciation of Old Master paintings took place in 1813 with the foundation of the Royal Irish Institution, which worked to put together displays of European masters at the gallery of the Dublin Society's House in Hawkins Street and later at its premises in College Street. The main fruit of the institution's endeavours was the establishment of the Royal Hibernian Academy in 1823, a body which continues to function to this day. The aspiration to create a public gallery of the great masters was actively taken up again in November 1853 with the establishment of the Irish Institution, a body which had as its stated aim 'the promotion of Art in Ireland by the formation of a permanent exhibition in Dublin and eventually of an Irish National Gallery'. The Irish Institution held exhibitions of the works of the Old Masters and acquired by gift pictures intended for presentation to the putative national gallery. The Institution held six exhibitions between January 1854 and 1859, before finally dissolving in 1863.

The catalyst for the establishment of the Irish Institution was the great Irish Industrial Exhibition, organized by the Royal Dublin Society in 1853 on the lawns of Leinster House, where the National Gallery now stands. Included in this mammoth event was a large hall dedicated to the display of works of art, a feature which proved immensely popular and which clearly evidenced the public's appetite for the fine arts. The hall, which contained over one thousand exhibits, including works listed as by Rembrandt, Canaletto,

Poussin, Reynolds and Hogarth, had been included in the Exhibition at the insistence of William Dargan, the great railway magnate, who had underwritten the cost of the event. To acknowledge his munificence a special Testimonial Committee was formed to provide a fitting memorial to Dargan's involvement in this historic project. The aim of the committee was to establish some form of permanent tribute to the man – not merely a statue or some such similar monument, but rather a testimony which would prove permanently useful. To this end the committee set about raising the necessary funds and within a short period had collected £5,000. After some discussion as to how best to apply these funds it was decided that the Testimonial Committee should link up with the Irish Institution and work together for the establishment of a permanent public art collection. Their aspirations were realized with surprising speed, and on 10 August 1854 an Act of Parliament was passed establishing the National Gallery of Ireland.

The inaugural meeting of the Board of Governors and Guardians of the new institution was held on 13 January 1855. A Building Committee was quickly established for the purpose of overseeing the construction of the new Gallery, which was to be handed over to the Board of Governors and Guardians on its completion. The choice of location for the Gallery had already been debated by the Irish Institution, which had identified four possible sites around the city: one of them on Park Street (now Lincoln Place), adjacent to where the Millennium Wing now stands, and another close by on Merrion Square,

in the grounds of Leinster House, which had the advantage of scope for future expansion. The disadvantage of this site was that the external design of the new structure would be required to mimic that of the Natural History Museum which was to be constructed for the Royal Dublin Society on the opposite, southern flank of Leinster Lawn, to the design of Frederick Villiers Clarendon. Despite this stipulation, the Committee approved the Merrion Square site and proceeded to select an architect to provide the designs. The earliest drawings for the building were supplied by the artist George Mulvany, later to become the Gallery's first Director. These proved unachievable for technical reasons. In 1856 Charles Lanyon was called in to progress the project, and whilst his designs were more technically accomplished, not everyone was pleased with them or considered them affordable. To resolve the issue, Francis Fowke, the Tyrone-born architect/engineer who was employed by the Department of Science and Art in London, was called in to advise on the project.

He made proposals of his own, addressing the most critical issues and promising considerable savings in cost.

The Board approved Fowke's plans in October 1858. The foundation stone of the new Gallery was laid in January 1859 and over the next five years Fowke's elegant design gradually took shape. When opened to the public in January 1864 the new building represented one of the most technically advanced museum structures of its time. The upper floor, where the paintings were displayed, boasted a graceful suite of galleries in which a balanced source of daylight was provided by means of a sophisticated arrangement of lay-lights or toplighting. In the darker months of winter and in the evening time, lighting was provided by a vast array of gas lights, of which there were over two thousand installed in the great picture gallery which housed the splendid display of large Baroque paintings. To reduce the risk of damage by fire, the flooring was constructed of wrought iron joists resting on iron girders encased in

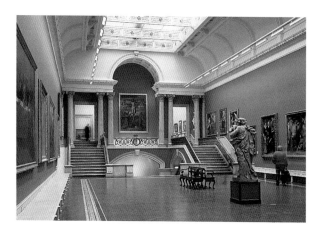

The Baroque Room

concrete, a construction technique that was a forerunner to the modern technique of reinforced concrete. The colonnaded ground floor gallery, which did not have toplighting, accommodated the sculpture collection, which was made up mainly of plaster casts taken from the antique.

The original display consisted of some 125 paintings, including 28 loans. The task of assembling a collection for the Gallery had not been an easy one as the new institution, unlike many of its international counterparts, did not incorporate a major princely or private collection. It was the aforementioned Irish Institution which first worked on securing works for a national gallery, as it was empowered by trust to accept paintings or financial donations for the planned building. By 1855 eleven pictures had already been secured. The following year, 1856, marked a significant advance with the building of the collection when 16 paintings, many formerly the property of Cardinal Fesch, uncle to Napoleon, were acquired in Rome from one Signor Aducci for £1,700 through the agency of the Scottish photographer/dealer Robert MacPherson. Included among the works were masterpieces by Giulio Cesare Procaccini and Giovanni Lanfranco. Very shortly afterwards MacPherson successfully negotiated the sale of a further 23 paintings for £1,600. All 39 pictures were purchased from the persuasive MacPherson on the somewhat rudimentary evidence of pencil sketches and with funds generously lent by the Lord Chancellor, Maziere Brady, who at the time was a member of the Board of Governors and Guardians of the Gallery.

Once sufficient paintings had been acquired to cover the available display space there was less pressure on the Board to consider acquiring works on such a scale and from 1864, the year the Gallery was officially opened, the collection grew at a more measured pace. Also, there was a switch of emphasis from the pursuit of Italian masters to the acquisition of works from the Low Countries and from Spain and France. In January 1864 Italian paintings accounted for more than half the works on view. The years leading to the turn of the century were particularly remarkable for the growth of the Dutch and Flemish collections. For the most part these works were purchased individually or in small lots at auction in London, or occasionally on forays to the Continent.

Gradually the collection was beginning to assume the character of a broad, well-balanced survey of European art, with a degree of thoroughness which belied the institution's modest resources. From 1866 onwards an annual purchase grant was established at £1,000, that modest sum being increased to £2,000 only in 1937. Given the limited funding available, the quality of the purchases made during the first 75 years, and most particularly before 1900, is very remarkable indeed. Among the most notable acquisitions during this period were Rembrandt's *Rest on the Flight into Egypt*, which was obtained in 1883 for £514; *St Peter finding the Tribute Money* by Rubens in 1873 for £75; *The Immaculate Conception* by Zurbaran in 1886 for 42 guineas; *Sts Cosmas and Damian and their Brothers surviving the Stake* by Fra Angelico in 1886 for £73 10s; and

The Lamentation by Poussin in 1882 for £503.

In 1884, under the supervision of the then Director, Henry Doyle, the National, Historical and Portrait Gallery was opened. The Portrait Gallery displayed 50 paintings together with works on paper, principally mezzotint portraits of distinguished individuals, an area of the collection which was to be significantly enhanced in 1887 and 1888 when the Gallery acquired a body of work at the two Chaloner Smith sales in London. The Portrait Gallery continued to be a feature of the display up until the 1970s, when it was dismantled. In 2002 the Portrait Gallery again became a feature of the presentation of the collection, having been enhanced in the meantime by a series of notable acquisitions and by the commissioning of a sequence of portraits of well-known personalities from contemporary Irish life, a project which was facilitated through the generous support of Irish Life and Permanent.

By the year 1891, as a result of the purchasing policy adopted by the Board, the collection had grown to such an extent that the available accommodation was proving inadequate and serious consideration needed to be given to the problem of providing an extension to Fowke's handsome building. In that year, the Director, Henry Doyle, reported to the Board that 'in the Great Gallery of Old Masters [room 44] recourse has already been had to the system of erecting Screens in the centre of the floor for the exhibition of some of the smaller and more important pictures'. The desire to construct a new wing became a necessity in 1897 when the Dowager Countess of Milltown, in a letter written in October of that year to the Director, Walter Armstrong, expressed her intention of presenting to the Gallery, in memory of her husband, 'the Pictures, Prints, works of Art and antique Furniture now at Russborough'. (Russborough House, constructed in the mid-eighteenth century – to the design of Richard Castles – was the country seat of the Earls of Milltown.) The new extension was quickly agreed and its design entrusted to Thomas Newenham Deane, who had been in consultation with the Board about such a facility since 1891. Construction of the new wing began in 1899 and the building was inaugurated some four years later, in March 1903. The Milltown gift, which included approximately two hundred pictures, a number of which had been collected on the Grand Tour by the first Earl, Joseph Leeson, was displayed in the upper galleries of the new wing which stood to the North of Fowke's original building. Among the works on display were masterpieces by Batoni, Panini and Poussin.

Another notable endowment which occurred at this time was the bequest from Henry Vaughan of 31 watercolours by J. M. W. Turner. This addition to the collection considerably enhanced the already burgeoning holding of prints, drawings and watercolours which was developing *pari passu* with that of oil paintings. Already in 1855 the Gallery had received, within a year of its foundation, a gift of 80 watercolours, mostly by contemporary artists of the Irish and British schools; the gift came from Captain George Archibald Taylor via the Irish Institution.

Parmigianino (1503–40) Putti with an Eagle (1522/23)

In 1864 George Mulvany, who was appointed Director in 1862, had purchased two small drawings by Federico Zuccari at the Watkins Brett sale in London. In 1866 he attended the sale of Dr Wellesley's celebrated collection where he acquired a number of Renaissance drawings by Mantegna, Lorenzo di Credi, Antonio del Pollaiuolo and Parmigianino. In 1872 a group of 53 watercolours and drawings, including examples by Gainsborough, John Robert Cozens and Philippe Jacques de Loutherbourg, were presented by the noted English collector, William Smith (1808–76), with a further 79 works entering the collection in 1876 under the terms of his will.

The National Gallery of Ireland, like most national institutions, suffered a reduction in its funding during the Great War, with its purchase grant suspended between the years 1914 and 1919. An even greater loss for the Gallery during these years was the death of Sir Hugh Lane (1875–1915) who drowned when the *Lusitania* was torpedoed off Cork in May 1915. Lane, perhaps the Gallery's most talented and certainly its most generous Director, was a gifted connoisseur who had the remarkable talent of appreciating both modern and Old Master paintings as well as being keenly concerned about the development of the native school of painting. Thanks to the support and influence of his aunt, Lady Augusta Gregory, he was able to embark on a career in picture dealing, first with Colnaghi's and later with the Marlborough Gallery, before setting up on his own in 1898. In 1904 he was appointed a Governor and Guardian of the National Gallery of Ireland. At this time his principal ambition was the establishment of a Gallery of Modern Art in Dublin. He was to be tragically frustrated in this ambition, however, and the consequences of this great disappointment are to be felt to this day as some of his most treasured Impressionist pictures – including Renoir's *Les Parapluies* and Monet's *Concert aux Tuileries* – travel back and forth between London (The National Gallery) and Dublin (The Hugh Lane Municipal Gallery of Modern Art), like lost souls. His interest in Old Master paintings brought him more satisfaction. In 1914 he was appointed Director of the National Gallery of Ireland and immediately proceeded to endow the institution with a series of generous gifts, beginning with El Greco's *St Francis*. Even in death his munificence remained unabated for in his will he bequeathed the bulk of his estate to the Gallery, including a host of fabulous pictures. Among the most

notable of the 43 works presented were masterpieces by Sebastiano del Piombo, Claude, Poussin, van Dyck, Lawrence, Hogarth and Gainsborough. His residual estate, which has operated since 1918 under the title of the Lane Fund, continues to contribute towards the purchase of works of art for the collection.

Another outstanding benefactor was George Bernard Shaw (1856–1950) who bequeathed to the Gallery one-third of the royalties from his residual estate (the other two-thirds going to the British Museum and RADA). The Gallery had evidently been an important element in the Dublin upbringing of the great playwright who later observed, with his characteristic wit, 'Let me add a word of gratitude to that cherished asylum of my boy-hood, the National Gallery of Ireland. I believe I am the only Irishman who has ever been in it, except for the officials. But I know that it did much more for me than the two confiscated medieval cathedrals so magnificently "restored" out of the profits of the drink trade' (*In the Days of my Youth*, 1898). The Shaw Fund, as it is known, has served the Gallery magnificently since its resources were first applied in 1959, to acquire Domenico Tintoretto's allegorical painting, *Venice*, for the collection. Notable purchases secured with the support of the Shaw Fund have been *Abraham and the three Angels* by ý El Mudo ý, *Marie Julie Bonaparte with her Daughters* by Gérard, *The Funeral of Patroclus* by David and *Two Women in a Garden* by Nolde. Most recently the Shaw Fund has provided the seed capital for the new Millennium Wing, of which more will be said later.

With the continued growth of the collection, the need for a further extension again became an issue for discussion as early as the 1930s. In 1951 Thomas MacGreevy, who was then Director, argued for the provi-sion of additional accommodation. The campaign continued until 1962, when £277,000 was made available by Government for a new wing. Designed by Frank du Berry of the Office of Public Works, this facility was opened to the public in September 1968, providing the Gallery not only with additional display space but also with a conser-vation studio, library, lecture theatre and restaurant. The rehang of the collection at this time proved a revelation as many of the great Baroque canvases, which had long been out of fashion and which had languished in storage for decades, were now put back on display.

In many respects the Gallery's holdings of French paintings had grown more slowly than the other Continental schools. This pattern was to change rapidly in the 1960s. With the availability of additional space and access to the Shaw Fund, Thomas MacGreevy and later James White, who was appointed Director in 1964, set about redress-ing the balance. Works by Courbet, David, Fragonard and Vouet were purchased for the collection. The French school was further enhanced in 1978 when 93 paintings, presented to the nation in 1950 by Sir Alfred Chester Beatty, were formally transferred into the care of the Gallery. This collection was composed almost entirely of works by nineteenth-century French artists, including Breton, Courbet, Couture, Meissonier, Millet and Tissot. A notable aspect of the gift

were the many works devoted to Oriental subjects, by artists such as Fromentin, Berchère and Gérôme. These works reflected Chester Beatty's consuming interest in the Orient, an interest which is most spectacularly manifest in the great library and museum which he established in Dublin 1953 and which is now housed in the grounds of Dublin Castle. There, thanks to his extraordinary generosity one can admire one of the world's finest collections of Islamic, Mughal, Japanese and Chinese art.

More recently the Gallery has been the fortunate recipient of two outstanding benefactions. In 1987 it received 14 works – paintings and drawings – from the estate of Máire MacNeill Sweeney. Included in the bequest, made in memory of her husband, John L. Sweeney, were *Still-Life with a Mandolin* by Picasso; *Pierrot* by Gris and *The Singing Horseman* by Jack B. Yeats. In the same year, incredibly, the Gallery received another extraordinary collection of pictures, 17 master-pieces gifted by Sir Alfred and Lady Beit. This spectacular donation included outstanding examples of Spanish, Dutch and British art, with compositions by Velázquez, Murillo, Ruisdael, Hobbema, Steen, Vermeer, Metsu, Gainsborough and Raeburn.

Notwithstanding these marvellous events it can fairly be stated that the 1990s witnessed one of the most exciting episodes in the history of the Gallery – the discovery of Caravaggio's lost masterpiece, *The Taking of Christ*, in the Jesuit house of studies in Leeson Street, just a ten-minute walk from Merrion Square. The painting had rested there unrecognized since it was gifted to the community by the Dublin paediatrician Marie Lea-Wilson around 1930. The frame carried a plaque erroneously indicating authorship of the work as by 'Gherardo della Notte' (sic), the nickname of Gerrit van Honthorst, one of the best-known Dutch followers of the great Italian master. The head of the house, the Rev. Noel Barber SJ, had sought the advice of the Gallery regarding the condition of some of the works housed in Leeson Street and it was during the tour of inspection that *The Taking of Christ* was noticed by Sergio Benedetti, who at that time was on the conservation staff of the Gallery. The Gallery secured the agreement of the Jesuit fathers to take the painting in and have it examined, as it represented a known composition by Caravaggio of which there were over a dozen replicas catalogued, but none of them accepted as being the original. Over a period of three years the painting was examined and researched until eventually, in 1993, it was exhibited to the public as a fully authenticated work by the master. Thanks to the generous cooperation of the Jesuit commu-nity, the painting is now exhibited in the Gallery where it has been joined most recently by a large authentic work by van Honthorst, *A Musical Party*. This painting was gifted to the Gallery by Lochlann and Brenda Quinn under the terms of Section 1003 of the Consolidated Tax Act 1997, a recent piece of tax legislation which has greatly benefited the national cultural institutions. Another fine example of the benefits of such enlightened legislation is Canova's *Amorino*, an elegant marble commissioned in Rome in 1789 by the young John David

La Touche and gifted to the Gallery by the Bank of Ireland in 1998 under the terms of the Act.

The first notable addition to the collection under such legislation was the Yeats Archive presented to the Gallery in 1997 by Anne Yeats (1919–2001). This magnificent gift, which included some two hundred sketchbooks by her uncle Jack B. Yeats, prompted the establishment of the Yeats Museum which opened in March 1999. The new museum, located on the ground floor of the Dargan Wing, presents an extensive display of the work of Jack B. Yeats alongside that of his father, John Butler Yeats, and other members of the family – including Anne Yeats, who was herself an influential figure in twentieth-century Irish art, being closely involved with the Living Art Group.

Further good news for the institution was to follow later in 1997 when Sir Denis Mahon publicly announced that part of his rich and unparalleled collection of Italian seventeenth-century painting was to come to the Gallery after his death. In the meantime the eight promised works, including Guercino's precocious masterpiece *Jacob blessing the Sons of Joseph*, are on permanent loan.

The last ten years have also witnessed intense activity with respect to the management of the existing complex of Gallery buildings on Merrion Square and the campaign to add additional accommodation, accessed from Clare Street, to host exhibitions, provide more space for the display of the permanent collection and upgrade the Gallery shop and restaurant.

In 1996, following a protracted campaign of work carried out by the Office of Public Works, the 1968 wing (now the Beit Wing) was reopened to the public following a four-year period of closure, having been substantially restructured and equipped over that time with full air conditioning and modern lighting systems. Over the first three years of the decade the original Dargan Wing and the Milltown Wing were also upgraded, providing improved conditions for the display of the collection. Most notable in this respect was the new arrangement of the Shaw Room, which in addition to being redecorated in the manner

View of the Irish Rooms (Milltown Wing)

of an Italian palazzo, was provided with a magnificent set of Waterford crystal chandeliers.

The most significant undertaking during this period, however, has been the campaign to construct the new Millennium Wing, a project first mooted in 1988. The catalyst for this historic undertaking derived from the fact that there was a growing realization that the existing accommodation was inadequate and inefficient, and there fortuitously existed a unique opportunity to address these deficiencies as some properties directly adjacent to the Gallery became available for development. With the acquisition of these properties in 1990 the way became clear for the expansion of the Gallery onto a new axis at Clare Street, where a more generous and better-equipped reception lobby could be provided, off a busy urban thoroughfare. The construction of the new wing would require substantial funding, most of which the Gallery would need to raise privately, to complement the £7.5m secured from the European Regional Development Fund (ERDF) in 1995. With the ERDF funding in place steps were immediately taken – with the guidance of the RIAI (Royal Institute of the Architects of Ireland)

– to organize an international competition to select architects for the project. This was eventually determined in September 1996 when, from an original list of some one hundred contestants, the London-based practice of Benson and Forsyth was awarded the commission. Whilst the Scottish architects' original plans for the new building had to be abandoned due to planning difficulties (on account of the requirement, following objections to the original scheme, to retain no. 5 South Leinster Street and its separate 'ballroom'), their subsequent design has retained much of the basic architectural aesthetic of the first scheme, while capitalizing on the potential for visual counterpoint as the new structure intertwines with its older counterpart. Work on the project began in early 1999 under the supervision of the Office of Public Works, who project-managed the construction. The new wing, which provides an additional 4,000 square metres of accommodation, was opened to the public in January 2002 by Síle de Valera, Minister for Arts, Heritage, Gaeltacht and the Islands.

Raymond Keaveney

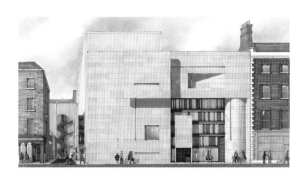

Drawing of the Millennium Wing, Clare Street

ITALIAN
PAINTING AND
SCULPTURE

UGOLINO DI NERIO

Active in Tuscany, flourished 1317–27

The Prophet Isaiah

1320s
Egg tempera and gold leaf on wood,
39 × 25 cm
Purchased 1943
NGI 1112

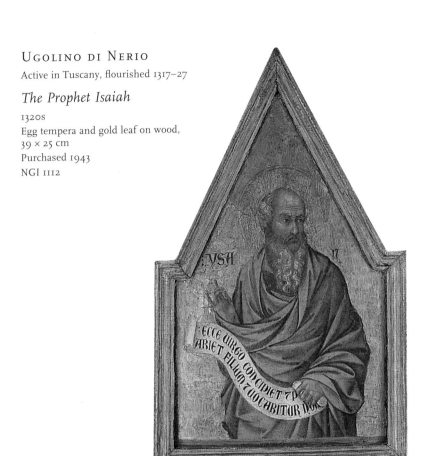

This single figure of the prophet Isaiah was formerly a pinnacle of an elaborate Gothic altarpiece, probably disassembled during the eighteenth or nineteenth century. The complete polyptych would have featured the Virgin and Child on the central panel, and a number of saints on the side panels. On the lowest register there would have been a plinth (a *predella*) with episodes of the life of Jesus or of a particular saint, while the upper area would have had a series of small half-figures of saints or prophets, such as this one.

Isaiah was an authoritative biblical preacher who predicted the birth of Jesus. His famous words appear written in Latin on the scroll held in his hands: 'Behold, a virgin shall conceive, and bear a son, and shall call his name Immanuel'.

In spite of its small dimensions this is an image of great tension and austerity, depicted by the artist with ability and sensitivity. Apparently, Ugolino learnt his craft from his father and having initially closely admired Duccio's works, he later created a very individual style.

Master of Verucchio

Active in Rimini during the first half of the 14th century

The Crucifixion, Noli me tangere

*c.*1330–40
Egg tempera and gold leaf on wood, 30 × 21 cm
Purchased 1940
NGI 1022

This panel was originally part of a small portable diptych formed by two wings. The second wing is currently in the Stibbert Museum in Florence, and from the saints represented on it, it appears that the diptych was painted for a Franciscan convent or for a family closely devoted to the Franciscan order. In our panel the episode of the encounter of Jesus with Mary Magdalene seems strictly derived from a famous example painted by Giotto in Padua. Indeed, the entire fourteenth-century school of Rimini was profoundly influenced by the art of that Florentine master.

The sobriquet used for the unknown author of this panel derives from the small village of Verucchio, near Rimini. It was in the local Collegiata church that a crucifix painted by him was first identified, a pivotal work which permitted the critical reconstruction of the personality of this artist. Recent studies propose the identification of this painter with Francesco da Rimini, a partially documented author of some frescoes which were originally painted for the refectory of San Francesco in Bologna.

DON SILVESTRO DEI GHERARDUCCI

Florence 1339–99

The Assumption of St Mary Magdalene

1380s
Egg tempera and gold leaf
on wood, 161 × 82 cm
Purchased 1922
NGI 841

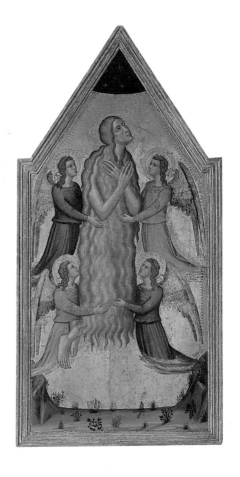

The cult of Mary Magdalene was always very popular. She symbolized Christian repentance and the final redemption. As a result of this widespread devotion, her legendary life soon became enriched with new episodes. According to some of these, in the last years of her existence she renounced the world and retreated into the wilderness, where she spent a long time in solitary penance before dying. Soon after, she was borne by angels and finally transported to Heaven.

Our picture is considered one of the earliest painted examples of her assumption. Mary Magdalene is represented physically emaciated, covered only by her long hair, with her hands crossed over her bosom and with an expression of total faith.

Silvestro de'Gherarducci, the author of this moving composition, was a Benedictine monk of the order of Camaldoli based in the church of Santa Maria degli Angeli in Florence. His activity as painter was not confined to altarpieces: he was also engaged in the illumination of many religious manuscripts.

ANDREA DI BARTOLO

Active in Tuscany, flourished 1389–1428

St Galganus inviting the people to adore the Cross

c.1415
Egg tempera and gold leaf on wood,
40.5 × 38 cm
Purchased 1942
NGI 1089

According to history, Galganus was a noble knight who, having led a dissipated youth, decided to retreat in 1180 to the solitude of Mount Siepi, near Siena. There, he took the vows of the Cistercian Order and devoted himself to preaching to the people of the surrounding country-side. Although he died only a year later, other believers soon followed his example, and in 1185 created a monastic community that was responsible for building an abbey on the burial place of their founder.

Today this is considered one of Italy's most important monuments of French Gothic influence.

The episode shown here is a miraculous event which occurred when Galganus, having driven his sword into a rock, started to adore it as a symbol of the Cross, inviting those present to follow him. The original use of the picture is unclear, but one opinion is that it once formed part of a large polyptych, together with a group of panels that are today held in the Museum of San Matteo in Pisa. Andrea di Bartolo was the son of the painter Bartolo di Fredi, and most certainly was trained by him. His father's influence is evident in the dramatic chiselled ground of the landscape seen here. Later he was for some time inspired by Taddeo di Bartolo, from whom he probably acquired the use of large figures in his compositions.

Fra Angelico
(Guido di Piero)

Florence *fl.*1417–1455 Rome

Sts Cosmas and Damian and their Brothers surviving the Stake

*c.*1440–42
Egg tempera on wood, 37.8 × 46.4 cm
Purchased 1886
NGI 242

Cosmas and Damian were two physician brothers living in Asia Minor in the third century. They and their three younger brothers were Christian, and during the Diocletian persecutions they were compelled to prove their loyalty to the traditional gods with a sacrifice. When they refused, Lycias, the Roman Consul, submitted them to a series of brutal tortures. Miraculously they survived the torments but, finally, the enraged Consul had them all beheaded.

The episode represented here is the fruitless attempt to burn the five brothers. A circle of flames surrounds them, but the fire turns against the torturers, under the incredulous eyes of Lycias and his dignitaries.

This small panel was part of the *predella* (lower register) of Fra Angelico's most important altarpiece. Other parts of it are scattered in various galleries worldwide. The altarpiece was painted for the church of San Marco in Florence, and was commissioned by Cosimo de'Medici – whose name is echoed in the profession of Sts Cosmas and Damian (*medici* means 'physicians' in Italian).

Fra Angelico is one of the great Florentine Renaissance masters. In 1407 he entered the Dominican monastery of Fiesole, assuming the name of Fra Giovanni. Within a few years he had become the most acclaimed monastic painter in Italy.

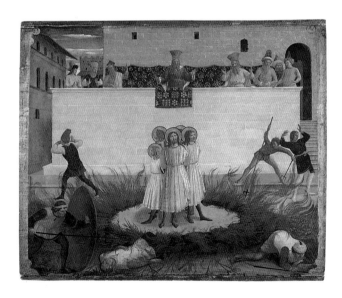

Paolo Uccello (Paolo di Dono)

Florence, 1397–1475

Virgin and Child

c.1435–1440
Egg tempera on wood, 62.3 × 41.4 cm
Purchased 1909
NGI 603

Uccello entered the workshop of Lorenzo Ghiberti at a young age. Little is known of his early activity. Between 1425 and 1430 he is recorded in Venice working as a mosaicist. After his return to Florence he was greatly impressed by the new artistic climate of the city. He soon started to study the possibilities offered by the new Renaissance space, and experimented in his compositions with bold, geometrical perspectives.

This *Virgin and Child* clearly shows the painter's intellectual interest during that period. At the centre of an imaginary space is a motionless Madonna. She emerges from a perfectly calibrated shell-shaped niche, holding back a chubby three-dimensional child who seems ready to jump towards the observer.

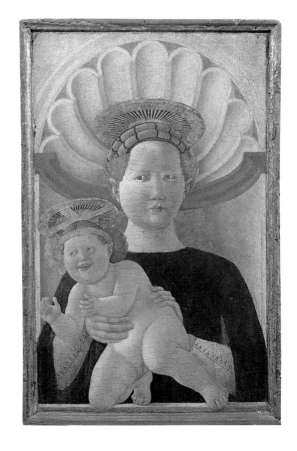

Giovanni di Paolo di Grazia

Siena c.1395–1482

Crucifixion

1460s
Egg tempera and gold leaf on wood,
original painted surface 163.3 × 99.5 cm
Purchased 1964
NGI 1768

The original location of this Crucifixion is not known, but it is reasonable to presume that it was executed for an important ecclesiastic building in Tuscany. Intended for a church, large images of Christ on the Cross were usually suspended high above the high altar, where they could be seen by the full congregation. Half-figures of the Virgin and St John the Evangelist would traditionally be placed on the horizontal terminals, with an image of the pelican – the symbol of redemption – at the top, just above Christ. Regrettably these are now missing from this example.

Giovanni di Paolo, the author of this dramatic Crucifixion, was a remarkably sensitive artist. He used a rich palette to paint a wide range of religious subjects in a visionary, expressionistic manner. His highly personal style represents the transition between the Gothic and the Renaissance period in Siena.

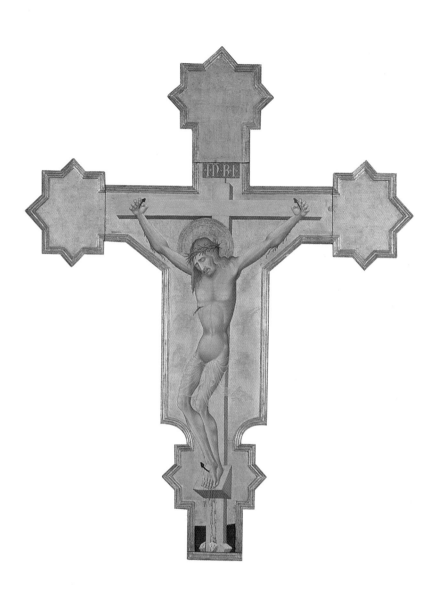

Zanobi Strozzi
(attributed to)
Florence 1412–68

Assumption of the Virgin with Sts Jerome and Francis
1460s
Egg tempera on wood, 190 × 170 cm
Purchased 1925
NGI 861

The Virgin is depicted seated on celestial clouds, with her hands raised in prayer. She is enshrined in a mandorla of multicoloured lights borne by six angels. Below, roses and lilies are growing from her empty marble tomb, while Saint Jerome and Saint Francis of Assisi kneel in adoration.

Three small panels – representing the *Death of the Virgin*, the *Stigmatisation of St Francis* and *St Jerome in the Wilderness* – were originally joined to the bottom of this altarpiece. These are now in the Museo Comunale of Prato, near Florence.

The name of Zanobi Strozzi as the author of this altarpiece was debated for a long time. However, his artistic personality is now better defined and a significant number of his works have been recognized. He was a contemporary of Fra Angelico, to whom he was deeply indebted. His manner was also close to that of Domenico di Michelino and of Pesellino. A versatile painter, he is better known as an illuminator of many religious codices.

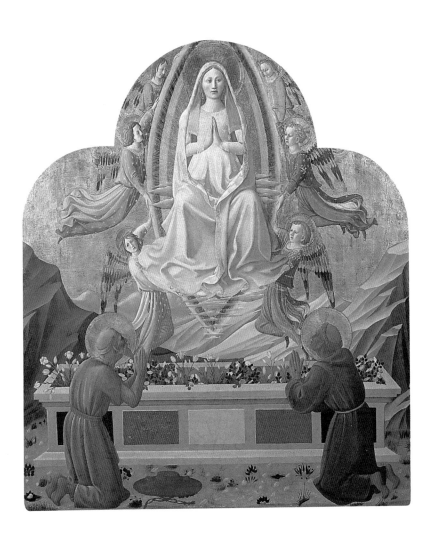

Zanobi di Jacopo Machiavelli

Florence 1418–79 Pisa(?)

Virgin and Child enthroned with Saints

*c.*1470

Signed: *OPUS ÇENOBII / DE MACHIAVELİS*

Egg tempera on wood, 132.5 × 148.7 cm

Purchased 1861

NGI 108

According to Giorgio Vasari – the well-known biographer of Italian Renaissance artists – Zanobi Machiavelli was a pupil of Benozzo Gozzoli. This opinion is certainly confirmed by his works, but his style seems also to have been influenced by Pesellino, and later orientated towards Filippo Lippi. The paintings produced by Machiavelli's workshop were numerous and the typologies were sometimes repeated, although with variants. Generally, his compositions have an elegant appearance but are rather crowded with figures.

Four saints accompany the Virgin and Child. St Bernardino of Siena is on the left, holding a roundel with Jesus' monogram encircled by golden rays, along with St Mark with his gospel. To the right is St Louis of Toulouse in his bishop's garb, and St Jerome with the cardinal's hat and his translation of the Bible. All the saints have bare feet because the vividly coloured marble floor on which they stand is holy ground.

The presence in this altarpiece of St Bernardino of Siena and St Louis of Toulouse, two Franciscan saints, may suggest that the picture was painted for a church of this religious order.

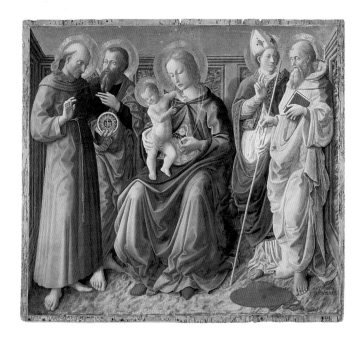

Andrea Mantegna

Isola di Carturo 1431–1506 Mantova

Judith with the Head of Holofernes

c.1495–1500
Tempera on linen, 48.1 × 36.7 cm
Purchased 1896
NGI 442

The biblical story of Judith is written in the Apocrypha (13: 7–8). When the Assyrian commander Holofernes besieged the Jewish city of Bethulia, Judith, a beautiful widow of the town, volunteered to kill the enemy. After gaining his confidence through deceit, she severed his head with a sword while he slept. Then, with the help of her maid-servant, she hid the head in a sack and returned to her town. In the morning the Assyrians discovered the corpse of the general and, discouraged, fled the battlefield pursued by the Israelites.

This small picture reveals the passionate devotion of Mantegna for antique sculpture. The subject was painted to simulate a marble relief with delicate greenish-grey warm tonalities. In the background, as in other similar compositions, the artist imitated a different type of marble, more colourful and transversally veined.

We do not know for whom Mantegna painted this picture, although it is quite possible that a member of the Gonzaga family commissioned it, as part of a series. If this was the case, the most obvious person would be the intellectual marchioness Isabella d'Este, wife of Francesco II Gonzaga.

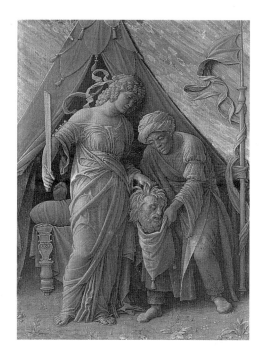

ANTONIAZZO ROMANO (Antonio Aquili)

Documented in Rome
1461–1508

The Virgin invoking God to heal the hand of Pope Leo I

c.1475
Egg tempera and gold leaf
on wood, 110 × 80 cm
Purchased 1920
NGI 827

According to the hagiographic Golden Legend, Pope Leo I, at the end of celebrating a mass, felt momentarily aroused by a woman who had kissed his hand. Ashamed of his sin, he punished himself by cutting off the hand that had been kissed, but the Virgin mercifully restored it. Apparently, this extraordinary healing took place in the Basilica of Santa Maria Maggiore in Rome, on the precise spot where the Pope used to venerate an icon of the Virgin Advocate.

Antoniazzo treats the episode with great skill and elegance. The Virgin is the protagonist, and is depicted in the act of imploring God to concede the miracle. Although modelled on traditional iconography she is not a rigid and hieratic figure, but has been transformed into a calm and gracious Renaissance Madonna. At the bottom, under a parapet, the miraculous event is represented in reduced scale; here an angel can be seen reinstating the hand to the Pope.

During the second half of the fifteenth century Antoniazzo became the most competent Roman painter. His ability to absorb influences from different artists who came to Rome helped him to develop an original style which, over a number of years, allowed him to compete successfully for numerous important commissions.

Filippino Lippi

Prato *c.*1457–1504
Florence

Portrait of a Musician

Late 1480s
Egg tempera and oil
on wood, 51 × 36 cm
Purchased London,
Lawrie & Co., 1897
NGI 470

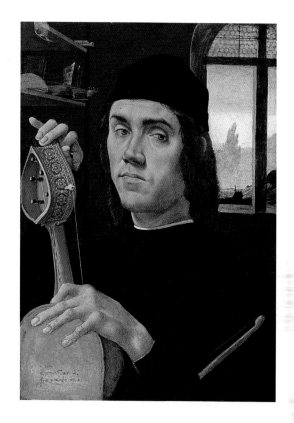

Music was constantly present in Renaissance life, and elaborate compositions were used to accompany religious events and popular dances. Performing was not confined to professional musicians: aristocrats and humanists, too, frequently enjoyed playing music for entertainment. The identity of the man in this portrait is unknown but the numerous musical instruments shown in the picture suggest that he must have been a famous composer or an important humanist of the period.

While resting the bow in the hollow of his arm, the musician appears to be tuning a finely carved *lira da braccio.* On the shelves behind him are books, a lute, a second *lira* and two wind instruments. Curiously, an inscription on the back of the *lira* which reads '*il chomîcar nõ fia p tempo mai*' (never start before the time), seems to warn against human impatience.

Filippino Lippi underwent his initial training with his famous father, Filippo, before becoming a young assistant to Sandro Botticelli. Once independent he became one of the most significant artists of the late fifteenth century. He paid particular attention to the outline of his figures, and his artistic language was intensely dramatic and frequently anti-classic and unconventional.

Florentine Master, sometimes called 'Master of Anghiari'

The Battle of Anghiari

The Taking of Pisa

1460s

Egg tempera on poplar, with gilding,
62.4 × 207.5 cm, 62 × 205.4 cm

Sir Hugh Lane bequest, 1918

NGI 778 and 780

These two panels were until recently considered to be the fronts of wedding chests or *cassoni*. The primary purpose of these highly decorated pieces of furniture was to contain the dowry gifts brought by the bride to her wedding. During the fifteenth century this traditional custom became particularly fashionable in the major Italian towns, particularly Florence. However, the relatively tall height of these two panels seems now to suggest a different, although uncertain, original application.

The subjects depicted are rare, and celebrate glorious events of contemporary Florentine history. In the first panel the diverse phases of the Battle of Anghiari, which took place on 29 June 1440, are described in the manner of a strip cartoon.

To the left is the town of Borgo Sansepolcro, in the hands of the Milanese army. To the right, ready to fight, are the Florentine and Papal troops coming from Anghiari. The small towns of Città di Castello, Citerna and Monterchi are visible in the distant hills. The river Tiber crosses the open plain, and it was near the bridge that the clash took place. For four hours the two armies fought bravely, but in the end the Milanese were defeated and were obliged to retreat. It was an outcome that led to the sanction of the supremacy of the Florentine Republic over all Tuscany, and stopped forever any expansionist plans of the Dukes of Milan.

The second panel illustrates the story of the conquest of Pisa. The narrative begins on the left-hand side with the departure of the army from Florence, and shows in a series of small episodes the eight-month siege of Pisa. On 9 October 1406, forced by the starvation of the population and with no hope of rescue, the Pisan authorities finally agreed to surrender the city and opened the gates to the Florentine troops. The victors promptly made the best political use of their entry, bringing in loaves of bread skewed at the top of their lances.

The subject matter of these two panels differs from the usual ornamental decoration of *cassoni*. The quality of painting, too, is unexpectedly sophisticated for the time in which they were presumably executed. Regrettably we do not know the name of the artist, but they would no doubt have been a full-time painter who probably only occasionally carried out this sort of work.

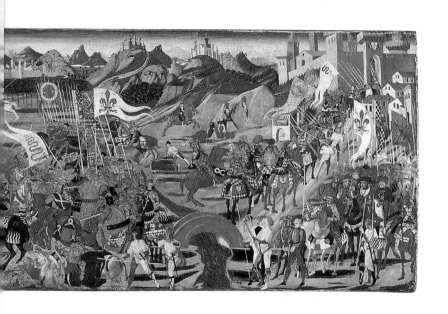

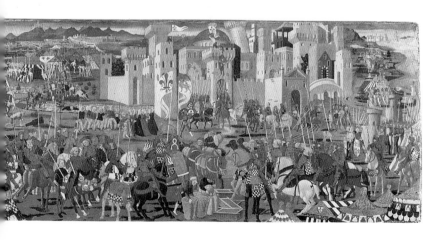

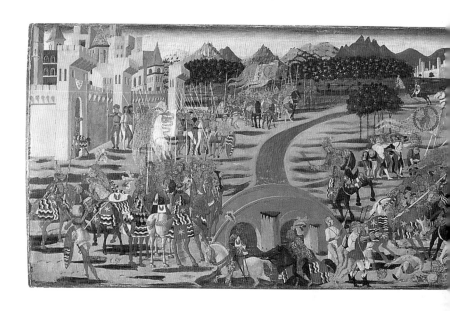

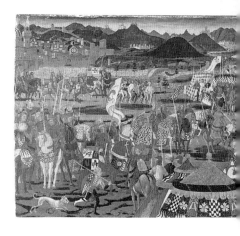

PERUGINO (Pietro Vannucci)

Città della Pieve *c.*1448–1523
Fontignano

The Lamentation over the Dead Christ

*c.*1495
Egg tempera and oil on wood,
169.5 × 171.5 cm
Signed: *PETRUS PERUSINUS / PINXIT*
Purchased 1931
NGI 942

Perugino trained in Perugia and in 1472 was already registered in the Guild of St Luke in Florence as an independent artist. In 1481, along with other important Florentine painters, he was invited to the Vatican to decorate the walls of the Sistine Chapel. Thereafter he was considered one of the leading artists in the field, and remained mainly active in Florence and in Perugia.

In our picture, the figures are symmetrically spaced under a three-arched loggia. The Virgin is seated at the centre, holding Jesus' dead body in her arms, while his head rests on the shoulders of St John the Evangelist. A visibly moved St Mary Magdalene is on the opposite side. The two figures standing behind are, presumably, Joseph of Arimathea and Nicodemus. This is a scene of great piety, created to induce deep meditation in the religious spectator.

Perugino painted two versions of this *Lamentation*, probably within a short space of time. The panel in the Uffizi is considered to be the earlier of the two and differs from this version in a few substantial details, the most significant of which is the gentle crepuscular Tuscan landscape which is only visible in our composition.

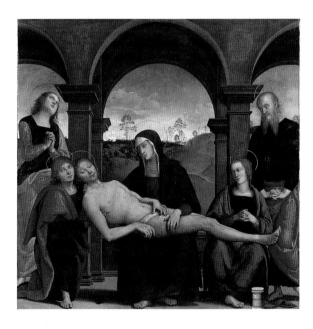

MARCO PALMEZZANO

Forlí c.1459/63 – before 1539

The Virgin and Child enthroned, with Sts John the Baptist and Lucy

1513

Signed: *MARCHUS PALMIZANUS / PICTOR / [F]OROLIVI[ENSIS] FECIT / MDXIII*

Egg tempera and oil on wood, 218 × 188 cm

Purchased 1863

NGI 117

Palmezzano was a pupil of Melozzo da Forlí and for a long period he collaborated with and imitated his teacher. He was active in the north-east of Italy, and his prolific work very much reflects the established artistic tendencies of that region. A typical example is our altarpiece, which, although dated 1513, has a symmetrical structure and other elements commonly used on the Adriatic coast at the end of fifteenth century. The scene presents the Virgin on a high throne holding the standing Christ Child, with an elegant canopy above their heads. Behind them, an arch opens onto a detailed wooded landscape with distant mountains and a church on the hill. The architecture is heavily decorated with classical bas-reliefs and *grottesche* motifs. At the foot of the throne a small angel is playing a lute, and beside him are the two patron saints, St John the Baptist and St Lucy. Although painted in a traditional manner and without any significant innovation, this Holy Conversation is appealing for its vivid colours and light effects.

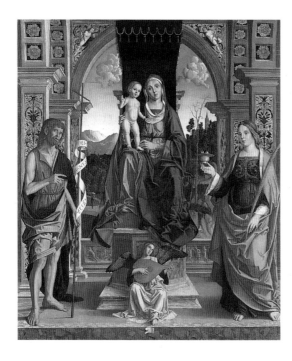

FRANCESCO GRANACCI

Villamagna 1469–1543
Florence

Rest on the Flight into Egypt with the Infant St John

*c.*1494
Egg tempera and oil on
wood, 100 × 71 cm
Purchased 1866
NGI 98

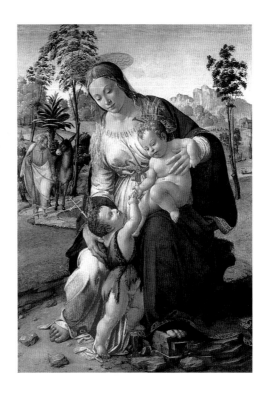

This delicate picture of the Holy Family was painted by one of the most gifted pupils of Domenico Ghirlandaio. Francesco Granacci was an apprentice in Ghirlandaio's workshop in Florence at the same time as Michelangelo, and the two pupils became close friends, also sharing the experience of studying sculpture in the Medici Garden at San Marco.

This Holy Family reflects the intellectual relationship that existed between the two artists in that period. The Virgin with the Child and St John is a compact group, constructed in a sculptural manner, a reflection of Michelangelo's influence. However, the presence of Ghirlandaio's style is also evident in

many parts, such as the beautiful, gentle face of the Virgin and the colourful landscape. (When Granacci painted this picture he was in his mid-20s and his master was probably already dead.) It is certain that this composition obtained some success as it was copied a number of times, and Granacci himself repeated it once, many years later, with a richer *sfumato*.

ALESSANDRO OLIVERIO

Active in Venice during the first half of the 16th century

Portrait of a Young Man

c.1510–20
Oil on wood, 67 × 57 cm
Signed: *Alesander Oliverius·V*
Purchased 1882
NGI 239

The identity of this young man is unknown. He is elegantly dressed, with a wide cloak covering a very elaborate waistcoat over a large white shirt. His hair is arranged in the fashionable Italian style of the beginning of the sixteenth century, called '*zazzera*', where it is parted in the middle and falls along the shoulders. Hanging at his neck is a curious but useful decorated jewel: a toothpick. The frontal pose of the man is most unusual, and reveals little of the sitter's personality. Even though it is difficult to recognize the sitter, however, it is clear that he was a well-bred man. He was quite probably the son of a wealthy merchant family.

This portrait is the only known picture to be signed by Alessandro Oliverio. He is a rare artist and only a few records document his activity. He certainly worked in Venice and had some rapport with Palma il Vecchio and Lorenzo Lotto, and for this reason he is often assumed to have come from Bergamo. However, inscribed on the parapet after his name is the letter V, which usually stands for Venice or Venetian.

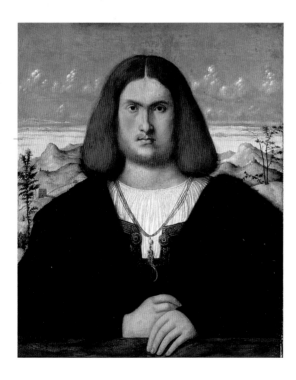

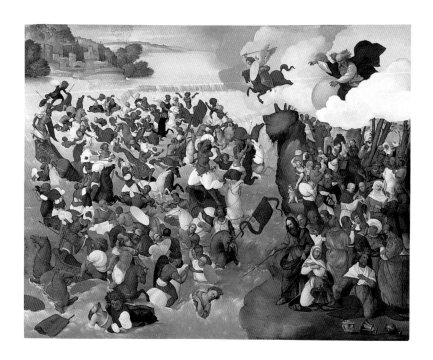

Ludovico Mazzolino
Ferrara c.1480 – after 1528

The Crossing of the Red Sea
Dated 1521
Oil on wood, 124 × 157 cm
Purchased 1914
NGI 666

Following an apprenticeship with
Lorenzo Costa in Bologna, Ludovico
Mazzolino went to Ferrara to work
for the Duke Alfonso I d'Este and
his wife Lucrezia Borgia. The
artistic climate of the court must
have been particularly congenial for
him – he initially produced small
works, but soon gained the
confidence to execute more
demanding compositions. In some
of these, such as in this panel,
Mazzolino proved his ability to
assimilate different sources, both
locally (Dosso, Garofalo) and from
beyond the Alps (Dürer, Cranach).

In this extraordinary rendition of
the biblical crossing of the Red Sea,
Mazzolino has managed to fit in
more than 150 small figures, each
distinctively painted without any
form of repetition and in vivid and
contrasting colours. God and the
punitive archangel Michael appear
emerging from the clouds. Below, in
a very dramatic scene, the Egyptian
soldiers are drowning while their
commander rises from his chariot
in a desperate attempt to save him-
self. On the right, in stark contrast,
Moses stands on the shore with the
saved multitude of Israelites.

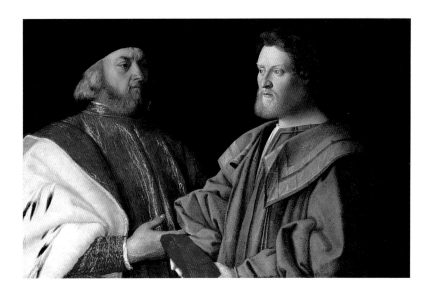

Vincenzo Catena and unknown artist

Active mainly in Venice c.1480–1531

Portrait of Two Venetian Gentlemen

c.1510
Oil on wood, 63.5 × 98.1 cm
Purchased 1867
NGI 100

In the past, the two personages seen in this picture were believed to be the poets Andrea Navagero and Agostino Beazzano. We now know that this identification was incorrect because of a painting by Raphael in which the two men appear quite dissimilar. The authorship of the picture has also caused puzzlement. While the young man on the right, wearing the coat of some religious confraternity, appears to have been convincingly executed by Vincenzo Catena, the man on the left, probably a representative of the Venetian oligarchy, seems to have been painted by a competent, different artist. Although collaboration between different painters is common, it seems that this picture may have been started by one artist and finished by another. However, both sitters share a formal appearance and, even if dressed differently, they both seem to wear ceremonial costumes as though protagonists in a particular social event.

Nothing is known about the origins of Vincenzo Catena. We presume that he was born in Venice. For a long time he was an eclectic follower of Giovanni Bellini. He appears to have had many friends in Venetian humanist circles. His later contact with Giorgione was very important and, after that artist's death, he developed a style which largely reflects Giorgione's manner.

Sebastiano del Piombo
(Sebastiano Luciani)
Venice(?) 1485/86–1547 Rome

Cardinal Antonio Ciocchi del Monte (1462–1533)

c.1512–15
Oil on canvas (originally on wood),
88 × 69 cm
Sir Hugh Lane bequest, 1918
NGI 783

Before his elevation to the Sacred College in 1511, the Cardinal was a jurist, an auditor of the Apostolic Chamber, and Archbishop of Siponto. In his portrait he is wearing a *mozzetta*, the red cape that signified ecclesiastical position. Sitting at his right is an exotic pet – a small monkey – and in his right hand he is holding a paper, perhaps a letter or an official document. The composition is typical of the early portraits of Sebastiano, and was painted soon after the artist's move from Venice to Rome.

The artistic milieu of the Papal City had a dramatic impact on the painter, leading him gradually to transform his style. Elements of this portrait, such as the severe pose of the Cardinal, reflect these changes, but the picturesque landscape in the background remains characteristic of Venetian taste.

During his early years in Venice Sebastiano was close to Giorgione, and assisted him on more then one occasion. Once in Rome, Raphael influenced him initially, and later Sebastiano became a friend of Michelangelo. In 1531 he obtained the office of Keeper of the Papal Seal, and consequently he was nicknamed 'del Piombo' (lead).

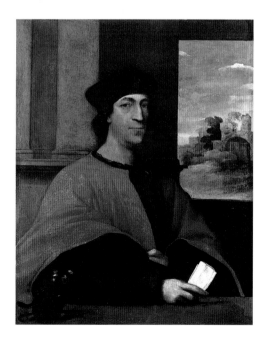

TITIAN
(Tiziano Vecellio)

Pieve di Cadore
c.1485/90–1576 Venice

Ecce Homo

c.1558/60
Oil on canvas,
73.4 × 56 cm
Purchased 1885
NGI 75

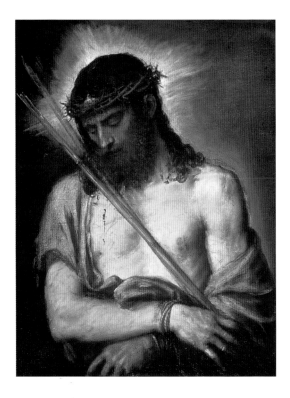

The episode of the Ecce Homo is one of most moving moments of Christ's Passion. Having been repeatedly flagellated and ridiculed with a crown of thorns, Jesus was presented by Pilate for the verdict of the Jewish people. The image of Christ offered by Titian in this picture is particularly moving. The Saviour appears powerless, in tears, and his tortured body is covered in blood. It is an image of real physical suffering, but it is also one of great spirituality. The painting was carried out rapidly with fast dabs of paint. This speed of execution is evident in a number of visible readjustments, such as the repositioning of the sceptre.

In the earlier part of his career Titian had collaborated with Giorgione in Venice. Soon, however, he was fully independent and was recognized as the most talented artist in that city. His fame led him to become the favourite painter of the leading Italian families, as well as of Pope Paul III and of the Emperors Charles V and Philip II.

PORDENONE (Giovanni Antonio de Sacchis)

Pordenone c.1483–1539 Ferrara

Portrait of a Young Nobleman

1530s
Oil on canvas, 107 × 94 cm
Purchased 1856
NGI 88

During the first half of the sixteenth century Pordenone was one of the most innovative artists in northern Italy. His style was broadly Venetian but was also open to mannerist influences coming from the nearby regions of Emilia and Lombardy.

When this picture first entered the Gallery collection it was entitled *Portrait of a Count of Ferrara*, but regrettably it has not been possible to verify this early identity. Nevertheless, the elegant dress and bold attitude of the sitter indicate that he must have belonged to a leading Italian aristocratic family.

In the portrait, the young man stands proudly but relaxed, with his favoured greyhound at his side. His figure is brought into focus against a background partially covered by a green curtain, which creates a pleasing contrast with the purple colour of his coat. The composed pose of the man is reminiscent of some of Titian's best contemporary portraits, and was very much in fashion at that time.

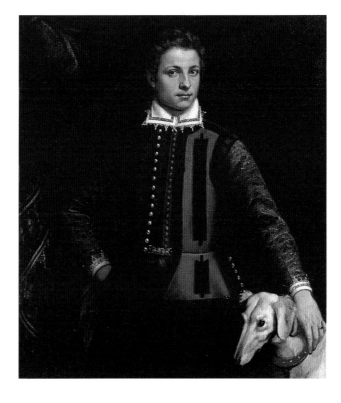

GIOVAN FRANCESCO PENNI,
sometimes called 'Il Fattore'

Florence 1496–1528(?) Naples

Portrait of a Young Man

*c.*1525
Oil on wood, 52 × 41 cm
Signed: G.Franc / Penni
Purchased 1939
NGI 1018

For a long period this picture was regarded as a self-portrait. This was found to be incorrect, however, after the discovery of a drawing by Giulio Romano revealing the real features of Penni. While the identity of the sitter has returned to anonymity, the quality of the portrait remains undiminished. The favourite pupil of Raphael, Penni assisted him in all the major works executed in the Vatican. Penni's portraits are not numerous, but they are always remarkable.

This portrait shows a young gentleman, probably in his late twenties, elegantly dressed in black. Baldassare Castiglione, in *The Book of the Courtier* (1528), offers an account of the fashionable colours used by his contemporaries: 'Black apparel is more becoming than any other colour, but if the clothes are not black they should be at least of a dark colour.' In the picture the physiognomy of the sitter appears carefully studied. A light beard outlines the oval face, and the mouth is precisely designed with a pronounced upper lip, while the eyes look directly to the observer.

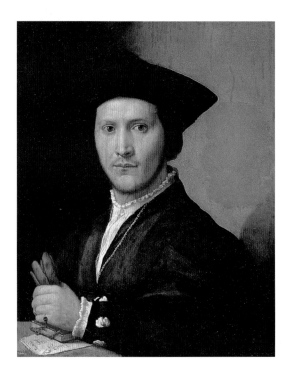

GIOVAN BATTISTA MORONI

Albino, before 1524–1578 Bergamo

Portrait of a Gentleman and his two Children

c.1570
Oil on canvas, 125 x 97 cm
Purchased 1866
NGI 105

This is a very intimate portrait showing a father protectively embracing his two children. The name of the sitter is unknown but traditionally it was presumed to be a widower with his children. Apart from the evident paternal tenderness, however, nothing really sustains that suggestion today. Even the sober black dress of the man is not definitive proof of his mourning since it was commonly worn at the time.

Although Moroni's production includes several religious altarpieces, he is best known for his portraits and is considered among the very greatest Renaissance painters of that genre. He operated throughout his life in northern Italy, and painted noblemen, prelates, scholars, and ladies of every age. They were all depicted with great likeness, without any idealization and, most of the time, with a meditative aspect. Since he generally portrayed single figures, the present picture is considered quite rare.

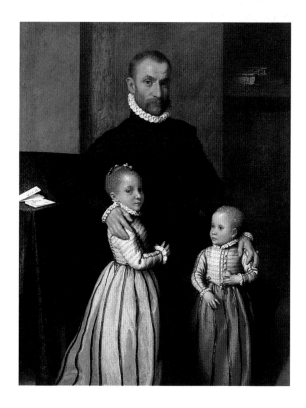

Lavinia Fontana

Bologna 1552–1614 Rome

The Visit of the Queen of Sheba to King Solomon

c.1600
Oil on canvas, 256.5 x 325 cm
Purchased 1872
NGI 76

The biblical episode of the encounter of Solomon with the Queen of Sheba is the pretext used here to represent a sumptuous event of a contemporary Italian court. Apparently, the real historical occasion was offered to the artist in 1600 by the transit, through Bologna, of the Dukes of Mantua on their way to Florence to attend the wedding of their relative Maria de'Medici with Henry IV of France. In the painting, Vincenzo I Gonzaga and his wife Eleonora de'Medici are disguised as Solomon and the Queen of Sheba. Also represented are a number of courtiers, mostly ladies dressed luxuriously, and the two favourites, the dwarf Stefanone and the Great Dane. Regrettably, we do not know the original purpose of this large picture but it seems reasonable to presume that it was commissioned for both allegorical and celebratory purposes.

Lavinia Fontana was one of the most successful female painters in the history of Western art. Having trained with her father Prospero, in Bologna, she became a very popular portraitist, and gradually moved from traditional mannerism to a more naturalistic style.

*Portrait of
Prince
Alessandro
Farnese
(1545–92),
afterwards Duke
of Parma and
Piacenza*

*c.*1560
Oil on canvas,
107 × 79 cm
Purchased 1864
NGI 17

The very young aristocrat portrayed here was the son of the Duke of Parma and grandson of King Charles V of Spain. His royal origins required that he be educated at the Spanish court. There he trained to become a military leader, and in 1571 he took part in the battle of Lepanto. In 1578 he was nominated Governor of the Low Countries, and eight years later he succeeded his father as Duke of Parma and Piacenza. He was one of the principal military figures of his time, and fought in a number of campaigns against the French and the English. Sofonisba Anguissola must have painted this portrait just a short time after her arrival at the court of Madrid. There, the Queen, whom she taught to draw, favoured her. The Prince was probably only 15 years old when he sat for this canvas, and his delicate features clearly show his adolescent age.

Anguissola was not only one of the few female artists of the High Renaissance, but also possibly the most gifted. What characterized her painting was her ability to obtain the likeness of her sitters, along with her accurate attention to detail.

ANNIBALE CARRACCI

Bologna 1560–1609
Rome

Portrait of a Man

1590s
Oil on canvas,
46.6 × 39.5 cm
Presented by Sir
Hugh Lane, 1914
NGI 673

During the early years of his career, portraiture was one of Annibale's favourite artistic activities. Later, he could rarely indulge in these relaxing exercises as he was too preoccupied with satisfying his patrons' taste for decorating palaces and churches with ambitious schemes.

A sharp observer of the human figure, Annibale was also a pungent caricaturist. This is not the case with the present portrait, however, which appears instead to have been painted from life with rapid touches of the brush. The sitter is unknown, but his features reveal a proud man with a penetrating look.

The portrait was probably painted during the last decade of the century, in Bologna, before Annibale left to work in Rome for Cardinal Odoardo Farnese. Annibale's approach to naturalism was one of the innovations promoted at the art academy, called degli Incamminati, that he founded in Bologna with his brother Agostino and his cousin Ludovico.

ORAZIO
GENTILESCHI
(Orazio Lomi)

Pisa 1563–1639
London

*David and
Goliath*

c.1605–07
Oil on canvas,
185.5 × 136 cm
Purchased 1936
NGI 980

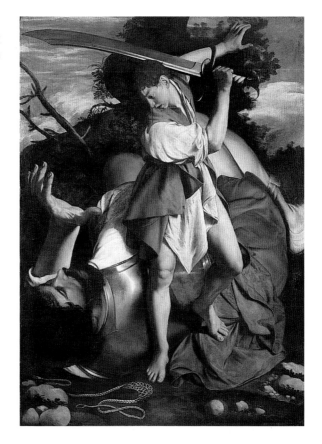

Gentileschi's real surname was Lomi. His father was a goldsmith and his elder brother Aurelio was a painter of fair ability. He went to Rome at the age of 17, and his early works were in the late mannerist style. From the beginning of the new century, after his encounter with Caravaggio, he turned to naturalism. *David and Goliath* is a rare example of this early change. The composition is strongly three-dimensional and in part still reflects Gentileschi's mannerist education, but the action is expressed in a new, dramatic, and realistic way. The figures are sharply lit from above,

creating distinct contrasts of chiaroscuro, even if the artist preferred to use softly blended colours.

In the 1620s Gentileschi moved first to France and later to England, where he became court painter to King Charles I.

The biblical subject of this picture became particularly popular after the Tridentine Council, as a symbol of the triumph of true Faith over Heresy, and was widely used by Caravaggio's followers.

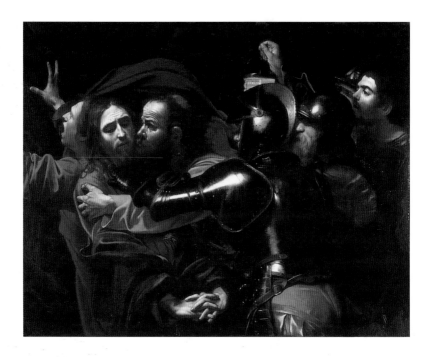

CARAVAGGIO
(Michelangelo Merisi)

Caravaggio 1571–1610 Porto Ercole

The Taking of Christ

1602

Oil on canvas, 133.5 × 169.5 cm
Indefinite loan from the Jesuit
Community of Leeson Street, Dublin,
who acknowledge the generosity of the
late Dr Mary Lea-Wilson, 1992
NGI 14,702

Throughout history, very few artists
have caused as radical a change in
pictorial perceptions as Caravaggio.
From the moment his talent was
discovered, he swiftly became the
most famous painter of his time in
Italy, as well as the source of inspira-
tion for hundreds of followers
throughout Europe.

The Taking of Christ was painted by
Caravaggio for the Roman Marquis
Ciriaco Mattei at the end of 1602,
when he was at the height of his
fame. Breaking with the past, the
artist offered a new visual rendering
of the narrative of the Gospels,
reducing the space around the three-
quarter-length figures and avoiding
any description of the setting. All
emphasis is directed on the action
perpetrated by Judas and the Temple
guards on an overwhelmed Jesus,
who offers no resistance to his
destiny. The fleeing disciple in
disarray on the left is St John the
Evangelist. Only the moon lights the
scene: although the man at the far
side is holding a lantern, it is in
reality an ineffective source. In that
man's features Caravaggio portrayed
himself, at the age of 31, as a passive
spectator of the divine tragedy.

RUTILIO MANETTI

Siena 1571–1639

Victorious Love

c.1625
Oil on canvas,
178 × 122 cm
Purchased 1856
NGI 1235

The theme of this charming painting is the victory of Cupid over human achievements. The subject originates from some verses from the Latin poet Virgil, entitled '*Omnia vincit amor*', which were exalted by the Neo-platonic humanists. Here, a young Cupid appears ready to strike an unsuspecting victim with his arrows, while he walks indifferently over instruments and books, all symbols of intellectual activities. The allegorical message is clear: no one can resist love.

The most important Sienese painter of the seventeenth century, Rutilio Manetti had an early mannerist education, but he quickly become a very talented naturalistic artist. His conversion seems to have started at the end of the second decade of the century, at which time he probably travelled to Florence and came into contact with the works of Bartolomeo Manfredi and Honthorst. However, the possibility of a trip to Rome, which could have happened almost at the same time, should not be excluded. If this was indeed the case, the direct acquaintance with some of the public and private works of Caravaggio would certainly have had a striking effect on him.

GIULIO CESARE PROCACCINI
Bologna 1574 –1625 Milan

The Apotheosis of St Charles Borromeo

*c.*1620
Oil on canvas, 383 × 248 cm
Purchased 1856
NGI 1820

St Charles Borromeo was born into one of the noblest families of Lombardy – yet from the moment he was elected Archbishop of Milan, in 1565, he became an extraordinary example of humility and spirituality for the entire region. He ate sparingly, and offered all his money to public charities. When the plague broke out in Milan, he remained in the city and tended the sick. Audiences of thousands, who recognized him as the spiritual soul of the Tridentine Council, followed his sermon that preached against the sins of society. As a result of this pious life, he was canonized only 26 years after his death.

The painting shows St Charles in his archiepiscopal vestments being carried up to Heaven by angels. He is holding the crosier in one hand, and beside him two angels are carrying his cardinal's hat and his religious device, the crowned word *Humilitas*. Below him, the Archangel St Michael combines his two principal roles. As conqueror of Satan, in full armour he steps over the defeated demon; and as lord of souls, he holds aloft a pair of scales with two small naked figures representing the souls.

The large dimensions of this picture indicate that it was painted to be an altarpiece. Gaspare Mola, a sculptor and a medallist, left it to the church of S. Maria in Traspontina in Rome, but we know that this was not its original destination.

Giulio Cesare Procaccini was a member of a Bolognese family of artists. After moving to Milan he initially trained as a sculptor, and only switched to painting in 1600. However, he soon became one of the leading local artists in that field.

GUIDO RENI
Bologna 1575–1642

The Suicide of Cleopatra
c.1639–40
Oil on canvas, 77 × 65 cm
Sir Denis Mahon promised bequest
NGI 4651

The tragic suicide of Cleopatra, the beautiful Queen of Egypt, was a theme much loved by many artists, and Guido Reni painted this subject several times throughout his career. The historical event happened immediately after the death of her lover, Mark Anthony. Cleopatra, discouraged and hopeless of her future, decided to kill herself by the bite of an asp to avoid falling into the hands of Octavius. The picture shows the moving moment when the small snake has just bitten the Queen, leaving two tiny red wounds on her bosom while the deadly poison starts to take effect.

Characteristic of Reni's style is the refined elegance of this composition. Throughout his life he experimented with new ways of painting, and in his last period he favoured a delicate silvery manner, working very quickly with freer brushwork and with light, soft colours, as in our picture.

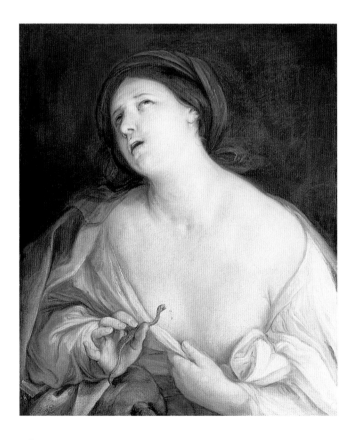

Domenichino
(Domenico Zampieri)

Bologna 1581–1641 Naples

Saint Mary Magdalene

*c.*1625
Oil on canvas, 122.4 × 95.7 cm
Sir Denis Mahon promised bequest
NGI 4646

This three-quarter-length figure is probably based on an earlier idea by Guido Reni. The two artists were lifelong friends, and sometimes Guido's works inspired Domenichino, as is evident here. The structure of the composition is decisively classical, with the saint diagonally positioned as she raises her eyes in prayer. Her vivid and sumptuous dress contrasts with her humble attitude as she rests her arm on a parapet where the jar of ointment stands.

Domenichino is one of the major Italian artists of the Baroque age. The figures in his painting are a balance of elegance and harmony, and are always supported by a perfect design. His compositions epitomized the ideal beauty of classicism and were highly praised by his contemporaries.

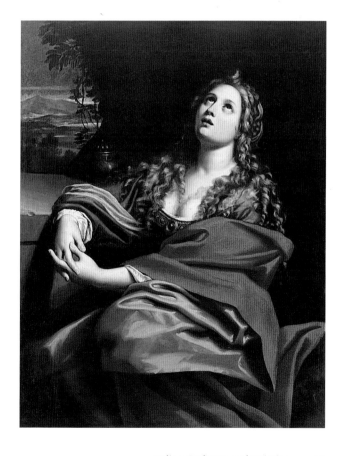

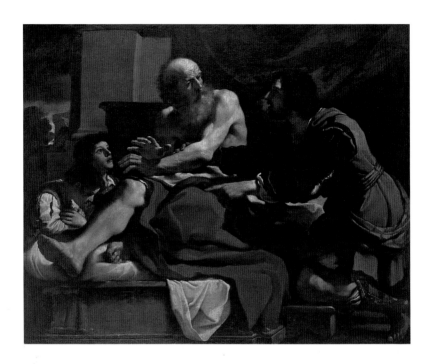

Guercino (Giovanni Francesco Barbieri)

Cento 1591–1666 Bologna

Jacob blessing the Sons of Joseph

*c.*1620
Oil on canvas, 170 × 211.5 cm
Sir Denis Mahon promised bequest
NGI 4648

According to the Book of Genesis, Joseph brought his two sons before his father Jacob to be blessed. The blind old man, unexpectedly, crossed his arms and blessed Ephraim, his younger grandson, with his right hand, thus favouring him over the first-born brother. In the picture Jacob's action is clearly expressed, as is the disbelief of Joseph and of his elder son Manasseh. Guercino paid particular attention to the prophetic pose of Jacob's hands in the sign of the cross. This was considered highly symbolic by the Catholic authorities, because it was from the young boy's descendents that Jesus was born. The artist was known throughout his life as Guercino (the squinter), due to a problem with his vision. Practically self-taught as a painter, he soon acquired an outstanding taste for colour and naturalism. This painting was commissioned by Cardinal Jacopo Serra, Papal Legate in Ferrara. The title of knight was conferred upon the artist as a consequence of this and other works.

BERNARDO STROZZI,
sometimes called 'Il Prete Genovese' or 'Il Cappuccino'
Genoa 1581–1644 Venice

Allegory of Summer and Spring
Late 1630s
Oil on canvas, 72 × 128 cm
Purchased 1924
NGI 856

The two young women seen here are personifications of two seasons. On the left is Summer, with sprigs of corn in her hair and holding a cornucopia full of fruits. Beside her, Spring carries numerous different flowers in her hands and in her hair. The images of the two women, with their attributes, appear to have largely originated from the literary interpretation offered by Cesare Ripa of the allegories of Abundance and Flora.

Bernardo Strozzi is said to have trained in the workshop of Pietro Sorri, a well-regarded colourist painter. His career was spent initially in and around his home town of Genoa, where he became a Capuchin friar. He subsequently obtained leave of the order to look after his critically ill mother, while remaining a priest. Around 1631, after the death of his mother, he settled in Venice and rejoined the Church, although in a different order. He was made a monsignor in 1635. This canvas was most probably painted in the last period of the artist's activity, when the colours he used became more delicate and the handling looser.

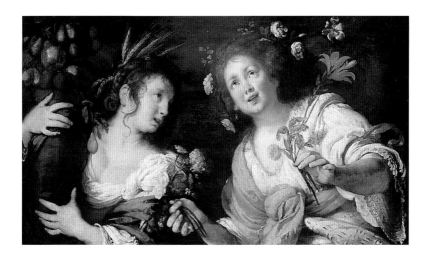

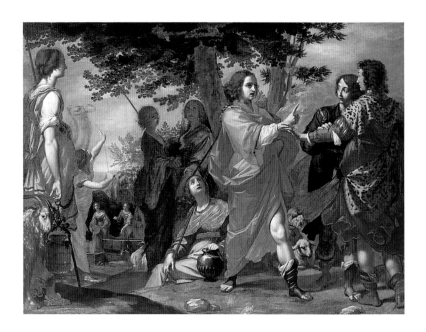

CESARE DANDINI
Florence 1596–1656

Moses Defending Jethro's Daughters at the Well

c.1635
Oil on canvas, 206 × 272 cm
Milltown gift, 1902
NGI 1683

Dandini is one of the most significant of the artistic figures to be working in Florence during the first half of the seventeenth century. Compared with other artists of the same origins, he seems to have found it particularly difficult to detach himself from the traditional mannerist legacy of his culture. Nevertheless, Dandini was gifted with an uncommon talent and gradually elaborated a refined style that was admired by his contemporaries, and is still appreciated today. His ability as an illustrator of moral concepts and of literary or biblical subjects is very evident in this scene drawn from the second book of Exodus (22–16), which is presented like an operatic scene loaded with effects.

When Moses fled from Egypt, he sought sanctuary in the land of Midian. One day, he was resting near a well when the seven daughters of a priest called Jethro came to draw the water for their father's flocks. The local shepherds drove the women away but Moses promptly defended them, forcing the men to share the water.

The canvas was commissioned from Dandini by Michel Agnolo Venturi. The painter handles the episode with his customary polished elegance, and with an unexpected sense of naturalism.

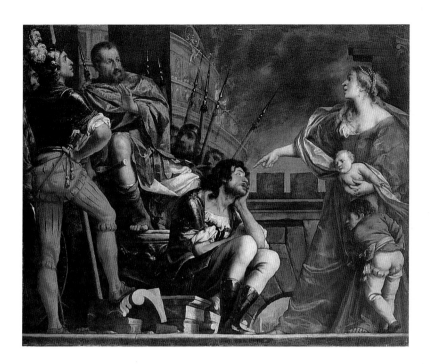

Pietro della Vecchia

Venice 1603–76

An Unidentified Episode of Classical History

1650s
Oil on canvas, 189 × 238 cm
Purchased 1856
NGI 94

The subject of this painting has not yet been identified. When the picture was acquired it was believed to represent 'Timoclea brought before Alexander'. Although this is now considered highly improbable, certain aspects of the scene are similar to that story. From a simple visual interpretation the event seems to have as its protagonist the woman with two children on the right. She is clearly pointing out a man seated at the centre. Above, apparently horrified by the woman's words, is a general – judging from his clothing and from the baton held his hand – surrounded by soldiers. In the background, flames engulf a round edifice where people are fighting. The scene has all the ingredients of a subject adopted from the vast repertoire of classical history.

Pietro della Vecchia is an unpredictable artist. Although his style is coherent, the results are of inconsistent quality. In this work, however, Vecchia treats the mysterious composition skilfully and with highly theatrical appeal.

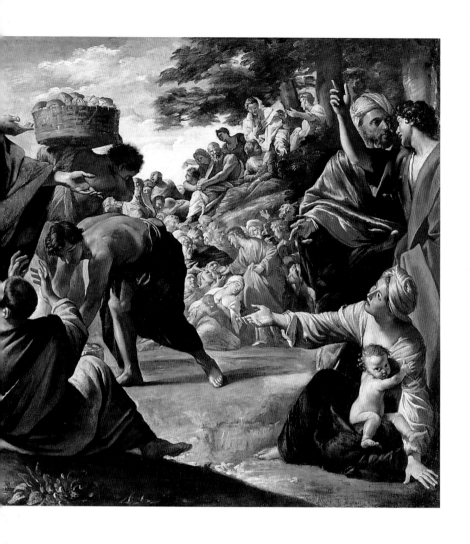

Fold out

GIOVANNI LANFRANCO

The Multiplication of the Loaves
and Fishes The Last Supper

GIOVANNI LANFRANCO
Parma 1582–1647 Rome

The Multiplication of the Loaves and Fishes

The Last Supper

1624–25
Oil on canvas, 227 × 423.5 cm,
226 × 422 cm
Purchased 1856
NGI 72 and 67

One of the major reaffirmations of the Counter Reformation was the real presence of Christ in the Eucharist, and numerous altars and chapels were dedicated to this dogma of the Catholic Church. Among the most ambitious of these programmes was the commission for the paintings for the Chapel of the Blessed Sacrament in Saint Paul's-without-the-Walls in Rome. Lanfranco accomplished the task in less than two years, producing eight oil canvases and three frescoes. This cycle of pictures is considered one of the masterpieces of the pre-Baroque age and one of Lanfranco's

most successful achievements. With the exception of two frescoes, the works are now in different galleries.

The two paintings in the Gallery's collection are the largest of the entire series and were removed, along with the others, because of rising damp in the chapel. The first shows a standing Christ miraculously feeding the surrounding multitude. It is a very colourful scene, which inspired many later painters. The second represents the final theme of the cycle, the divine establishment of the Eucharist during the Last Supper. It is a highly evocative composition, with Jesus and the Apostles emerging dramatically from the dark background as a result of the sharp light.

It is from these paintings, and other works, that we today appreciate the full importance of Lanfranco's art. His inventive pictorial conception precede, by many years, the use of illusionist compositions which later became so typical and popular all over Europe.

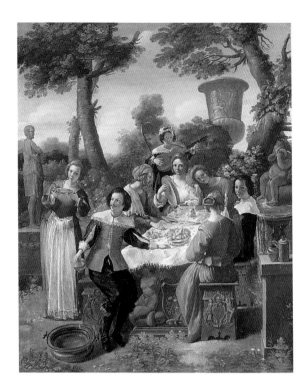

This pleasant scene shows a group of elegantly dressed guests gathered together for a picnic in the garden of a Roman villa. A few classical statues, memories of a glorious past, emerge from the bushes. Curiously, the company does not appear to enjoy the moment and a veil of melancholy seems to pervade all present. The reason for their pensive expressions is revealed by the Latin inscription on the emblem at the side of the table: '*cadunt et remanent*' (they fall and they remain). Apparently referring to the roses on the shield, which are starting to lose their bloom, the motto alludes to the young guests and is a warning of the transitory nature of human existence.

In seventeenth-century Italian art, moralizing concepts were frequently used in paintings, but were more commonly confined to biblical subjects or to still lifes. The author of this composition was also an art critic and became a priest at the end of his life. His written work on the lives of the artists of his own time is considered of great historical importance. Regrettably, only a half dozen pictures by Giovanni Battista Passeri have so far been identified, and our canvas is the only one which carries his signature.

SASSOFERRATO
(Giovan Battista
Salvi)
Sassoferrato 1609–85
Rome

Virgin and Child
1650s
Oil on canvas,
105 × 65.5 cm
Purchased 1873
NGI 93

With the exception of the four charming cherubs at the top of the canvas, the composition of this picture is derived from Raphael's famous *Madonna of Foligno*, now housed in the Pinacoteca Vaticana. However, the figures are reversed from the original, which demonstrates that Sassoferrato did not copy directly from the painting but from an engraving made by Marcantonio Raimondi.

Sassoferrato was nicknamed after his birthplace, a small town in central Italy. His art is characterized by a brilliant palette of saturated, translucent colours, which he employed in compositions that were inspired by the great Italian masters of the fifteenth and sixteenth centuries, or by the works of some of his famous contemporary classical artists.

During his long career, the artist painted numerous images of refined Madonnas, often repeating the most successful or adding small variations. Although his paintings were once seen as excessively sentimental, today they are appreciated for their polished beauty and purity of modelling.

Lorenzo Lippi

Florence 1606–65

Angelica and Medoro

c.1632–34
Oil on canvas, 171 × 204 cm
Milltown gift, 1902
NGI 1747

This is a literary subject taken from Ludovico Ariosto's poem, *Orlando Furioso*. The female protagonist, Angelica, was the daughter of the king of Cathay. During her flight from the Christian camp, where the sorcery of her beauty bewildered the knights of Charlemagne, she met a young Moor, Medoro, injured from battle. Angelica decided to take care of him by treating his wounds with special herbs but, unexpectedly, as she tended to him, she fell in love.

This poetic and romantic episode is elegantly illustrated at the moment when Cupid is ready to instigate their love affair by striking the couple with his arrow. Lippi was one of the leading Florentine artists during the first half of the seventeenth century. The clarity of his pictorial images, which he inherited from Santi di Tito, made him the favourite painter of a sophisticated circle of private patrons, eager for intellectual compositions of theatrical and philosophical inspiration.

CARLO DOLCI
Florence 1616–86

St Agnes
*c.*1670
Oil on canvas, 63.5 × 52 cm
Purchased 1951
NGI 1229

St Agnes was one of the early Christian martyrs venerated by the Church. According to legend she was only 13 when a Roman governor arrested her for refusing to offer a sacrifice to the idols. After that she was submitted to a series of tortures but still she did not renounce her faith. Next, she was paraded naked in a brothel, but she miraculously managed not to lose her innocence. Enraged by her spiritual strength, the governor finally ordered that she be put to death by the sword.

In this image the saint delicately holds a lamb in her arms. The Latin word for lamb is '*agnus*', from which the name of Agnes derives; but the lamb is also a symbol of Christ and therefore her embrace signifies her faith in God.

Dolci spent nearly all his life in Florence. His works have frequently, but unjustly, been accused of excessive sentimentality. In reality he was a gifted artist, but perhaps his fervent religiosity limited the variety of his subjects.

FERDINANDO TACCA

Florence 1619–86

Hercules with the Pillars

*c.*1650
Bronze, height 33.5 cm
Milltown gift, 1902
NGI 8125

According to classical legend, in order to achieve immortality Hercules was commanded to serve Eurystheus for 12 years. During one of his labours he reached the borders of Europe and Africa and erected two pillars, one on each side of the straits of Gibraltar, since known as the 'Pillars of Hercules'. We know that some time before 1581, Giambologna made a set of small sculptures on the theme of the 'Twelve Labours of Hercules'. These statuettes were lost but, fortunately, bronze copies of them were executed by some of his pupils.

Ferdinando Tacca cast the present bronze after a model made by his father Pietro, a favourite assistant of Giambologna. Pietro had made his copies at the request of the Grand Duke, Cosimo II, and in turn Ferdinando inherited his father's workshop in Florence and the position of grand-ducal sculptor.

The Gallery owns three more examples from the series of 'Hercules' Labours', all of which were purchased by Joseph Leeson, first Earl of Milltown, probably in Florence during his first trip to Italy in 1744 or 1745.

MASTER OF THE CARPETS

Active in Italy during the middle of the
17th century

Still Life with Musical Instruments

*c.*1650
Oil on canvas, 92.5 × 155.5 cm
Miss H. M. Reid bequest, 1939
NGI 1014

The sobriquet 'Master of the Carpets'
refers to the author of a small num-
ber of still lifes. Almost certainly
Italian, he was influenced in equal
measure by three other painters
working in the same genre, namely
Baschenis, Bettera, and Giuseppe
Recco. Our picture is probably the
most significant work that has been
attributed to this artist to date. The
composition has an unusual diagonal
structure, with the objects placed on
three different levels. Described in
a very naturalistic manner, they
emerge from the dark background
with vivid colours. Three instruments
are represented: a violin, a lute, and a
mandolin. Beside them is a musical
script and a footed silver plate with
pastries and candied figs. The thick,
colourful carpet is the recurrent
element used by the artist. On the
ground is a cooler containing wine
bottles and grapes. As was frequently
the case with this genre of pictures,
this still life may have been painted
as an allegory of the five senses.

LUCA GIORDANO
Naples 1634–1705

Venus, Mars and the Forge of Vulcan

1660s
Oil on canvas, 131 × 158 cm
Sir Denis Mahon promised bequest
NGI 4647

Luca Giordano is the most prominent Neapolitan painter of the second half of the seventeenth century. His artistic output was so prolific that, during his life, he became known as '*Luca fa presto*', on account of the speed with which he used to finish his paintings. His professional training was carried out in the workshop of Jusepe Ribera, but he soon became attracted by the work of artists such as Pietro da Cortona and the earlier Venetian masters.

The scene represents Venus falling in love with Mars. The goddess is sitting naked on her bed, and is embraced by a small Cupid as Mars appears behind. On the left, totally unaware of the liaison, Vulcan and his assistants are forging Jupiter's thunderbolts.

The format of the composition is a little squat, but the Venetian-inspired handling is superbly fluid. Stylistically, Giordano seems to have combined motifs reminiscent of da Cortona with the luminous chromatic effects of Rubens.

Giovanni Benedetto Castiglione, sometimes called 'Il Grechetto'

Genoa 1609–64 Mantua

The Infant Cyrus discovered by the Shepherdess

c.1651/9
Oil on canvas, 234 × 226.5 cm
Purchased 1937
NGI 994

Castiglione trained in Genoa under various artists, including Van Dyck and Giovan Battista Paggi. Around 1632 he moved to Rome, and was influenced by Poussin and Bernini. His own style portrayed picturesque pastoral and biblical scenes with loose brushstrokes of great virtuosity.

Here he depicts the discovery of the abandoned baby Cyrus. As told by Herodotus, legend has it that Astyages, daughter of the King of Media, gave birth to an illegitimate son, Cyrus. An oracle had predicted the King would be overthrown by his grandson, and so she was forced to abandon the child. A shepherdess named Spako found the abandoned infant *Spako* literally means 'bitch', so a second legend arose that Cyrus was suckled by a dog.

Castiglione's composition is faithful to the narrative. All the elements of the story have been harmoniously blended on the canvas, using a palette of luminous and vibrant colours.

CARLO MARATTI
Camerano 1625–1713 Rome

The Rape of Europa
*c.*1680–5
Oil on canvas, 249 × 423 cm
Purchased 1856
NGI 81

This is one of the largest canvases in
the collection, and illustrates the
passion of Jupiter for the young
Europa, daughter of Agenor, King of
Tyre. She was so beautiful that the
god fell madly in love with her. One
day, while Europa was gathering
flowers in the meadows near the
shore with her female attendants,
Jupiter disguised himself as a docile
bull and mingled with the group,
raising the curiosity of Europa and
her companions. The young princess,
evidently attracted by the good nature
of the bull, placed a fresh garland on
his horns and mounted his back,
wherewith the god swiftly abducted
her and swam away to the island of
Crete.

Many artists have interpreted this
mythical episode, and the visual
description offered by Carlo Maratti
is one of the most accomplished. He
preferred not to represent the more
commonly portrayed abduction, but
rather the moment just before it,
when Europa and her friends are still
joyfully playing in the field, unaware
of the deceit. The result is an impres-
sive composition of graceful and
refined classicism that was widely
admired and celebrated among
Maratti's contemporaries.

Fold out
CARLO MARATTI
The Rape of Europa

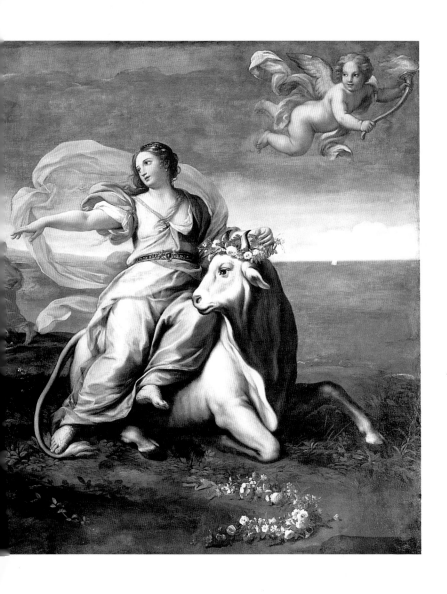

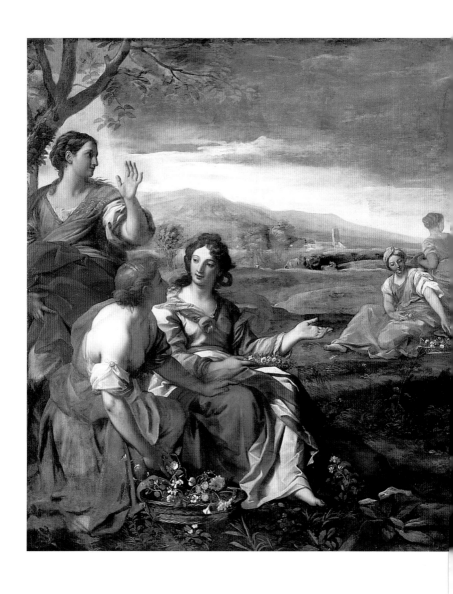

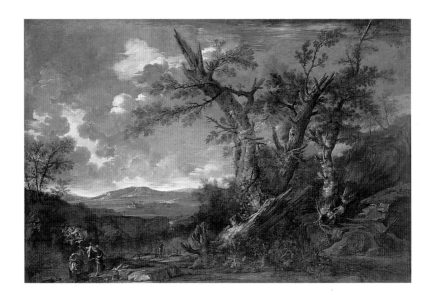

Salvator Rosa

Arenella 1615–73 Rome

Landscape with the Baptism of Christ

1650s
Oil on canvas, 147 × 223 cm
Purchased 1856
NGI 96

Salvator Rosa was a talented and versatile artist, with an extravagant personality. A gifted draughtsman and an excellent printmaker, his interests also included poetry and acting. Highly intellectual, he preferred to paint erudite historical themes, scenes of witchcraft, and portraits of stoic philosophers. He is best known, however, for his creation of an innovative new type of landscape. As an alternative to the idealized Arcadian views of Claude Lorrain, Rosa's landscapes comprise picturesque scenes of roughly shaped rocks and twisted trees.

Significantly, in this picture the painter has chosen to incorporate both of these landscape tendencies. On the left he has used a wide and lyrical panoramic perspective to embody the sacred episode of the Baptism of Jesus on the shores of the Jordan. By way of contrast he has filled the right-hand side of the composition with a cluster of large warped trees and trunks.

GIROLAMO TROPPA

Rocchette in Sabina 1630 – after 1710
Rome

Adoration of the Shepherds

1670s
Oil on canvas, 153 × 110.7 cm
Signed with monogram: *TPR*
Milltown gift, 1856
NGI 1669

Information about the life of Troppa is quite scarce. He was nevertheless a painter of significant qualities, a fact proven also by the title of *Cavaliere* with which he was honoured. Like many other artists working in Rome at the time, he was influenced by the elegant painting of Carlo Maratti, and sometimes in his pictures he combines that artist's classical style with the romantic handling of Salvator Rosa.

In this enchanting depiction of the nativity, the newborn Saviour and his Mother are the shining source that attracts the attending angels above, and St Joseph and the shepherds on earth. Both groups are left in shadow, and compositionally separate, to emphasize the two different spheres of joy: the divine and the human.

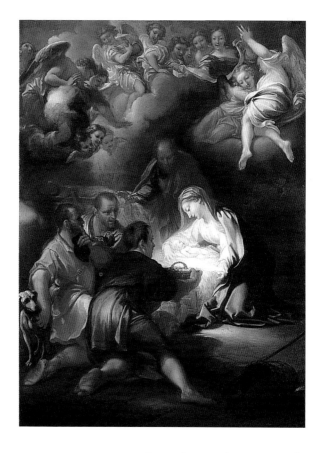

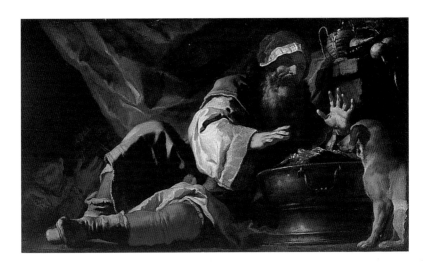

FRANCESCO SOLIMENA, sometimes called 'Abbate Ciccio'

Canale di Serino 1657–1747 Barra

Allegory of Winter

c.1690
Oil on canvas, 87.5 × 127.2 cm
Presented by Mr A. Buttery, 1911
NGI 626

Solimena was a prolific artist, and extremely famous in his day. For many years he dictated the visual taste of Neapolitan society, and his reputation was equally high all over Europe. He became a painter after having initially studied law and, after his training with Francesco Guarino, found his sources of inspiration in Mattia Preti and Luca Giordano. He soon exploited, with great ability, the illusionistic effects offered by the Baroque style, and created some of the most grandiose compositions of the period, using a technique of strong contrasts and vivid colours in both oil and fresco.

The theme illustrated here is allegorical. An old man is intent on warming himself near a brazier. He is lying in a sort of alcove with his dog beside him, and wine and vegetables resting on a shelf. Meanwhile a servant appears ready to bring in more logs. In artistic literature, winter was symbolically identified as a melancholic, cold, old man resting after an entire year of labour.

The picture was perhaps part of a series of 'Seasons' painted for an undisclosed patron.

CANALETTO (Antonio Canal)
Venice 1697–1768

St Mark's Square

*c.*1756
Oil on canvas, 46 × 77 cm
Purchased 1885
NGI 286

Canaletto was the most sophisticated Venetian painter of *vedute* (views) of his era. During his career he painted hundreds of topographical images of Venice – a substantial number of which are iconic views of St Mark's square. The artist could only have achieved the extraordinary wide angle presented by our example by using a *camera obscura*. This was an optical instrument that allowed painters to repeat detailed images with great precision. Or else he could have copied from one of the many existing engravings of the subject. The perspective is taken from the Procuratie Vecchie and shows, on the left, the Doge's Palace and, only marginally, the Basilica. In the foreground are the Campanile and the long building of the Procuratie Nuove. The scene is a perfect synthesis of light, form and colours.

Canaletto's skill in this genre had its origins in the education that he received from his father, a painter of theatrical scenes. As Canaletto's reputation grew his fame spread beyond Italy, in particular to England, where he eventually went to work for nine years.

GIOVANNI BATTISTA TIEPOLO

Venice 1696–1770 Madrid

*Allegory of the Immaculate
Conception*

c.1769
Oil on canvas, 58.7 × 45 cm
Purchased 1891
NGI 353

Although Tiepolo painted the subject
several times, the Dublin example is
considered to be the most complex
and the most charged with religious
meaning.

Surrounded by angels, the Eternal
God receives the Virgin with open
arms. On his head the triangular halo
signifies the Trinity. The Virgin is
kneeling in devotion, and from the
sky above the Holy Spirit sheds his
light upon her. She is crowned with
stars, while the crescent moon, the
terrestrial globe, and the snake of
Original Sin are at her feet. All these
images are associated with the Lady
of the Apocalypse – a symbol of puri-
ty and the prefiguration of the
Immaculate Conception – as are the
obelisk, the angel holding a mirror
and the palm. They are all references
to the Virgin's virtues.

The format, as well as the sketchy
handling of this picture, indicate that
it was a study for a fresco or a large
canvas, which Tiepolo possibly did
not have the time to carry out.

BERNARDO BELLOTTO
Venice 1721–80 Warsaw

Dresden from the right bank of the Elbe, above the Augustus Bridge

*c.*1750
Oil on canvas, 51.5 × 84 cm
Purchased 1883
NGI 181

Bellotto was a nephew of Antonio Canaletto and from his uncle learnt how to become a skilful view painter. From 1747 he worked in Dresden at the court of Frederick Augustus II, Prince Elector and King of Poland. At Frederick's request, the artist painted numerous views of the city to celebrate the architectural renovations promoted by the King, and by his father Frederick Augustus I before him.

In this scene the artist has taken some liberties, such as presenting certain buildings in a completed state when in actual fact their construction was still in progress. Otherwise the panoramic view of the centre of the city is precisely rendered, with the buildings beautifully mirrored in the river. In the foreground Bellotto has included some of his court acquaintances. The two gentlemen in the middle are painters and colleagues: Christian Wilhelm Ernst Dietrich and Johann Alexander Thiele. In the nearby group are, on the left, Filippo di Violante, personal physician of the King and, at the centre, the corpulent castrato singer Niccolò Pozzi, known as 'Niccolini'. Conversing with them are a Turkish servant and, dressed in Tyrolean costume, the court buffoon Fröhlich.

Pompeo Batoni

Lucca 1708–87 Rome

The presumed portrait of the Marchesa Caterina Gabrielli as Diana

1751
Oil on canvas, 47 × 36 cm
Signed: *P.B. 1751*
Milltown gift, 1902
NGI 703

Batoni was without doubt the most famous painter in Rome in the second half of the eighteenth century. His ability as a portraitist attracted innumerable clients to his studio, most of them foreigners who wanted to have their images immortalized during their stay in the Eternal City. Many qualities distinguished his portraits, but perhaps what most fascinated his contemporaries was his facility in obtaining the sitter's likeness with informal, elegant poses, using a range of moderately bright colours and polished contour lines.

We have reason to believe that the young woman portrayed here is the Marchioness Caterina Gabrielli. She was among the best-known social hostesses of the Roman aristocracy, and was widely considered one the beauties of her time. Here the painter offers a lyrical image of the lady; she is dressed as the huntress goddess Diana, with two greyhounds resting beside her. This poetic interpretation was probably influenced by the intellectual activities of the local Arcadian circles.

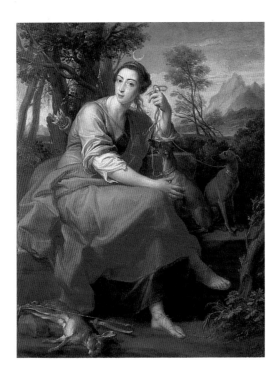

Antonio Canova

Possagno 1757–1822 Venice

Amorino

1789
Marble, height 142 cm
Gift of the Bank of Ireland, under S1003,
Taxes Consolidation Act 1997, 1997
NGI 8358

The most gifted and innovative sculptor of the late eighteenth and early nineteenth century, Canova learnt the rudiments of carving from his grandfather. His precocious talent was first discovered by an aristocrat, Giovanni Falier, who became his patron and made it possible for him to be properly trained in Venice. In 1779 Canova visited Rome for the first time, and two years later he returned to settle there permanently. With the success of his early monumental works, his fame grew rapidly, and his studio became a meeting point for intellectuals, collectors, and foreign tourists. During one of these visits, in 1789, John La Touche, the 19-year-old son of the wealthiest Irish banker, commissioned this statue from the artist. Within two years the marble was finished and dispatched to Ireland.

The sculptor carved four similar versions of the Amorino, with some modifications, but the present one is considered the most accomplished.

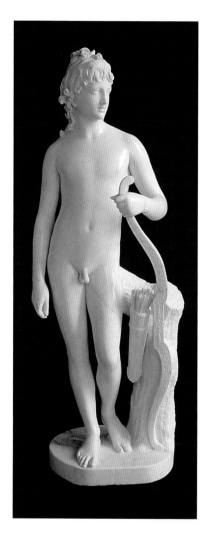

GIOVANNI PAOLO PANINI

Piacenza 1691–1765 Rome

Preparations to celebrate the Birth of the Dauphin of France in the Piazza Navona

1731
Oil on canvas, 109 × 246 cm
Purchased 1871
NGI 95

Giovanni Paolo Panini was the most famous painter of Roman *vedute* during the eighteenth century. His early education in Piacenza was apparently in perspective painting. In Rome, he trained under Benedetto Luti, and in 1719 he set up his own studio and became a member of the Accademia di San Luca. His early artistic engagements were almost all decorative schemes, painted in religious and aristocratic palaces. From the 1720s his descriptive compositions of the Eternal City gradually became popular, first among the French community and then with collectors and with foreign visitors.

One of Panini's most important patrons was Cardinal Melchior de Polignac, the French Ambassador to the Holy See. After the birth of the Dauphin, heir of the King of France, on 4 September 1729, the Cardinal decided to celebrate the royal event by promoting, at his own expense, a programme of 10 days of festivities in Rome. In accordance with the Cardinal's plans, the final day culminated with a display of fireworks in Piazza Navona. Pier Leone Ghezzi was placed in charge of the architectural apparatus, and a number of extravagant monuments in papier mâché, after his designs, were added to those by Bernini along the spine of the square. To record the occasion properly, the Ambassador then commissioned from Panini two large, nearly identical, views of the preparations. The first was given to his King, while the second one, the painting shown here, he kept for himself.

Panini's accuracy in describing the episode is quite extraordinary. All the palaces of the square are decorated with carpets and coats of arms of the King of France, while workers are busy erecting poles with festoons and candles. The distinguished gentleman at the centre, with red socks and the badge of the Order of the Holy Spirit, is Cardinal Polignac. All around the square are noblemen, ladies, abbots and clerks. Behind, on the right, is a small group with two children, all wearing the blue sash of the Garter. They are the exiled royal Stewarts: James III, known as the Old Pretender; Charles Edward, called Bonnie Prince Charlie; and Prince Henry, who later became Cardinal of York. In front, on the right, are represented two more protagonists of the celebration, Panini himself and, beside him, Pier Leone Ghezzi.

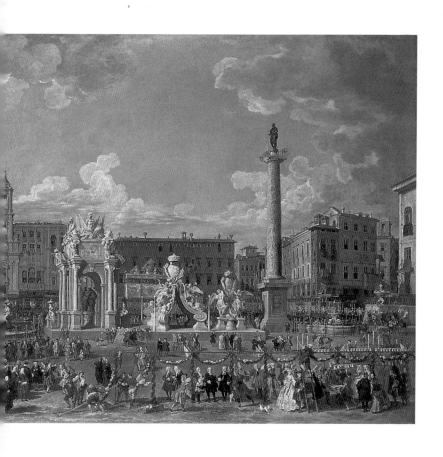

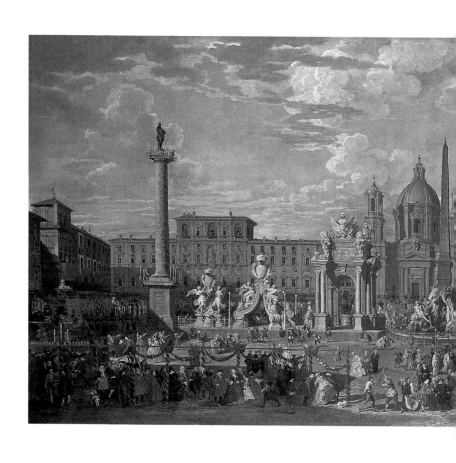

SPANISH
PAINTING AND
SCULPTURE

Pseudo Master of Alcira

Active in Valencia
and environs in the
mid-16th century

The Martyrdom
of St James the
Major

1553
Oil on wood,
140 × 120.5 cm
Purchased 1971
NGI 354

This mysterious artist was the partner of an equally unknown Valencian painter who has been identified by scholars as the Master of Alcira. Together, they painted a large *retablo* (altarpiece), representing on each side the legendary life of St James Major. Regrettably, this monumental work was subsequently dismembered and today it is known only by a few recovered panels. The fragment shown here is the most significant of these, and depicts the execution of St James. Very little is known about the saint except that he was the earliest of the Apostles to be martyred. During the Middle Ages, however, a number of legends arose in Spain that told of the miracles he had reputedly performed there; a cult grew around him and he became the country's patron saint.

The author of our picture undoubtedly shared a studio with the Master of Alcira for a substantial period, since both hands can be recognized in a number of works. Nevertheless, the artist's own personality is quite distinct, demonstrating a more polished design, a richer palette, and a greater expressivity in the figures. The painter's artistic formation is a combination of mannerism with a certain Gothic flavour, which reflects not only northern Italian but also south German influence.

Luis de Morales, sometimes called 'El Divino'

Badajoz *c.*1520–86

St Jerome in the Wilderness

1570s
Oil on wood,
63.7 × 46.5 cm
Purchased 1872
NGI 1

Morales is one of the great visual interpreters of the Counter Reformation in Spain. He was born in the Estremadura region, but very little is known of his life. He is reputed to have trained in Seville under the Flemish artist Peter Kempeneer (naturalized as Pedro de Campaña). This Flemish influence left a very deep impression on Morales, and although his style reflects other sources of inspiration, his vast and individual production is affected predominantly by northern ideas.

Here, the artist presents a mystical portrait of St Jerome that is highly expressive of the physical abstinence and spiritual contrition sustained by the saint in the wilderness. Clasped in prayer, his hands rest on a skull, a symbol of the transience of human life. Jerome is one of the four Doctors of the Latin Church, the founder of Western monasticism, and translator of the Old and New Testaments. Devotion to him grew considerably after the middle of the sixteenth century, when he was seen as an example of the essential Christian virtues required for salvation. Morales's painting is generally very lyrical and sentimental and, as in this work, shows a sophisticated and highly finished execution.

Juan Fernández de Navarrete, sometimes called 'El Mudo'

Logroño 1538(?)–79 Toledo

Abraham and the three Angels

1576
Oil on canvas,
286 × 238 cm
Purchased 1962
NGI 1721

A deaf mute from the age of three, Navarrete became court painter to Philip II in 1568, his training having been financed by Hieronymite monks. His painstaking early style apparently affected his health, so he turned to the faster and more practical Venetian style. This large picture was painted for the royal monastery and is considered his masterpiece.

In the book of Genesis, three men visit Abraham and predict that his aged wife Sarah will give birth to a son within a year. The men are three angels sent by God. By showing them as three bearded, Christ-like men, the artist is symbolizing the Trinity.

Stylistically, this late period of Navarrete is his most fertile and original: his sincere naturalism is expressed with contrasting colours by the use of fluid brushwork.

Pedro Núñez del Valle

Madrid(?) 1590s–c.1657

Jael and Sisara

Early 1620s
Oil on canvas, 122.5 × 131 cm
Signed: *Pº nu[n]ez Fe[cit]*
Hugh Lane Gift, 1914
NGI 667

Nothing is known about the early life of this painter, his date nor place of birth, nor his training. Furthermore, records that were once believed to indicate his participation at meetings of the Academy of St Luke in Rome in 1613–14 were recently proven to refer instead to a Portuguese artist of the same name. However, in a canvas dated 1623 for the church of San Lorenzo in Huesca he calls himself 'Academicus Romanus', which tells us that he was, perhaps briefly, a member of that prestigious institution. His stay in Rome must have taken place at the end of the second decade of the 1600s. Naturalism, at least at the beginning, was his preferred artistic language, with references initially to the work of Cecco del Caravaggio and later to Bartolomeo Cavarozzi.

This composition illustrates the story of Jael, the Hebrew widow who killed Sisera – the general of the Canaanites, who had terrorized the people of Israel – by driving a tent pin into his temple while he slept in her tent. Caravaggesque accents are most evident in this theatrical representation of the biblical episode, and the artist has taken great care to describe the armour and costumes meticulously.

The signature of Núñez on this picture is of capital importance for the reconstruction of his early career, because soon after his return to Spain his style conformed to the uninspired and conventional mannerisms preferred in Madrid.

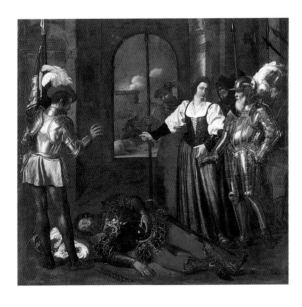

JUAN VAN DER
HAMEN Y LEON
Madrid 1596–1631

St Isidore
Early 1620s
Oil on canvas, 140.5 ×
100 cm
Purchased 1926
NGI 1987

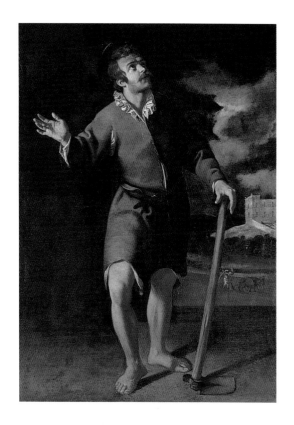

The author of this picture is better known for his beautiful, symmetrical still lifes. In spite of his Flemish origins, his artistic manner does not show any link with the northern school, and is essentially Spanish. He spent nearly all his life in Madrid, where he was well established among aristocratic collectors and where he tried, without success, to be appointed court painter in 1627. His ability as a painter of portraits and religious pictures has only met with due appreciation in recent years, as paintings such as this one have finally been recognized as by his hand.

St Isidore was canonized by Pope Urban VIII in 1622. However, he was already venerated in many Catholic centres, particularly in Madrid where the King himself, Philip III, was a devotee. The artist chose to represent the saint in a very naturalistic way, probably as a result of innovations introduced to Spain by contemporary Italian painters. The saint is harshly lit from above, captured in an ecstatic expression with his eyes raised to Heaven. His bare feet indicate his condition as a poor farmer, and in the background is an angel, who, according to the legend, was sent to plough the fields during St Isidore's daily prayers.

MADRID
SCHOOL of
c.1620

*Portrait of a
Spanish noble-
woman*

Oil on canvas,
105 × 82 cm
Purchased 1920
NGI 829

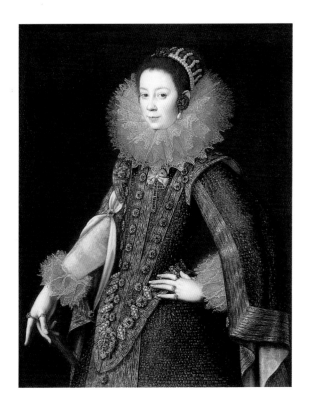

In Spain, as in other European countries, the circulation of official portraits of the king and the royal family had many purposes, but their principal intent was propagandist. Both members of the court and the aristocracy were keen to be painted, motivated as they were by the vanity of recording their features or proving their social status. The example here of a young noblewoman, whose identity is regrettably unknown, reflects the conventional mannerist court portrait, the objective of which was to emphasize the wealth and elegance of the sitter while maintaining an air of great dignity.

It was Alonso Sánchez Coello who first established this typology, during the second half of the sixteenth century, and his stylish handling of clothes and jewellery was later adopted by the king's painters, Pantoja de la Cruz and Bartolomé Gonzalez.

In this example the woman is wearing an elaborately embroidered olive green dress with inset jewels and pearls. Her pose is identical to a portrait of the Princess Isabel de Borbón by an unknown artist, now in the Museo del Prado, Madrid, but the treatment of this work is less stiff and her flesh tones have a distinct porcelain-like appearance. A few artists' names have been proposed for this beautiful portrait, but none so far has been convincing.

JUSEPE DE
RIBERA,
sometimes
called 'Lo
Spagnoletto'

Játiva 1591(?)–1652
Naples

St Onuphrius

Late 1620s
Oil on canvas,
90 × 70 cm
Signed: *Jusepe de
Ribera / español F*
Purchased 1879
NGI 219

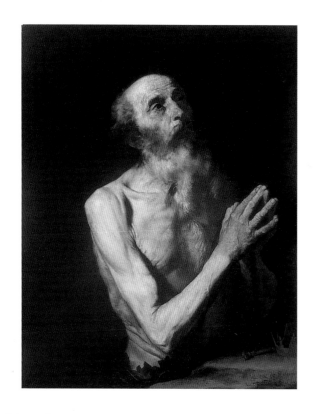

Nothing is known of the early part of Ribera's life. The first records date to the 1610s, when he had already emigrated to Italy. Between 1616 and 1617 he married, and became firmly established in Naples, the second city of the Spanish kingdom. There, his immediate success in the viceregal court, both with the local aristocracy and with the church hierarchy, transformed him into the most sought-after artist in the city, and his huge production just about satisfied the continuous requests for work. In the Counter Reformation climate of Naples, specific religious themes were encouraged, and subjects of penitent, emaciated, suffering saints, like this depiction of St Onuphrius, were regularly painted in Ribera's workshop.

This pious hermit lived in fourth-century Egypt and spent 40 years in the desert, in prayer and complete isolation. He is traditionally represented as a meagre old man, covered only by a girdle of leaves and fully absorbed in his prayers, with a crown and sceptre depicted in front of him to signify his scorn for human vanities. Ribera's early, harsh realism is still partly evident in our picture; later this would be substituted by a softer rendering.

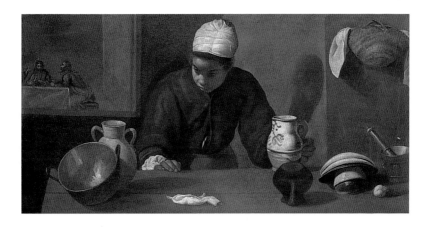

Diego Velázquez de Silva
Seville 1599–1660 Madrid

Kitchen maid with the Supper at Emmaus

c.1617–18
Oil on canvas, 55 × 118 cm
Sir Alfred and Lady Beit Gift, 1987
NGI 4538

Velázquez is indisputably the greatest Spanish artist of his age. Born in Seville, at that time a very cosmopolitan city and the capital of commerce with the New World, he trained for approximately six years in Francisco Pacheco's studio, a meeting place for intellectuals. In 1618 he married Pacheco's daughter.

Undoubtedly Velázquez was influenced by Pacheco, and by the early naturalism of artists such as Pedro de Campagña and Juan de Roelas. However, probable contacts with works by some of the followers of Caravaggio, such as Bartolomeo Cavarozzi, should not be underestimated.

Our canvas is widely considered to be the earliest known picture by Velázquez. The religious theme is treated in more or less the same way as similar Flemish subjects of the late sixteenth century. The miraculous event depicted in the background leaves room in the foreground for a display of ordinary kitchen objects, attended by a Moorish servant.

The symbolic significance relates to charity, and for this reason it has been suggested that the original location of the painting could have been the refectory of a convent. Particularly impressive is the realistic foreshortening of the dishes, and the use of a limited palette of browns, ochres, and whites.

FRANCISCO DE ZURBARÁN

Fuente de Cantos
1598–1664 Madrid

The Immaculate Conception

Early 1660s
Signed indistinctly:
F / Zurbaran
Oil on canvas,
166 × 108.5 cm
Purchased 1886
NGI 273

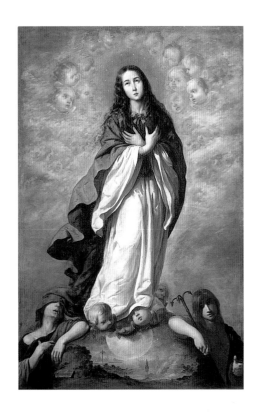

Like many other artists born in Estremadura, Zurbarán went to Andalusia for his education. At the age of 15 he entered the Seville workshop of Pedro Diaz de Villanueva, a painter of whom we know very little. It was probably soon after this that he became acquainted with Pacheco, and above all with Velázquez, who became a lifelong friend. Once confident of his professional ability Zurbarán moved to Llerena, where he lived and worked for a long period. In 1629 he returned to Seville where he produced some of his best paintings, many of which were destined for the New World.

In his last years, Murillo's growing success in Seville induced Zurbarán to seek the favour of collectors in Madrid, and while there he probably painted this Immaculate Conception. Today we are aware of 13 versions of this popular theme by Zurbarán, of which this is one of the most intimate and attractive. The Virgin is standing on a full moon, and small cherubs emerge from her garments. Beneath, in a landscape, are displayed the attributes of the Lorettan litany: the palm, the temple, the cypress, and so on. The two allegorical figures are Faith and Hope. With the Virgin representing Christian Charity, together they symbolize the three theological virtues.

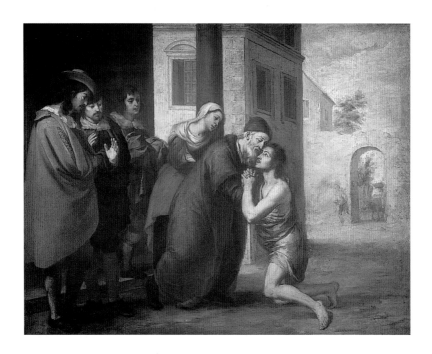

BARTOLOMÉ ESTEBAN MURILLO
Seville 1617–82

The Return of the Prodigal Son
c.1660
Oil on canvas, 104.5 × 134.5 cm
Sir Alfred and Lady Beit Gift, 1987
NGI 4545

The parable of the prodigal son is told in St Luke's Gospel (15: 11–32). The younger son of a wealthy father demanded his share of his inheritance and then left the family home. Having wasted many years abroad in a shameful existence, the young man, close to starvation, repented of his life and returned to his father's house. Unbeknownst to his family, he worked at the house as one of the servants. One day he was recognized by his father, who compassionately embraced him and rejoiced at his return.

In his picture Murillo emphasizes the Christian values of forgiveness and repentance, and most of all of charity, which is expressed by the maid carrying a robe for the distressed man. This canvas tells the final episode of the story and, along with another five canvases, also in our collection, was painted by the artist for an unknown patron. Four preliminary sketches for the series are in the Museo del Prado, Madrid, and another version of this particular scene is in Washington. The composition derives from a drawing by Annibale Carracci, which was later developed by Jacques Callot and Pietro Testa. Murillo undoubtedly knew the etchings of this subject by these two artists, and used them as the model for his work.

JOSÉ ANTOLÍNEZ

Madrid 1635–75

The Liberation of St Peter

Early 1670s
Signed:
Josef / Antolinez
Oil on canvas,
55 × 118 cm
Purchased 1859
NGI 31

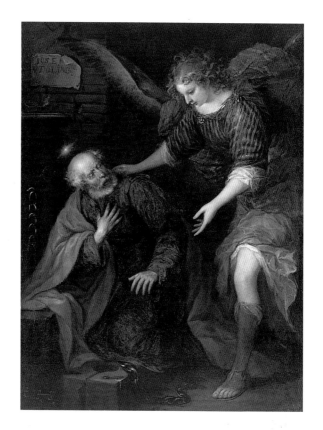

Antolínez was a pupil of Francisco Rizi and worked mainly in Madrid. A prolific artist, he is best known for his many theatrical versions of the Immaculate Conception. In his relatively short life, however, he proved that he was able to treat any subject in a very personal style, that combined Venetian colouring with a fluid and vigorous Flemish-Baroque technique.

The story portrayed here is recounted in the Acts of the Apostles (12: 6-8). King Herod Agrippa arrested St Peter in Jerusalem for his preaching. In prison the saint was bound with two heavy chains and was guarded by soldiers, but during the night an angel came and set him free. Antolínez chose to represent the moment when the angel woke Peter and the chains fell from his hands.

The variety of colours normally used by Antolínez, as seen in this picture, make him one of the most original artists of his time.

Juan Alonso Villabrille y Ron

Argul 1663 – after 1728 Madrid

The Prophet Elijah

1720s
Oil on carved limewood, 138 × 86 cm
Purchased 1987
NGI 8031

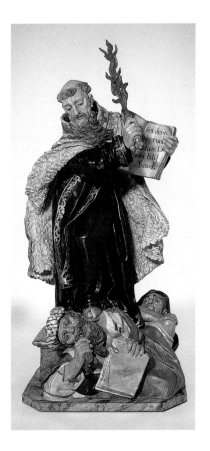

Villabrille was born in the Asturias but moved to Madrid in 1686. One year later he was already working independently. His early document-ed works date from the beginning of the eighteenth century, and demon-strate his ability to carve equally in wood or stone. Characteristic of Villabrille is the twirling movement of some of his sculptures, the great attention to detail, and the moderate realism expressed by his figures.

The Carmelites claimed that their order originated from a community of hermits created by the prophet Elijah on Mount Carmel, where an oratory dedicated to the Virgin was subsequently built. Our statue shows one of the most frequently represent-ed iconographical images of Elijah. The prophet is shown in combat, defending the true faith against the heretics, holding the Holy Scriptures in one hand while with the other brandishing a flaming sword. Beneath his feet the false prophets of Baal are visibly in agony.

This splendid sculpture has been attributed also to Manuel Gutiérrez.

Francisco José de Goya y Lucientes

Fuendetodos 1746–1828 Bordeaux

Doña Antonia Zárate

c.1805–06
Oil on canvas, 103.5 × 82 cm
Sir Alfred and Lady Beit Gift, 1987
NGI 4539

The sitter was a famous actress, the daughter of Pedro de Zárate Valdés, also an actor. She married the singer Bernardo Gil y Aguado and their son Antonio Gil y Zárate was to become a renowned poet and playwright. In the picture her black dress and her black lace mantilla create a strong contrast with the yellow sofa on which she sits. In her hands she hold a *fleco*, a fan, and her arms are covered with white, silky, fingerless gloves. Her gaze is slightly melancholic, while a pinch of irony appears in her smile. This painting is among a number of beautiful female portraits that Goya executed before the Peninsula War. He greatly admired the theatre and its protagonists, and painted many of their portraits. A few years later the señora Zárate sat for him again and that portrait, on a smaller scale, is today in the Hermitage Museum, St Petersburg.

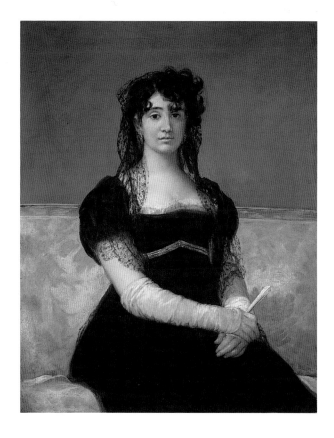

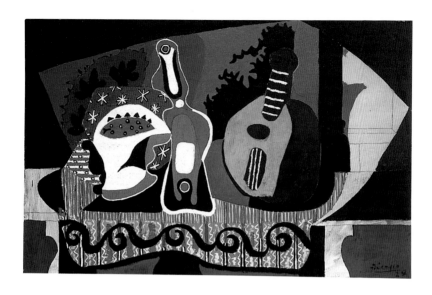

PABLO RUÍZ PICASSO

Malaga 1881–1973 Mougins

Still-Life with a Mandolin

1924
Signed: *Picasso 24*
Oil on canvas, 101 × 158 cm
Máire MacNeill Sweeney bequest, 1987
NGI 4522

Picasso was a leading figure of the avant-garde first in Spain, and then in Paris, and he became the most influential figure in modern art in the first half of the twentieth century. He was still in Barcelona when he underwent his melancholic 'Blue Period' (1901–04). He settled in Paris in 1904, taking a studio in the Montmartre tenement known as 'le Bateau-Lavoir'. In 1907 he painted the revolutionary *Les Demoiselles d'Avignon*, under the influence of African primitivism. With Georges Braque, Picasso created Analytical Cubism (1907–14), which challenged the optical realism of Impressionism, aiming to express the permanent structure of an object by depicting it as a series of planes that showed it as it would be seen from a number of viewpoints.

In 1924 Picasso spent the summer in Juan-les-Pins where he continued to work on large-scale, Cubist still lifes of a type started the year before. The exuberant light and colours of the Mediterranean inspired him to create more vibrant compositions like the canvas shown here.

Still Life with a Mandolin is a night scene in which a fruit dish, bottle and mandolin are displayed on a table covered by a white striped red cloth. All the objects are painted in a rhythmic and balanced order with lush plain colours and different pattern motifs, showing a decorative taste acquired by Picasso from Henri Matisse.

JUAN GRIS
(José Victoriano
Carmelo Carlo
González Pérez)

Madrid 1887–1927 Paris

Pierrot

1921
Signed on the reverse:
Juan Gris
Oil on canvas, 60 × 81 cm
Máire MacNeill Sweeney
bequest, 1987
NGI 4521

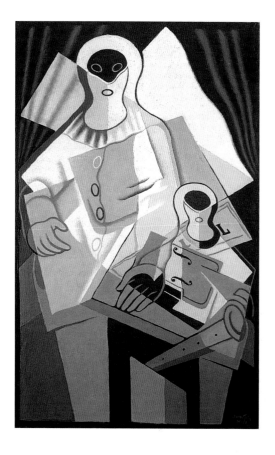

Juan Gris began by studying landscape painting in Madrid, but after only two years, in 1906, he moved to Montmartre in Paris. There he met Matisse, Apollinaire, Jacob, Braque, and Picasso. The last two painters were vitally important for his artistic formation and he collaborated with them to develop Analytical Cubism. In the early 1920s Gris succumbed to the first symptoms of pneumonia, which later developed into pleurisy. He painted *Pierrot* while convalescing in Bandol on the Mediterranean in 1921, and it was exhibited two years later in Paris. This is a typical theme of those years, a time when the artist was fascinated by the masks of the traditional *commedia dell'arte*, by popular images from humourous magazines, and by noisy carnivals in Paris. However, like Picasso some years earlier, Gris was attracted by the melancholic aspect of the Pierrot character, the pathetic and unfortunate lover of many pantomimes.

In this painting the human figure and still life are reduced to a series of overlapping flat planes coloured with shades of black, grey, brown, ochre, and white, all harmoniously linked together.

FRENCH
PAINTING AND
SCULPTURE

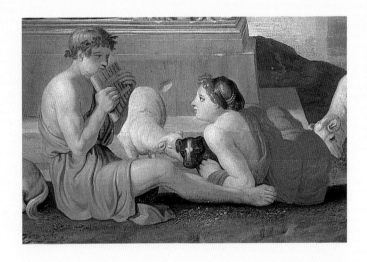

Jacques Yverni

flourished 1410–38

The Annunciation

*c.*1435
Tempera on panel, 151 × 193 cm
Purchased 1965
NGI 1780

This panel is attributed to Yverni by comparison with the artist's only known signed work, a triptych in Turin. Against a gold background the Virgin of the Annunciation kneels at an altar. As she receives the message from the archangel Gabriel she raises her right hand to her throat, while her left hands signals the words *Magnificat anima mea Dominium* in her open book. A vase containing a tall lily stem, symbol of her purity, stands between them. St Stephen presents two donors; the saint is dressed as a deacon with the palm of martyrdom in his left hand, and bears the instrument of his martyrdom, a stone, on his head. Above the archangel, God the Father appears in a celestial sphere, and emanating from the heavenly rays are the dove of the Holy Spirit and a tiny figure of the Christ Child.

Stylistically and iconographically, Yverni's style is a combination of Italian and predominantly French influences. The picture was transferred at an early stage from its original poplar wood support to canvas, and as a result has suffered some damage, evident principally in the draperies. Before its acquisition it was transferred to a new panel.

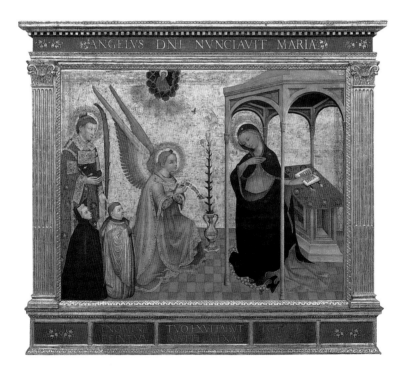

Simon Vouet
Paris, 1590–1649

The Four Seasons
1640–45
Oil on canvas, diameter 113 cm
Purchased 1970
NGI 1982

As the most influential artist of his generation, Vouet had an active and brilliant career. When he returned to Paris, following 15 years in Italy, he brought with him a fully developed Baroque style. Moreover, he had acquired the organizational ability to co-ordinate the subsequent flow of commissions for altarpieces and large-scale decorative cycles. He was able to maintain the pace of activity due to the large studio he established, where many great painters of the next generation were trained.

Vouet's interpretation of the four seasons is unprecedented. Flora (spring, synonymous with Venus) can be identified by the wreath of flowers and the crown she is holding. She exchanges an amorous look with Adonis (winter), clad as a hunter. They are watched by Ceres (summer), who carries a sickle and ears of corn. Below, the infant Bacchus (autumn), carrying grapes, is frightened by the dog. A circular movement of curves and arcs echoes the shape of the canvas. The flat blue background throws the figures into relief, and the pale, cool colours (the expanse of creamy flesh, the pink and the cool green) emphasize the gay, decorative quality of the tondo.

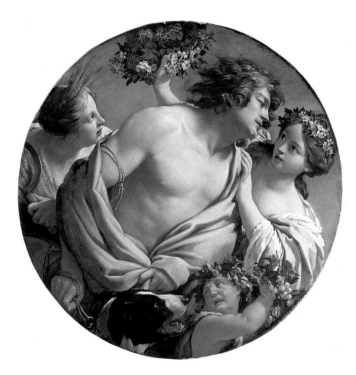

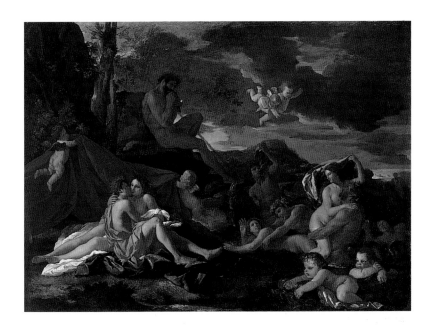

Nicolas Poussin

Les Andelys 1594–1665 Rome

Acis and Galatea

1627–28
Oil on canvas, 98 × 137 cm
Sir Hugh Lane bequest, 1918
NGI 814

In its close adherence to Ovid's account of the story of Acis and Galatea (*Metamorphoses XIII*), this composition indicates how closely Poussin, recently arrived in Rome and now in the circle of Cassiano dal Pozzo, was applying himself to classical texts. Polyphemus, the one-eyed giant, is seated on a promontory overlooking the sea, his shepherd's crook laid aside, playing a love song to Galatea on the syrinx. The lovers Acis and Galatea lie in the foreground on a rocky outcrop, shielded from his sight by the red drapery held up by *amorini*.

Their distance from the Cyclops is therefore more psychological than real. Tritons and nereids play around them in the waves, and Mount Etna looms in the distance.

While Poussin's interpretation of this episode is on one level playful and sensual, the brooding figure of Polyphemus adds a note of tension, a foreboding of the dormant violence in the story. Polyphemus, in a jealous rage, hurled a great rock at Acis and killed him. The sharp blue, red and burnt orange draperies create strong notes in the foreground group.

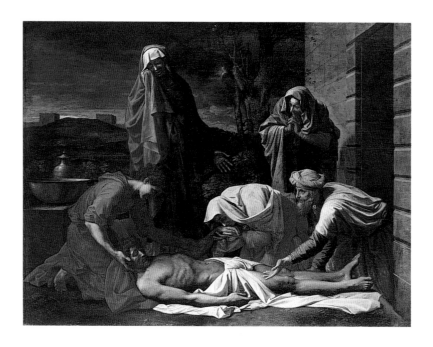

Nicolas Poussin

Les Andelys 1594–1665 Rome

The Lamentation over the Dead Christ

1657–60
Oil on canvas, 94 × 130 cm
Purchased 1882
NGI 214

This moving late work by Poussin depicts the moment after Christ's body has been embalmed and just prior to the placing in the tomb, when Christ's mother and a few of his disciples reflect on and grieve his death. Joseph of Arimethea kneels in the entrance to the tomb; St John raises Christ's head on to his lap; Mary Magdalene kisses his hand, while behind her is the 'other Mary' (both are mentioned in the gospels of Matthew and Mark). The jar and basin refer to the anointing with 'myrrh and aloes to preserve the body' (John 19: 39).

The expression of grief is largely concentrated in the upright figure of the Virgin, who wipes a tear away with her cloak. Standing apart, she indicates her acceptance of the sacrifice of her son, for the salvation of man, with the gesture of surrender she makes with her left hand. Her role preludes the message of the steadfast strength of faith in the imminent Resurrection, alluded to by the stark tree bearing new shoots. The drama is further increased by the use of intense and vibrant colours. The aging Poussin has conceived the *Lamentation* as a meditation and reflection on death.

Jean Lemaire

Dammartin 1598–1659 Gaillon

Architectural Landscape with Classical Figures

1627–30
Oil on canvas, 163 × 140 cm
Sir Hugh Lane bequest, 1918
NGI 800

This is one of Lemaire's finest works. From contemporary records it is clear that Lemaire and Poussin were working and living closely together during their early years in Rome. It seems that Lemaire borrowed the two foreground figure groupings from a pendant pair of paintings by Poussin, which were formerly in the collection of Sir Joshua Reynolds. The figures are placed against a fantastic river landscape of sculpture and architecture. It is an imaginary scene, but many of the individual elements are reminiscent of, or can be identified with, ancient works. To the left the funeral monument consists of a sarcophagus, the lower part of which recalls that of the *Labours of Hercules* which at the time was located in Palazzo Savelli at the Teatro di Marcello, and was engraved in Cassiano Dal Pozzo's *Museo Cartaceo*. The two large figures above also derive from a classical model, namely a sarcophagus then in the Guistiniani collection. The Hebrew inscription reads: '*da questo sarcofago, secondo il tuo desiderio, prendi dal suo corpo sia quel che sia, mai fai presto, e volgi il capo verso il tuo Dio*' ('From this sarcophagus, according to your desire, take whatever you like from his body, but be quick, and turn your head towards your God').

CLAUDE LORRAIN

Chamagne 1604/05–82 Rome

Juno Confiding Io to the Care of Argus

1660
Oil on canvas, 60 × 75 cm
Sir Hugh Lane bequest, 1918
NGI 763

Claude's landscapes are never
records of actual places; rather they
are idealized memories of the golden
age of antiquity, like this episode
from Ovid's *Metamorphoses*, which he
imbues with a romantic and nostalgic
spirit of the antique world. *Juno
Confiding Io to the Care of Argus* was
painted as one of a pair of pictures,
that remained together until 1805.
Ovid relates how Io, the daughter of
Inachus,the first King of Argos, was

seduced by Jupiter. She was then
transformed by him into a white
heifer, to conceal her from his wife
Juno. Juno was not deceived, howev-
er, and cunningly asked her husband
for the heifer as a gift. Claude shows
the moment when Juno confides the
heifer to the custody of Argus, the
100-eyed giant (here, however,
depicted as a shepherd).

The theme of the picture may be
tragic, but the mood is charming and
gentle. The pendant painting, an
evening scene entitled *Mercury Piping
to Argus* (now in a private collection),
portrays the subsequent episode in
the story when Mercury charmed
Argus to sleep with his lyre and then
cut off his head. Both works are
recorded in the form of finished
drawings in the *Liber Veritatis* that
Claude kept from 1635.

NICOLAS DE LARGILLIÈRE

Paris, 1656–1746

Portrait of Philippe Roettiers (c.1640–1718)

1680-85
Oil on canvas,
81 × 64 cm
Purchased 1962
NGI 1729

Largillière was considered one of the leading portraitists during the reign of Louis XIV. He knew and painted several members of the Roettiers family. This is Philippe (II) Roettiers, medallist, the third and youngest son of Philippe Roettiers, a goldsmith and medallist working in his native Antwerp. In 1661 the three sons, John, Joseph, and subsequently Philippe, were invited to England by Charles II to work at the English mint. According to Horace Walpole, their father had lent money to Charles during his exile in the Low Countries and the King in turn had promised employment for his three sons. Philippe (II) was officially connected with the English mint as an engraver from at least 1670 to 1684. In 1684 he was nominated Engraver-General of the mint of the King of Spain in the Low Countries (which is referred to in the inscription on the portrait), and in 1686 he took the oath as Engraver of the Antwerp mint. In this portrait Philippe appears to be holding the 'Liberty of Conscience' medal, which shows the bust of Charles II.

NICOLAS LANCRET
Paris, 1690–1743

La Malice (Mischief)
*c.*1735
Oil on canvas, 36 × 29 cm
Sir Hugh Lane bequest, 1918
NGI 802

Lancret was a painter of *fêtes galantes*, influenced by Watteau. His works are characterized by their grace and decorativeness, but lack the poetry and originality of Watteau's paintings. Painted around 1735, this charming interior sketch shows a young girl dozing, her book resting in her lap. A young boy, determined to disturb her, kneels to blow smoke into her face from a lighted roll of paper, his animated and mischievous expression contrasting with her relaxed and sleepy features. The figures are a variation on the theme of lovers depicted in both Watteau's and Lancret's *fêtes galantes*. Set in a dimly lit room, the bright colours are saved for the girl, whose dress has a red bodice and blue apron matched by the blue hair ribbon. The flush of her cheek is echoed in the rose pinned in her hair.

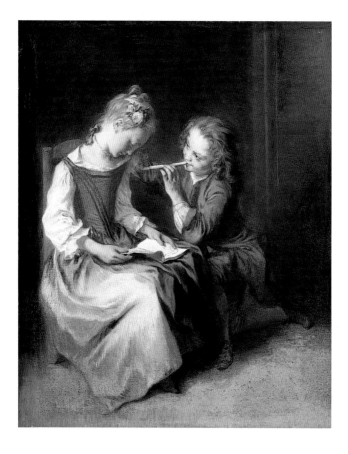

Jean-Siméon Chardin

Paris, 1699–1779

Still Life: Two Rabbits, a Grey Partridge, Game Bag and Powder Flask

1731
Oil on canvas, 82.5 × 65 cm
Sir Hugh Lane bequest, 1918
NGI 799

The year 1731 was a significant one for Chardin: it was the year he got married and had a son. This appears to be last of a series of paintings of dead game by Chardin – around 1730 he began to diversify, painting scenes of kitchen interiors, genre scenes and figure compositions – and has one of the most rigidly organized compositions. The rabbits, partridge, game bag and powder flask are arranged in a pyramid resting on a stone ledge. The overall effect is softened by the branch of honeysuckle creeping in from the upper left-hand side, introducing a lighter note in the severe composition. The blue of the petals is picked up by the blue ribbon that binds the animals' legs, while the spot of blood on the neck of one of the animals adds a note of realism.

The painting strikes a solemn note: the mood is quiet and almost reverential. Through a controlled use of muted browns and grey, and by combining a formal composition with accurate, quick brush strokes, Chardin has succeeded in imbuing a simple still life, the lowest of genres, with a sense of dignity.

JEAN-BAPTISTE
PERRONNEAU

Paris 1715–83
Amsterdam

Portrait of a Man

1766
Oil on canvas,
72.5 × 58.5 cm
Purchased 1929
NGI 920

Perronneau is best known as a pastellist, but he also painted and exhibited regularly in oil. This painting has captured something of the fragility and softness of finish of a pastel portrait. The subtle tonality and neutral background – relieved by the loosely but carefully painted white lace of his shirt, and the glimpses of freer brushwork in his brocade waistcoat – draws the viewer to the steady, clear gaze of the sitter. The light, coming from the upper left, models his face and falls down to his hand where the slip of paper inscribed *Agriculture, Arts et Commerce* presumably records his achievements and holds the key to his identity.

Despite the comment from a contemporary critic that Perronneau's portraits, particularly those in oil, should be viewed from a short distance, the artist has sensitively differentiated between the white of the wig, that of the shirt, and of the piece of paper. The features are painted with fine brush strokes, while broader sweeps of paint capture the velvet texture of his jacket. The appeal of the portrait lies in its simple, understated realism.

JEAN-HONORÉ FRAGONARD
Grasse 1732–1806 Paris

Venus and Cupid (Day)

*c.*1755
Oil on canvas, 114 × 133 cm
Purchased 1978
NGI 4313

This romantic, playful, and decorative image is in the Rococo style. Venus, goddess of love and fertility, and her son Cupid repose in a gilded chariot, drawn through the clouds by a pair of doves. The painting is one of a series of four overdoors depicting the hours of the day. The others are *The Three Graces as Dawn, Cupid setting the Universe Ablaze as Dusk*, and a painting representing an allegorical figure of *Night*.

Madame du Barry, *maîtresse en titre* to Louis XV, purchased the series in 1770 from Fragonard's friend the painter Drouais, to decorate her château at Louveciennes. She paid 1,200 *livres* for the pictures, and the same day paid another 420 *livres* to have three of them enlarged, relined and retouched, presumably to fit in with a pre-existing decorative setting. The addition of a strip of canvas is clearly visible across the top of *Venus and Cupid*.

FRANÇOIS-MARIE PONCET
Lyon 1736–97 Marseilles

Adonis

1784
Marble, height 165 cm
Presented by F.W. FitzGerald, 4th Duke
of Leinster, 1878
NGI 8135

Poncet spent most of his career in
Italy, where he established a reputa-
tion as an imitator of the ancients.
This statue of Adonis exemplifies his
approach. It is based on two ancient
sources: the *Antinoüs* in the
Capitoline collection, which had been
found in the Villa Adriana and pre-
sented to Clement XII by Cardinal
Albani; and the *Adonis*, discovered in
Centocelle in 1780 and displayed in
the Museo Pio-Clementino. In draw-
ing upon classical examples, Poncet
was creating works in the popular
neoclassical taste. His work was
greatly praised in the contemporary
press.

Adonis is portrayed at the moment
of departing for the hunt. His quiver
rests against a tree trunk and in his
right hand he carries an arrow.
Originally he probably held a bow in
his left hand. Elizabeth Dominick
Saint-George Usher commissioned
the work for her daughter, for the
sum of 300 *zecchini*, during a visit to
Rome in 1784. Her daughter, Emilia
Olivia, had married the 2nd Duke of
Leinster in 1775 and that family pre-
sented the statue to the Gallery in
1878.

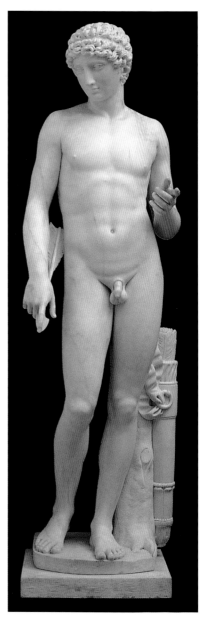

JACQUES-LOUIS DAVID
Paris 1748–1825 Brussels

The Funeral of Patroclus

1778
Oil on canvas, 94 × 218 cm
Signed and dated: bottom left: *J.L. David f.*
Roma 1779
Purchased 1973
NGI 4060

This oil sketch, a student work, was painted by David while he was studying in Rome. It is an example of the artist's ambitious attempt to cast off Rococo influences and assume instead a purer, more lucid, classical style. The resulting canvas is a panoramic *mise-en-scène*. This was an important moment in the artist's development towards his mature neoclassical style.

The scene depicts the climatic close of Homer's *Illiad*. Achilles mourns Patroclus (who was slain by Hector), on the raised bier in front of the great funeral pyre. In vindication of his friend's death, Achilles has ordered that Hector's naked and twisted body be tied by the ankles to his chariot, and dragged around the city walls.

The theme of the virtue of sacrifice for one's country was popular among neoclassical artists. David exhibited the picture in Rome in 1778 (despite it being dated 1779). It was then sent to Paris, along with works by other students of the French Academy in Rome, to allow the Academicians to judge his progress.

BARON FRANÇOIS PASCAL SIMON GÉRARD

Rome 1770–1837 Paris

Julie Bonaparte as Queen of Spain with her daughters, Zénaïde and Charlotte

1808–09
Oil on canvas,
200 × 143.5 cm
Signed, lower right:
F. Gerard
Purchased 1972
NGI 4055

Gérard quickly became one of the principal portraitists to the imperial court of Napoleon I. This is one of five portraits painted by the artist – at the height of his power – for Napoleon's Salon de Famille at the Palais de Saint-Cloud. In a letter of September 1808 its commission is recorded.

Marie-Julie Clary was the elder daughter of a wealthy Marseilles family, reputedly of Irish descent. Her sister Desirée was a renowned beauty who became engaged to Napoleon Bonaparte at the age of 15. Although that engagement was eventually broken off, Marie-Julie married Napoleon's brother Joseph

in 1794. Her large dowry saved the Bonapartes from penury, and allowed Joseph the means to pursue his political career. Daughter Zénaïde was born in 1801, and Charlotte the following year. In 1806 Joseph became King of Naples and in 1808 King of Spain, a title he held in name until 1814.

Gérard's highly polished finish faithfully captures the fashionable interior, and renders the textures of the muslin and voile and satin dresses. Zénaïde inherited the picture and it remained in her family until 1972.

EUGÈNE DELACROIX

Charenton-Saint-Maurice 1798–1863
Paris

Demosthenes on the Seashore

1859
Oil on paper, laid on panel, 47.5 × 58 cm
Purchased 1934
NGI 964

Delacroix was the leading painter of
the Romantic movement in France.
Vibrant colour harmonies and
brilliant paint surfaces characterize
his works, breaking with the domi-
nant tradition of classicism. When
first exhibited in 1860, *Demosthenes*
was admired above all as a marine
painting. The shifting cloud forma-
tion, the frothing waves of the incom-
ing tide, Demosthenes' billowing
cloak, and the gestures of his two

compatriots waving wildly in the
distance, are rendered with lively
brush strokes.

Delacroix had already treated this
subject in 1844–45 as part of a deco-
rative cycle for the library ceiling at
the Palais Bourbon. Demosthenes,
one of the greatest Athenian orators
of the fourth century BC, is said to
have spoken with pebbles in his
mouth to cure a stammer, and to
have walked the seashore addressing
the incoming waves to improve his
speeches to the tumultuous Athenian
crowds.

JEAN-FRANÇOIS MILLET
Gruchy 1814–75 Barbizon

Country Scene with a Stile

*c.*1872
Oil on canvas, 54 × 64 cm
Chester Beatty gift, 1950
NGI 4265

Millet is best known for his paintings of peasants at work. This peasant naturalism arose out of the 1848 Revolution in France, and against the backdrop of the rural depopulation that resulted from the Industrial Revolution. Although landscape provided settings for his figure compositions, pure landscape only became important to him late in his career, from the mid-1860s. For his landscapes he principally drew on his native Normandy, where he remained for the duration of the Franco–Prussian War.

In this idyllic view, the geese – scrambling through the stile to freedom – draw the eye from the shady foreground to the gentle sunlit scenery beyond, where the rooftops of a farmhouse nestle below the slope of the hill. Millet has playfully foreshortened the last bird as he struggles to squeeze his rounded body through the twig barrier. The unusually high horizon line, the interest in the reflected warm glow of sunset and the use of a light priming, left to show through the thin paint layers, place this small work in the years after 1870.

THOMAS COUTURE
Senlis 1815–79 Villiers-le-Bel

La Peinture Réaliste
1865
Oil on canvas, 56 × 45 cm
Chester Beatty gift, 1950
NGI 4220

This satire on the realism of Courbet
is one of Couture's best-known
and most controversial paintings.
The Realism of the mid-nineteenth
century was intended to be an attack
on the institutionalized classical
model.

Couture ran an atelier in Paris
from 1847 to 1860, attracting pupils
from all over Europe and North
America. He based his own teaching
methods on the art of ancient Greece
and the classical Renaissance
masters. The Realists, by contrast,
preferred to reproduce the vulgarity
of modern life, an attitude that
Couture attacked in his *Méthodes et
Entretiens d'Atelier* of 1867: 'I am
depicting the interior of a studio of
our time; it has nothing in common
with the studios of earlier periods,
in which you could see fragments of
the finest antiquities ... As for the
painter, he is a studious artist,
fervent, a visionary of the new
religion. He copies what? It's quite
simple – a pig's head – and as a
base what does he choose? That's
less simple, the head of Olympian
Jupiter.' Along the wall are strung a
cabbage, an old lantern, and a shoe,
allegedly sources of inspiration for
the Realist painters.

ERNEST MEISSONIER
Lyon 1815–91 Poissy, Paris

*Group of Cavalry in the Snow:
Moreau and Dessoles before
Hohenlinden*
1875
Oil on canvas, 37.5 × 47 cm
Alfred Chester Beatty gift, 1950
NGI 4263

Best known for his historical genre
subjects, Meissonier is also associ-
ated with battle paintings, depicting
scenes from Napoleonic campaigns.
He had accompanied Napoleon III,
whom he greatly admired, on his
campaign to Italy in 1859, and on his
return to Paris Meissonier conceived
a series of paintings to the glory of
Napoleon I.

This is one of Meissonier's most
important military scenes. It depicts
the French General, Jean-Victor
Moreau, planning strategies with his
Chef d'Etat, Dessoles, before his
famous victory at Hohenlinden
(1800), a critical battle in Napoleon's
campaign. Although signed and
dated 1876, the picture is recorded
in Meissonier's studio in 1875, and
known studies for the composition
date from 1872. Meissonier was
highly conscientious in his research,
and his works provide a precise and
reliable record of events that occurred
during the Napoleonic Wars, in a
style that was much appreciated by
contemporary Academic taste.

GUSTAVE COURBET

Ornans 1819–77 La Tour de Peliz, Switzerland

Portrait of Adolphe Marlet

1851

Oil on canvas, 56.5 × 46.5 cm
Purchased 1962
NGI 1722

Artistically and politically, Courbet was one of the most important and most controversial figures of the Realist movement. Throughout his career, he painted portraits of fellow artists and writers, particularly those who shared his political and social views. When he held a private exhibition of 115 works in Paris in 1867, he included this portrait of Marlet, at which time he dated it to 1851. Both Adolphe Marlet and his brother Tony were boyhood friends of the artist. Adolphe was a barrister and councillor for the department of Mayenne and appears to have worked for a while with the artist Hesse. Courbet also included him in two earlier compositions, *After Dinner at Ornans* and his famous *Burial at Ornans*.

In this portrait he reveals the influence of seventeenth-century Dutch painting. Like the Dutch masters, Realist critics required that a portrait should reveal character. Here, using a strong, vigorous brush technique, Marlet's face is built up of short strokes of grey–green, brown, pink, light yellow, and white over yellow and ochre. This multi-layered approach enabled the artist to capture the nuances of light playing on his friend's familiar features.

EUGÈNE FROMENTIN

La Rochelle 1820–76 Saint-Maurice

Falcon Hunt: Algeria Remembered

1874
Oil on canvas, 111 × 152 cm
NGI 4231

By 1850–51 Fromentin had established himself as a painter of landscape genre scenes of Africa. In the spring of 1874 he brought out new editions of his travel books, *A Summer in the Sahara* and *A Year in the Sahel*. In the accompanying preface he tells how Algeria became the principal subject of his work – unexpectedly and to a greater extent than he ever wished. The two paintings that Fromentin sent to the Salon that year, *Falcon Hunt* and *A Ravine*, were both called *Algeria Remembered*

and, as suggested by the title, both exhibits were nostalgic reminders of the artist's youthful journeys to North Africa. The *Falcon Hunt* is an extremely successful reworking of an earlier composition, the *Heron Hunt*, painted in 1865. Both works are similar in scale and composition. Here the action of the hunt becomes a secondary focus, while the grouping of three magnificently portrayed huntsmen on horseback creates a powerful and memorable image of the Orient.

Fromentin disliked the sketchiness of contemporary avant-garde artists – most probably the Impressionists, although he was never specific – and his work generally lacked spontaneity. Instead he favoured carefully thought-out compositions, and a deliberate, finished style of execution.

Eugène Boudin
Honfleur 1824–98 Deauville

The Meuse at Dordrecht
1882
Oil on canvas, 117 × 159 cm
Chester Beatty gift, 1950
NGI 4212

Believing that 'everything painted on the spot always has a strength, a power, a vividness of touch that is not to be found again in the studio', Eugène Boudin was one of the major precursors of French Impressionism. In his own lifetime, he was regarded as a modern descendant of the great Dutch seventeenth-century marine painters. He discovered Holland surprisingly late in his career, travelling there for the first time in 1876. As always, with his great love of the sea, he was drawn to cities with busy ports, like Rotterdam and Dordrecht. At Dordrecht he enjoyed the picturesque attraction of the River Meuse and, in a letter to a friend, he described the tranquillity of watching the river as it flowed under a beautiful sky. It was always Boudin's aim to capture the atmosphere: the formation and movement of the clouds, the motion of the water, and the unifying light. Although he participated in the first Impressionist exhibition of 1874, he remained a naturalist, and his palette never developed into the broken touches of paint characteristic of the Impressionists.

JEAN-LÉON GÉRÔME

Vesoul 1824–1904
Paris

Guards at the Door of a Tomb

1870s
Oil on canvas,
81 × 65 cm
Chester Beatty gift,
1950
NGI 4234

Gérôme was the most successful and influential artist of the Orientalist movement in the second half of the nineteenth century. Most of his Near Eastern scenes depict Egypt, especially contemporary Cairo where this composition appears to be set. A sentinel stands before a tomb, armed with a musket. His two companions have laid their arms aside and are resting in the strong sunshine: a silver decorated rifle has been leant against the doorway, while the shorter gun, a blunderbuss, leans against the wall. The four handprints, so evident against the bleached white wall, are the bloody handprints of the faithful. Above the door and below the arch, with its stalactite vaulting, six

chains with ornamental balls are suspended from a wooden beam, with small bells and scales (the symbols of justice) swinging from four of them.

Gérôme employed a careful, highly polished technique of laying down thin layers of paint. This, coupled with his fidelity to detail, contributes to the remarkable realism found in his works. When working at home in his studio he used props brought back from his travels, and he also used photographs as aides-mémoire.

JULES BRETON

Courrières, Pas-de-Calais 1827–1906
Paris

The Gleaners

1854
Oil on canvas, 93 × 138 cm
Chester Beatty gift, 1950
NGI 4213

Jules Breton painted scenes of con-
temporary provincial life, stressing
the humble dignity of peasants in
their labour. He generally censored
the harsh realities of life from his
paintings, however, thereby making
them less threatening and more
acceptable to the official authorities.

The Gleaners is set in Breton's
native Courrières (the village is
depicted in the distance, its curious
tapering church tower breaking the
horizon line), and in it he used his
future wife Elodie as the model for
the standing figure beside the small

boy in the foreground. Both choices
indicate Breton's personal approach
to the time-honoured custom of
gleaning the remnants of the wheat
harvest.

He was recording a tradition that
he had seen practised many times in
Courrières – a back-breaking task,
but one where he saw dignity and
nobility in the toil of the labourers,
epitomized in the strength and noble
grace of Elodie's figure. The subject
was topical: in 1854 the rights of
gleaners were debated in the French
Senate. Breton exhibited the picture
at the Salon that year, where it was
exceptionally well received.

CAMILLE PISSARRO

Saint Thomas
(Virgin Islands) 1830–
1903 Paris

*Chrysanthemums
in a Chinese Vase*

1873
Oil on canvas,
60 × 50.5 cm
Purchased 1983
NGI 4459

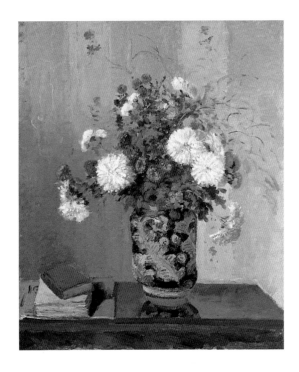

Pissarro had been in London during the Franco–Prussian War, but by November 1871 he had returned to Louveciennes with his family. In the absence of the family, however, the Prussians had used their rented house as a stable and billet. The place was unrecognizable but, worse still, more than 1,200 of Pissarro's paintings and drawings, representing 20 years' work, had disappeared or been destroyed.

Not surprisingly Pissarro and his family left Louveciennes early in 1872, moving to Pontoise. Here he remained for 10 years, painting the rural and suburban environments. He also painted a number of still-life and flower pieces in the period 1872–73, several featuring the same pretty wallpaper with a sprig repeated in vertical bands. *Chrysanthemums in a Chinese Vase* is the most 'finished' of these. The rich dark blue vase with its ornate Chinese pattern is reflected on the highly polished table. The flowers are tightly and carefully painted in muted shades that are repeated in the wallpaper. The effect is sophisticated but warm. Pissarro's wife, Julie, was extremely fond of flowers, and often gathered bouquets for her husband to paint on rainy days.

James Tissot

Nantes 1836–1902 Buillon

Marguerite in Church

c.1861
Oil on canvas, 50.2 × 75.5 cm
Chester Beatty gift, 1950
NGI 4280

Tissot painted a series of works that depicted the Faust legend. The story of Faust dates back to the sixteenth century: a doctor who travelled widely, he reportedly worked magic cures before dying in mysterious circumstances. The legend that quickly grew up around him maintained that he had made a pact with the devil, trading his soul for youth, knowledge and magical powers. The most celebrated version of the legend was written by Goethe in the early nineteenth century, and it was he who introduced the character of Marguerite. Tissot depicts Marguerite in church, struggling with her crisis of faith. A representation of the Last Judgement on the wall behind her, the intent prayer of the two young children at the altar on the left, and the void that divides them, heighten her sense of spiritual isolation. Costume-pieces like this were typical of Tissot's early work, when the Belgian artist, Baron Henri Leys was an influence on him.

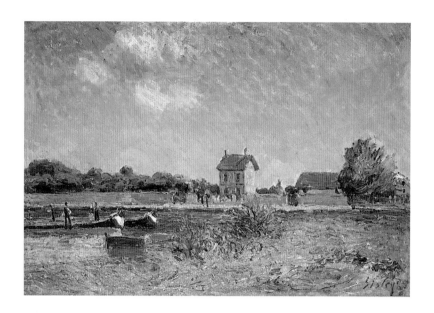

ALFRED SISLEY
Paris 1839–99 Moret

The Banks of the Canal du Loing at Saint-Mammès
1888
Oil on canvas, 38 × 55 cm
Purchased 1934
NGI 966

Saint-Mammès lies at the confluence of the Seine and Loing rivers, and the canal runs parallel to the Loing. Writing to Monet in 1881, Sisley described the region: 'It's not a bad part of the world, rather a chocolate-box landscape. When I arrived there were many fine things to do, but they have worked on the canal, cut the trees, made quays, aligned the banks.' The artist painted a series of landscapes at Saint-Mammès dating from 1883, all of which feature, from varying viewpoints, the cluster of small houses which lies beside the locks at the mouth of the canal. Here he has chosen a direct view of the canal banks, resulting in the division of the canvas into horizontal bands representing the sky, the far bank and the foreground. He has used different types of brushwork to create light effects on different surfaces. The expanse of sky is smooth, the house and outbuildings are clearly delineated and throw deep shadows, while long, criss-crossed brush strokes are used to convey the reeds and foliage on the near banks.

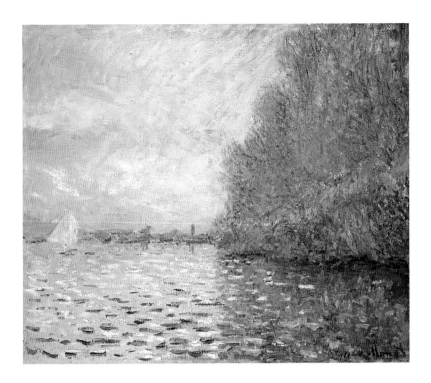

CLAUDE MONET
Paris 1840–1926 Giverny

Argenteuil Basin with a Single Sailboat
1874
Oil on canvas, 55 × 65 cm
Edward Martyn bequest, 1924
NGI 852

During the Franco–Prussian War Monet was in London, and upon his return in 1871 he moved with his family to Argenteuil. A picturesque, historic town and a developing suburb, Argenteuil was just 15 minutes away from Paris by train, and in the second half of the nineteenth century was unrivalled for Sunday trips and pleasure boating. Over the following years Sisley, Renoir, and Pissarro joined Monet to paint in the region of Argenteuil and the surrounding villages. As the once rural areas became increasingly accessible by rail, they became popular weekend retreats for Parisians. These young artists, dedicated to painting contemporary urban bourgeois life, were attracted by this blend of traditional landscape and modernity.

Monet acquired a boat, which he turned into a floating studio, and the River Seine and its sailing boats became the principal theme of his paintings. In this picture, the town of Argenteuil can only be glimpsed on the horizon. Light and its effect on the water's surface – captured by distinct, bold brush strokes – is the true subject matter of the painting.

LÉON
LHERMITTE
Mont-Saint-Père
1844–1925 Paris

*Harvesters
at Rest*
1888
Oil on canvas,
95 × 64 cm
Chester Beatty gift,
1950
NGI 4255

Corot and the Barbizon School were important influences on Lhermitte's early work, as was Jules Breton. In around 1880, however, seeking to create an important work that would bring him to the attention of the Salon jury and the public, Lhermitte looked to Courbet's monumental style. In 1882, with his painting *Harvesters' Payday*, he achieved this success and from this time on he specialized in the representation of rural life.

Unlike Millet, and in the tradition of Breton, Lhermitte was committed to the idealization of the French peasant. He regarded field labourers as heroic figures, seldom complaining and always dignified even when exhausted by their day's toil. This painting is based on a drawing made at Ru Chailly farm in the artist's native village of Mont-Saint-Père in 1886. Despite the *plein air* effects in the landscape, there is a strong emphasis on formal composition and academic drawing. From the beginning of the 1880s, with the increasing availability of threshing machines and other devices, rustic life was changing irrevocably, and Lhermitte knew that the activities represented in his paintings were already *retardataire*.

BERTHE MORISOT

Bourges 1841–95
Paris

Le Corsage Noir

1878
Oil on canvas,
73 × 65 cm
Purchased 1936
NGI 984

In 1874 Morisot participated in the first Impressionist exhibition, and at most of the group's subsequent shows. That same year she married Edouard Manet's brother, Eugène. With her husband's support and encouragement she continued to paint and exhibit professionally throughout her life. Her canvases concentrate almost exclusively on private domestic scenes, depicting the surroundings and daily activities of middle-class women. This was the kind of subject matter considered appropriate for a woman artist belonging to the *haute bourgeoisie*.

Le Corsage Noir is a portrait of a hired model called Milly. The stylish black evening dress is from the artist's own wardrobe – Morisot had worn it in formal studio photographs taken in about 1875. Morisot's characteristically rapid execution only just suggests the details on the bodice of the dress, with light feathery brush strokes. The model is contained in a shallow enclosed space that is compressed by the jardinière directly behind her, so that its large, bold leaves surround her head and merge with the horizontal strokes of her wrap.

PAUL SIGNAC
Paris, 1863–1935

Lady on the Terrace
1898
Oil on canvas, 73 × 92 cm
Purchased 1982
NGI 4361

It was May 1892 when Signac sailed his boat *Olympia* into the port of Saint-Tropez. He found a house to rent just five minutes from the town, lost among pine trees and roses, with a view of the distant mountains. In Saint-Tropez Mediterranean light entered his work, and gradually led him to transform his style towards a freer and less systematic divisionism. Gradually, his oil paintings became more distanced from reality and his works became more decorative, and more classical.

In his journal, the artist noted that he began this painting on 16 August 1898. His wife Berthe posed for the figure on the terrace. Signac had the Italian-style terrace constructed so that he could benefit from the wonderful view of the village and gulf below.

He has chosen to paint the scene in the late afternoon light, taking great liberty with the colour, and using loose brush strokes that follow the shape of the trees and the movement of the clouds

PIERRE BONNARD

Fontenay-aux-Roses
1867–1947 Le Cannet

Boy eating Cherries

1895
Oil on board,
52 × 41 cm
Presented by Lord and
Lady Moyne, 1982,
in memory of their
cousin May Guinness
NGI 4356

During the 1890s Bonnard would spend his summers with his family at Le Grand-Lemps, in the southeast corner of France. His maternal grandmother's house was situated in the Dauphiné province. Here we see his sister's first child, Jean, seated at the table with his grandmother, the artist's mother, Elizabeth Mertzdorff. The little boy is intent upon eating a plate of cherries as his grandmother tenderly watches over him. With her dark hair and dark dress she is seen in profile, large and affectionate, set against the flat doorway in the background, while Jean becomes the focus of the composition with his brightly chequered blue and white shirt.

Bonnard enjoyed exploring the decorative effects created by checked fabric, in paintings from 1891. Here the checks are laid flat, and although they follow the shape of the toddler's arm there is little attempt at modelling. More important for Bonnard is the decorative surface pattern created by the juxtaposition of the shirt with the floral wallpaper.

KEES VAN DONGEN

Delfshaven 1877–1968 Monaco

Stella in a Flowered Hat

*c.*1907
Oil on canvas, 65 × 54 cm
Purchased 1981
NGI 4355

Born in Holland, van Dongen was
a member of the Fauve movement
that flourished in Paris from 1905
to about 1909, and included Matisse
and Vlaminck. The Fauves used vivid
colours to express feelings and emo-
tions, and the effect was shocking for
their contemporaries.

Van Dongen, inspired by the
example of Toulouse-Lautrec, painted
the nightlife of Montmartre and other
similar areas of Paris, and Stella is
probably a *demi-mondaine.* She is por-
trayed in the violent, dissonant
colours that are the hallmark of the
powerful Fauve portraits of women
executed by the artist between 1905
and 1910. He uses the hot, unrealistic
pinks and purples to express the
woman's personality and convey her
seductive charm. These are balanced
by the cool greens used to shade the
neck and arm. Forms are flattened
and simplified, and yet van Dongen
seeks to create volume, and to raise
Stella in relief from the picture sur-
face, by adding a bold outline (along
the right side) reinforced by the heavy
yellow hatching which follows the
contour of her head and shoulders.

CHAÏM SOUTINE

Smilovitchi, Lithuania
1893–1943 Paris

Landscape with Flight of Stairs

c.1922
Oil on canvas,
81.6 × 65.1 cm
Purchased 1984
NGI 4485

Born in a poor Jewish ghetto in the village of Smilovitchi, near Minsk, Soutine was the tenth of 11 children. In spite of the objections of his family he studied art, first in Vilna and then in Paris. In 1919 he went to Céret in the French Pyrenees where, over a period of three years, he painted his first great series of landscapes in response to this mountainous terrain. The so-called Céret landscapes appear unstable – a pattern of swirling movement and convoluted images – and are generally regarded as the artist's most expressionistic works. Gradually this chaos gave way to greater clarity in his work, and individual elements in the landscape become identifiable in paintings produced after 1921–22.

Soutine visited Cagnes on the Côte d'Azur in 1922 and 1923, and *Landscape with Flight of Stairs* dates to these transition years. The town, which may be Cagnes, is seen from below. The inclusion of a flight of steps invites the viewer to enter the painting. A man descends them, but is leaning to the left, perhaps in response to the trees. The resulting sense of imbalance is disconcerting. This is a tense image, painted with charged and forceful brush strokes.

GERMAN AND
NETHERLANDISH
PAINTING

Salzburg School

Christ on the Cross with the Virgin Mary and John

c.1430
Egg tempera on panel, 24.9 × 23.7 cm
Purchased 1936
NGI 979

This small devotional image, intended to be seen at a close distance, was probably used for worship in a private dwelling. It is finely crafted – the small central panel is attached to the bevelled edge of a gilded frame which forms an integral part of the painting. The artist has used the surround to advantage, extending the grassy setting and the cross onto the bevelled edge. The rest of the background and frame is decorated with gold leaf, with dotted punched ornament.

The central figure of Christ on the cross, with his emaciated body and sunken eyes, dominates the small composition. The viewer's response to his suffering is reflected in the expressions of the Virgin and St John. Although they gesture in despair and grief, the mood is one of acceptance of Jesus' fate and quiet contemplation.

**MASTER OF
THE YOUTH OF
ST ROMOLD**

Active in Brabant
*c.*1490

*St Romold taking
leave of his parents*

*c.*1490
Oil on oak panel,
57.6 × 42 cm
Purchased 1958
NGI 1381

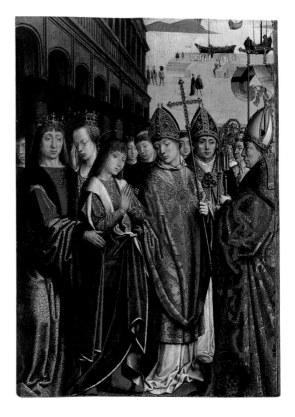

This master, a late fifteenth century artist, painted a group of seven pictures with scenes from the life of St Romold of Malines. Romold was apparently born in Scotland and, after a pilgrimage to the graves of the Apostles, settled in Malines. Although it is not proven, Romold is generally referred to as the (Arch)-bishop of Dublin in hagiographic literature from the thirteenth century onwards.

In this panel St Romold is portrayed as a layman, so presumably the scene illustrates an early episode in the saint's life – he joins the clerics in order to embark for Dublin, where he is to be consecrated bishop. In the background, a boat sits waiting in the harbour. Behind the young man are his father and mother, depicted as the King and Queen of Scotland.

The Gallery has a second panel by the same artist, depicting *The Enthronement of St Romold as Bishop of Dublin*. Both works are characterized by their elongated, immobile figures with solemn expressions, grouped tightly together.

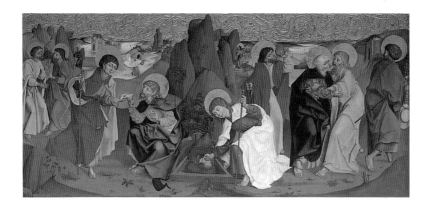

Styrian School

The Separation of the Apostles

1494
Spruce wood panel, 67.2 × 134.5 cm
Purchased 1936
NGI 978

The separation and subsequent travels of the Apostles were recorded in the apocryphal acts of the apostles, written during the second and third centuries. The feast day of their separation was celebrated mainly in northern Europe after the ninth century. Consequently, it was in the art of that area that the theme was depicted, particularly between 1480 and 1510.

This panel shows the twelve Apostles taking leave of one another as they embark upon their mission to spread the word of Jesus to different parts of the world. The other side of the panel shows two angels holding Veronica's veil. The horizontal shape indicates that it originally formed the *predella* of an altarpiece; placed at the base, it would have been the same width as the central section of the altarpiece.

We know very little about the artist who painted this panel, but we can see that he concentrated on the decorative aspects of the composition, particularly on the brightly coloured costumes of the Apostles, the symmetrical landscape, and the richly tooled, gold-leaf ornament that takes the place of the sky.

BERNHARD STRIGEL

Memmingen 1460–1528

Portrait of Count Johann II, Count of Montfort and Rothenfels

*c.*1523
Limewood panel,
28.3 × 21.1 cm (painted surface)
Purchased 1866
NGI 6

The inscription seen on the wooden plaque at the base of the portrait identifies the sitter as Johann, Count of Montfort and Rothenfels, adviser and ambassador to the Emperor in 1523. The chain worn by the Count and the two keys in his left hand are probably intended to allude to his noble status, while the towns and castles in the landscape almost certainly refer to the lands owned by his family just to the east of Lake Constance – where today the borders of Austria, Germany and Switzerland meet. The letters on the sitter's hat are more enigmatic, and as yet have not been decisively interpreted.

Strigel was an obvious choice to paint the portrait of Johann II. The artist had been official portraitist to Emperor Maximilian I until his death in 1519 and, moreover, the Strigel family had a long history of producing art works for the Montfort family.

A companion portrait of Johann's wife may originally have accompanied this portrait. Alternatively, the sitter's glance to the left may have been intended to direct the viewer's eye to the landscape.

CONRAD FABER

Creuznach before 1524–52
Frankfurt

Portrait of Katherina Knoblauch

1532
Limewood panel,
50.5 × 35.9 cm
Purchased 1866
NGI 21

Katherina Knoblauch was a member of the aristocratic House of Limpurg of Frankfurt. According to the in-scription on the back of the panel, she was 19 years old when the painting was made in 1532; by this time she would have been married for three years. Faber also painted her husband, Friedrich Rohrbach (Art Institute, Chicago), and the continuation of the panoramic landscape in both portraits confirms that they were conceived as a pair.

The style of Faber's landscapes suggests that he had first-hand knowledge of Flemish paintings – landscapes that filled the entire back-ground were a more frequent feature of Flemish portraits at this date. Katherina is an almost three-quarter length figure, dressed in a brightly coloured outfit that is sumptuously decorated with gold embroidery and jewellery, reflecting her aristocratic status. The reverse of the panel also carries a painted coat of arms of the Knoblauch family, which features three cloves of garlic (*knoblauch* in German).

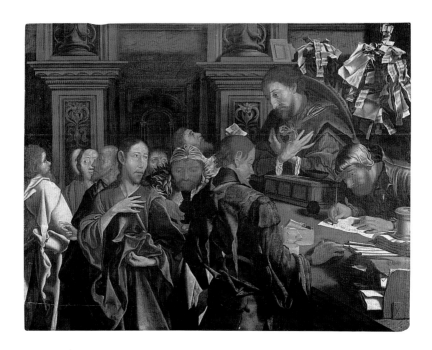

Attributed to MARINUS VAN REYMERSWAELE

Reymerswale c.1490/95–c.1567
Antwerp(?)

The Calling of Matthew

c.1530–40
Oil on oak panel, 82.9 × 108.3 cm
Purchased 1943
NGI 1115

According to the Gospel of Matthew, Jesus saw Matthew at his seat in the customs house and said to him, 'Follow me'. In this composition, as Jesus' eyes meet those of Matthew amid the bustle of activity in the office, the artist has portrayed both the summoning and the psychological moment of the tax collector's conversion.

This work is one of many interpretations of the *Calling of Matthew* by Reymerswaele. He restricted his subject matter to a limited number of themes, and subjects that criticized tax collectors and usurers were a constant feature in his work. The present panel differs from other versions in that the background is of a heavy Italianate architecture with a foreshortened corridor behind Jesus' head. Despite the attempt at perspective, the ornate nature of the backdrop heightens the sense of crowding in the foreground. But the lively bunches of invoices behind Matthew's head, his long tapering fingers folded across his chest, and the gesture made by Jesus, combine to ensure that our attention is focused on the two protagonists.

PIETER POURBUS
Gouda(?) c.1523/24–84 Bruges

The Golden Calf

c.1559
Oil on oak panel, 92.7 × 148.5 cm
Purchased 1882
NGI 189

Pourbus was the leading painter of altarpieces and portraits in Bruges during the second half of the sixteenth century. Although innovative in his use of figure types and techniques influenced by Italian painting of the High Renaissance, he adhered to the bright colours and precision of the Bruges school of painting. Here we can see his novel treatment of the subject matter, painted in the pictorial style that typifies his works of the late 1550s.

The subject of the main scene is taken from the Book of Exodus (32: 1–6) which relates how the Israelites, during the temporary absence of Moses, fell into idolatry and began to worship the golden calf that his brother Aaron had cast. Pourbus shows them dancing, hands held, around the elevated statue.

Indeed, the artist appears to be more interested in portraying the festivities and the still life than in the religious essence of the story. When Moses returned from Mount Sinai, he threw the tablets of the Law on the ground and broke them: this subsequent moment is depicted in the left background, while in the distance on the right, the Israelites are shown melting down their golden vessels to make the golden calf.

GEORG PENCZ

Active in
Nuremberg,
1500–50

Portrait of a Gentleman

1549
Oil on canvas
84.1 × 65.5 cm
NGI 1373

Although the identity of this man is unknown, the inscription in the upper right corner informs us that he was aged 28 when this portrait was painted. It is also fairly certain that he was a citizen of Nuremberg, since Pencz was living and working in that city when the portrait was painted in 1549. The artist, an outspoken critic of the authorities, had been expelled from Nuremberg in 1525 but was able to return 10 months later. In 1532 he was named the city's official painter.

Pencz appears to have travelled twice to Italy, and the small bronze statuette that the sitter holds in his left hand derives in type from those by the Paduan sculptor and goldsmith, Andrea Riccio. It is of a satyr on the point of embracing a nude woman, and has been identified as Pan seducing Diana.

Although it has been suggested that this is a portrait of a sculptor, the inclusion of the bronze with its unusual and erudite subject matter, the young man's elegant costume, and the interior setting all point to his being a nobleman, portrayed in the contemporary Italian mannerist style.

FRANS POURBUS THE YOUNGER

Antwerp 1569–1622
Paris

Portrait of the wife of Nicolas de Hellincx

1592
Oil on oak panel,
107.1 × 76.6 cm
Purchased 1910
NGI 606

This work was painted as one of a pair of portraits of a married couple. Its pendant, a portrait of Nicolas de Hellincx, is in the Museum voor Schone Kunsten, Antwerp. Both works remained together until 1910.

Pourbus came from a family of painters, and made an international career as a painter of courtly portraits. He was court painter to the Dukes of Mantua from 1600 until 1609. He then moved to Paris at the invitation of Marie de'Medici, and his portraits became extremely popular in court circles.

In this work, the lady's costume and jewellery convey her prominent social position. She is wearing a Spanish coat-dress with shoulder rolls, decorated with ribbed silk bows. The southern Netherlands were at this time still governed by Philip II of Spain, and Spanish fashion was widely worn.

ANTON RAPHAEL MENGS

Aussig (Bohemia)
1728–79 Rome

Thomas Conolly, 1739–1803

1758
Oil on canvas,
135 × 98 cm
Purchased 1983
NGI 4458

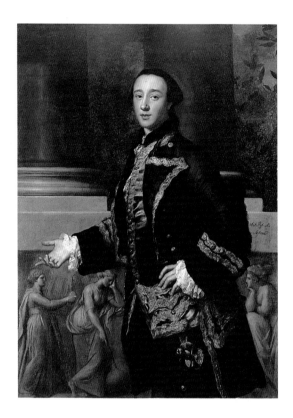

Thomas Conolly visited Rome in the late 1750s, like so many other young gentlemen who sought to finish their education by travelling in Europe. He was only about 19 years of age when Mengs painted him. On his return to Ireland he married Lady Louisa Lennox. She was the sister of the Duchess of Leinster, who lived at Carton, Co. Kildare. The Conollys took up residence at the adjoining estate, Castletown, which had been built by Thomas's granduncle, William Conolly, Speaker of the Irish House of Commons.

Wearing a dark blue coat and jacket trimmed with gold braid, the young man gestures to the monumental base of the Doric columns behind him. The sculptural relief, showing three of the nine Muses, is taken from a sarcophagus that is now in the Louvre, Paris.

Conolly was a pleasant young man, more given to country pursuits than to cultural studies, but it was this ability to endow his sitters with a learned elegance that made Mengs a serious rival to Pompeo Batoni as portraitist to the Grand Tourists in Rome.

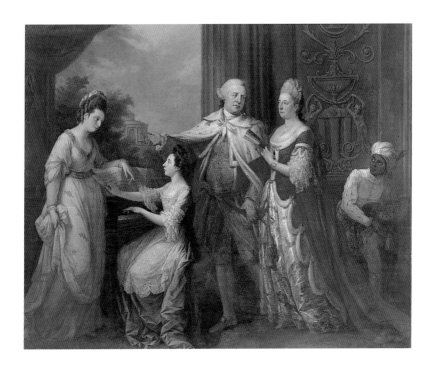

ANGELICA KAUFFMAN
1741–1807 Rome

The Ely Family

1771
Oil on canvas, 243 × 287 cm
Presented by the 4th Marquess of Ely,
1878
NGI 200

Angelica Kauffman achieved a
remarkable success for a woman
painter of her period. Under the
patronage of Joshua Reynolds she
became one of the leading artists in
England, renowned for her allegori-
cal subjects as well as her society
portraits. She visited Ireland briefly
during 1771, where she received
numerous commissions. One of the
families she stayed with was that
of the Earl of Ely at Rathfarnham

Castle, for whom she painted this
large family portrait.

Lord and Lady Ely are standing
in the centre. The two young women
to their left are thought to be their
nieces – Frances (seated at the harp-
sichord playing an aria from 'La
Buona Figliuola' by Niccolo Piccini)
and Dolly Monroe (one of the great
beauties of her day). At the right, a
young black page in Oriental dress
carries a cushion with two coronets.
The pseudo-classical costume of the
figure on the far left is intended to
give the sense of an allegorical figure,
while still being a portrait.

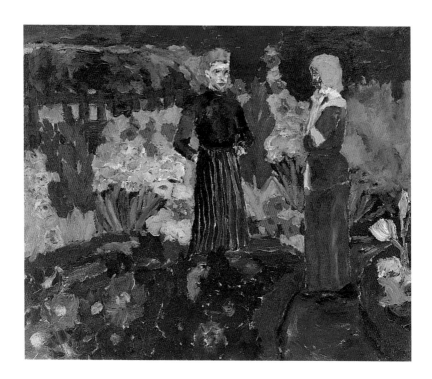

EMIL NOLDE

Nolde, Schleswig-Holstein 1867–1956
Seebüll, Schleswig-Holstein

Two Women in a Garden

1915
Oil on canvas, 73 × 88 cm
Purchased 1984
NGI 4490

Emil Nolde was one of the principal exponents of Expressionism. The Expressionists deliberately sought to abandon the naturalism implicit in Impressionism in favour of a simplified style which would carry far greater emotional impact. In 1913, in order to study at first hand the 'primitive' art he had admired in the Berlin Ethnographic Museum, Nolde accompanied a scientific expedition that travelled through Russia to Japan and the South Seas. Although it was brought to an end by the outbreak of World War I, the voyage marked a turning point in the artist's career. It coincided with the end of first-generation Expressionism and marked Nolde's return to painting gardens and flowers rather than urban subjects.

Nolde spent most of 1915 in his small cottage on the island of Alsen. He produced some 88 works that year, many of which drew upon the sketches he had made during his voyage. *Two Women in a Garden* was painted in his garden in strong, dark colours, using large brush strokes.

FLEMISH
PAINTING AND
SCULPTURE

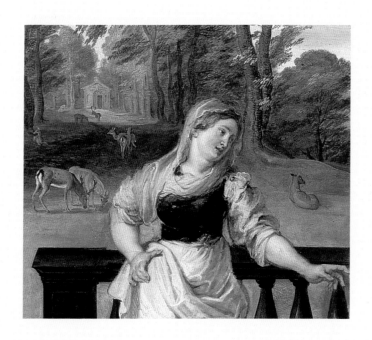

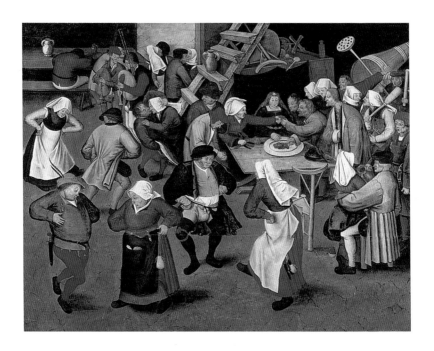

PIETER BRUEGHEL THE YOUNGER

Brussels c.1564–c.1637 Antwerp

Peasant Wedding

1620
Oil on panel, 81.5 × 105.2 cm
Purchased 1928
NGI 911

This peasant feast is fully signed and dated by the artist. It was clearly a very popular image, as it was replicated many times. Its attraction lies in its animated and amusing portrayal of Flemish peasants, enjoying a country wedding. The bride looks down demurely at her dowry plate, as the old woman to her left grabs the money pouch from one of the guests. The figures are deliberately caricatured and comical, as they dance and make love at the wedding reception.

It has been argued that subjects like this were intended not just as comical genre scenes but as satirical images conveying a moral message. The crude carvings on the tabletop include a windmill, a heart pierced with arrows, a wine flask, an owl, and two intertwined fish. They may be symbolic, but many seem to be simply rough score marks.

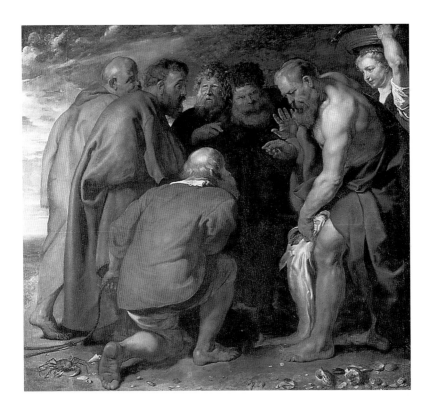

PETER PAUL RUBENS
Siegen 1577–1640 Antwerp

St Peter finding the Tribute Money
1617–18
Oil on canvas, 199.4 × 218.8 cm
Purchased 1873
NGI 38

Rubens is the most famous of all seventeenth-century Flemish painters. This painting has been identified as one of 12 pictures exchanged by Rubens in 1618 for antiquities belonging to Sir Dudley Carleton, a noted connoisseur and English Ambassador in The Hague. Writing to Carleton, the artist described the picture as 'Original, by my hand', to reassure him that it was painted by the master himself rather than by a member of his workshop, as was often the case by 1618. The loose folds of the drapery, the rugged naturalism of the figures, the powerful anatomy, and the strong lighting all support this claim.

In St Matthew's Gospel, Christ tells Peter he will find money needed for taxes in the jaws of fish. The subject was relatively rare in European art before the seventeenth century, and may have been commissioned by the fishermen's guild.

JAN BRUEGHEL II

Antwerp, 1601–78

and PETER PAUL RUBENS

Siegen 1577–1640 Antwerp

Christ in the House of Martha and Mary

c.1628
Oil on oak, 64 × 61.9 cm
Sir Henry Page Turner Barron bequest, 1901
NGI 513

This picture has long been recognized as a collaborative effort between Jan Brueghel II, who painted the landscape and still life, and Rubens, to whom the figures are attributed. Rubens had painted the figures in several works for Jan Brueghel I, and it is understandable that he would have done the same for Brueghel's son when he took over the family workshop after his father's death in 1625. Originally, the picture was larger, possibly some 40 or 50 cm wider.

Christ in the House of Martha and Mary was traditionally an interior scene. The move here to an outdoor terrace changes the emphasis – the landscaped grounds of an aristocratic villa lend a peaceful note to the foreground activity. In the distance on the right is the Château de Mariemont, the summer residence of the Spanish regents Albert and Isabella. Both Rubens and Brueghel I were court painters to the regents, and it is possible that the picture was intended for an aristocratic patron.

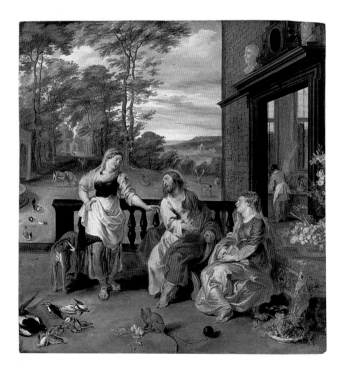

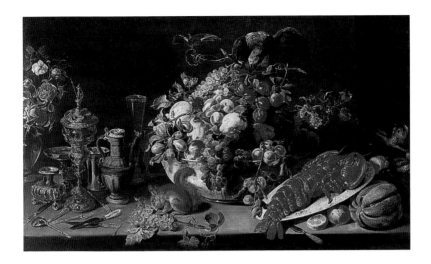

FRANS SNYDERS
Antwerp, 1579–1657

A Banquet Piece
Late 1620s
Oil on canvas, 92.3 × 156.1 cm
Sir Hugh Lane bequest, 1918
NGI 811

Snyders had an enormous influence on still-life painting in Antwerp. Occasionally he collaborated with Rubens, and he had a large workshop to assist with the production of his still lifes and hunting scenes. This sophisticated banquet-piece depicts an impressive array of fresh fruits, a reminder that Antwerp was renowned as a marketplace for exotic fruit and vegetables in the sixteenth and seventeenth centuries. The sumptuous display appears to celebrate wealth and abundance for its own sake, while the expensive metalware and the relatively large size of the canvas suggest that it may have been intended to decorate an aristocratic dining room. Snyders was able to demand enviably high prices for his best work from noble patrons.

Jacob Jordaens

Antwerp, 1593–1678

The Veneration of the Eucharist

*c.*1630
Oil on canvas, 283.6 × 23.9 cm
Purchased 1863
NGI 46

Jordaens was recognized internationally as the leading painter in Antwerp after Rubens's death in 1640. *The Veneration of the Eucharist* is a religious allegory of a central tenet of Roman Catholicism, but today the work is difficult to interpret fully. A woman seated on a lion is set above the rock of the Church and holds a symbol of the Eucharist, the monstrance with the sacred host inside. Her exact identity is unclear, but she may be a personification of the Catholic Faith. The Holy Spirit, in the form of a white dove, hovers above. The woman is flanked by Sts Peter, Paul (left), Catherine, Rosalie and Sebastian (right). They are identified by their symbols and dress, as are the Latin Doctors of the Church below (Sts Augustine, Jerome, Gregory and Ambrose). The Christ Child, holding a cross and a flaming heart, triumphs over death and the Devil.

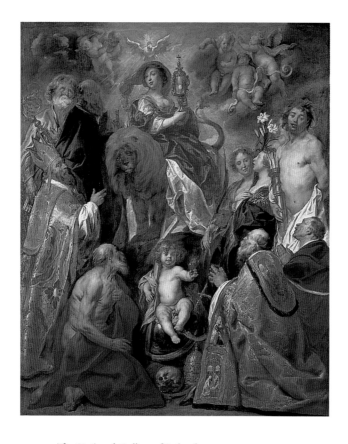

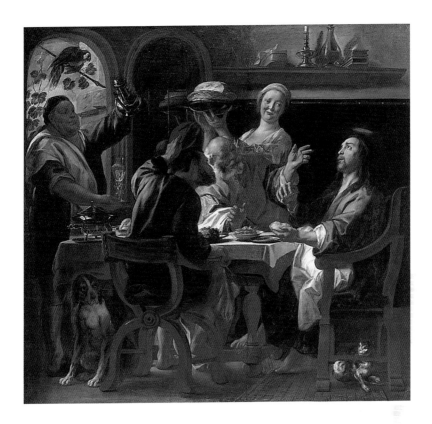

JACOB JORDAENS
Antwerp, 1593–1678

The Supper at Emmaus
c.1645–65
Oil on canvas, 198.5 × 211.5 cm
Presented by Charles Bianconi, 1865
NGI 57

Taken from the Gospel of St Luke, the subject recounts how Christ on the day of his Resurrection met two of his disciples on the road to the village of Emmaus. When they stopped to eat in the village Christ broke the bread, and at that moment the disciples recognized their fellow traveller. The theme was popular in the art of the Counter Reformation because it was seen as an important precedent for the eucharistic celebration of bread and wine in church, as a remembrance of Christ's sacrifice on the cross.

The rustic realism of the figures and the humble setting are typical features in Jordaens's work. The strong use of light and shade, and the broad use of paint, indicate that this is a later work by the artist, dating to c.1645–65. During these years the artist had several assistants, and it is possible that one of these had a hand in this painting, working on some of the weaker areas such as the figure of the male servant on the left.

François Duquesnoy, called Il Fiammingo
Brussels by 1594–1643 Livorno

Bust of Cardinal Guido Bentivoglio (1577–1644)
After 1638
Marble, height 78 cm
Purchased 1967
NGI 8030

Cardinal Guido Bentivoglio was Papal Nuncio in Brussels from 1607 to 1615, and later Cardinal Protector of France in Rome. Here he was in close contact with Rubens and van Dyck, who belonged to the same circle as Duquesnoy. Bentivoglio was also an intimate collaborator of Pope Urban VIII, whose protégé Duquesnoy had become in 1626.

The sculptor intended this bust to be viewed frontally. Although the pose is quite static, the portrait is enlivened by carved details such as the pouches under the eyes and the small groove at the base of the nose. The surface treatment gives the bust a wax- or alabaster-like quality. These attributes, together with a general softness and lack of bold relief, combine to reveal the sitter's intense intellectual physiognomy.

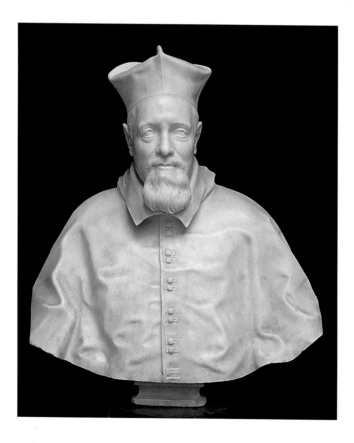

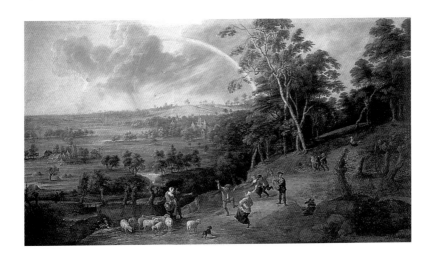

LUCAS VAN UDEN
Antwerp, 1595–1672
and DAVID TENIERS II
Antwerp 1610–90 Brussels

Peasants Merrymaking

Early 1640s
Oil on canvas, 122.2 × 218 cm
Purchased 1874
NGI 41

Van Uden and Teniers collaborated on many occasions. Most of their paintings have a similar format, featuring peasants in the right foreground and a view of a distant landscape immediately behind them with no significant middle ground in between. Teniers painted the merry peasants as caricatures in exaggerated poses, displaying the usual carefree vices of seduction, idle frolics and drunkenness. The Rubenesque landscape is by van Uden, who was greatly influenced by the landscapes of that most famous Flemish painter of the period.

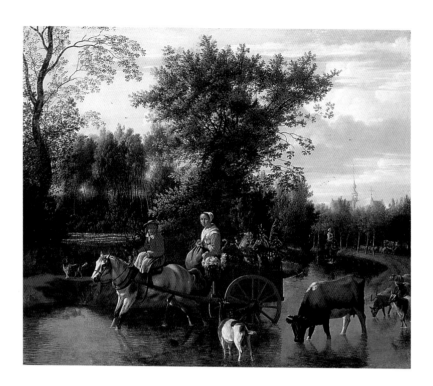

JAN SIBERECHTS

Antwerp 1627–c.1700 London

The Farm Cart

1671
Oil on canvas, 72.4 × 85.5 cm
Purchased 1928 (Lane Fund)
NGI 900

Siberechts is best known for his land-
scapes of the 1660s and early 1670s,
where he specialized in scenes of
peasants crossing a ford with their
carts and animals. They were intend-
ed for bourgeois city patrons, who
had a certain fascination with the
carefree existence of country life.
This composition, dominated by the
cart and its occupant, suggests an
idyllic, pastoral world. The woman
looks directly out at the viewer. She is
presumably headed towards a market
where she can sell the produce and
livestock.

This work was painted the year
before Siberechts left for England.
The variety and richness of the
colours in the surrounding country-
side, the meticulous detail in the
trees, and the reflections on the water
illustrate the artist's considerable
skill as a landscape painter.

ADAM DE COSTER

Mechelen c.1586–1643 Antwerp

A Man Singing by Candlelight

1625-35
Oil on canvas, 123.6 × 90.7 cm
Purchased 1938
NGI 1005

De Coster was known as a painter of nocturnal scenes. The subject of a single performing musician became very popular among those northern artists who imitated the dramatic lighting of Caravaggio and his followers. There is no record that de Coster ever travelled to Italy, but he would certainly have had the opportunity to see pictures of this kind painted by fellow countrymen. The high quality of this work makes it an important addition to the genre. The splendid lighting effects of the candle on the costume, and the subtle play of light and shade on the man's face and hand, are sufficiently realistic to suggest that the figure is a life study. The singer's half-open mouth heightens the sense of drama and the realism of a captured moment in time.

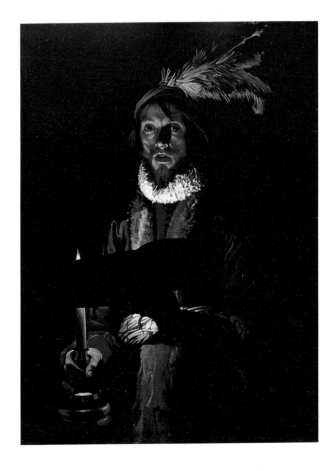

ANTHONY VAN
DYCK

Antwerp 1599–1641
London

*A Boy standing
on a Terrace*

c.1623–24
Hugh Lane bequest,
1918
NGI 809

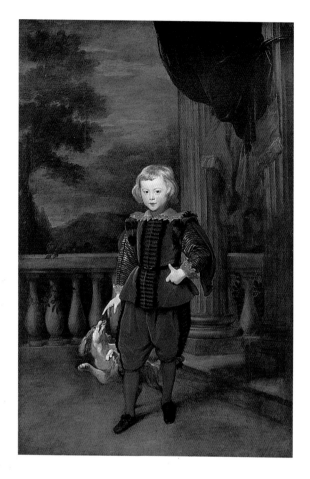

The most famous portraitist of his
time, van Dyck enjoyed an interna-
tional career, working in England and
Italy as well as in his native Flanders.
This young boy was almost certainly
a member of a Genoese family, as the
style of the portrait is similar to other
works painted in Genoa in the 1620s.
It is the largest and most elaborate of
van Dyck's portraits of children. In
his velvet, silk, and lace suit, the
small boy poses confidently on a pala-
tial terrace. However, his childish
expression, the playful spaniel at his

feet, and the grandeur of the setting
lend a vulnerability to the image,
testifying to van Dyck's great skill as
a portraitist.

Van Dyck arrived in Genoa around
November 1621 and lived there, on
and off, until late 1627. Based on the
costume, this picture is thought to
date from c.1623–24, although the
sophisticated setting as well as other
elements in the composition may
indicate a later date of c.1625–27.

DUTCH
PAINTING

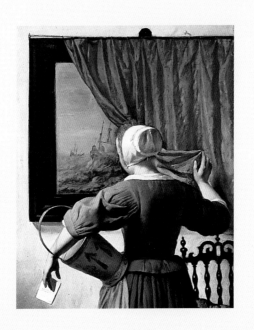

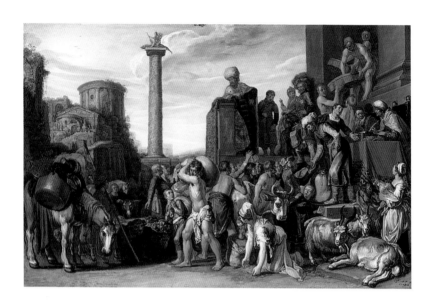

Peter Lastman

Amsterdam(?) 1583(?)–1633 Amsterdam

Joseph Selling Corn in Egypt

1612
Oil on panel, 57.6 × 88.2 cm
Purchased 1927
NGI 890

Joseph was sold into slavery by his jealous brothers, but, through his gift of prophesy, became a leading official of the Egyptian Pharaoh. In this episode, a rare subject for Dutch artists, he is shown selling corn during the time of famine that he had predicted. The central youth with a sack may be a reference to one of the brothers he later forgave, and the accompanying boy might represent the blameless Benjamin whom he forced the brothers to bring from their home.

Lastman spent his formative years in Italy, where he resided from 1603 to 1604, and subsequently became the leading history painter in Amsterdam. His small canvases – which tend to depict a multitude of figures in a landscape setting – show the strong influence of Adam Elsheimer, around whom a circle of Dutch artists worked in Rome. In this colourful tableau, the story is almost lost in the accompanying detail. Notable are the treatment of the muscular figures and the variety of facial expressions. The triumphal column and ruined classical buildings allude to the antique world.

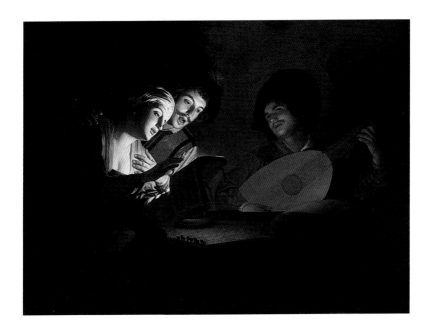

GERRIT VAN HONTHORST

Utrecht 1590–1656

A Musical Party

c.1616–18

Oil on canvas, 131.5 × 182 cm

Mr and Mrs Lochlann Quinn gift under Section 1003 of the Taxes Consolidation Act (1997), 2001

NGI 4693

Two men and a woman are singing, accompanied by a lute. On the table is a Spanish guitar. The use of candle-light and dramatic chiaroscuro to reveal facial expressions was a favour-ite device of the artist, and earned him the nickname 'Gerard of the night scenes'. Honthorst had been a pupil of the Utrecht history painter Abraham Bloemart, and sub-sequently travelled to Rome where he ab-sorbed the work of Caravaggio and his followers. He painted religious and genre subjects at this time, and some of the leading Italian church-men and nobility were among his patrons. Returning to Utrecht in 1622 he became one of the city's most successful artists, bringing a strong Italian influence.

The solemnity and restrained colour of this scene exemplifies the artist's earlier work. The canvas was acquired in Rome in 1756 for Lord Charlemont, forming part of his renowned collection in Dublin.

Hendrick Avercamp

Amsterdam 1585/86–1634 Kampen

Scene on the Ice

1620
Oil on panel, 20.5 × 43.8 cm
T. Humphry Ward gift, 1900
NGI 496

Winter landscapes, with figures enjoying themselves on a frozen canal, were a speciality of Avercamp. Details such as trees, drawbridges and sailing boats are found in his many drawings, some of which are tinted with watercolour, and were used in a number of his paintings. The feel of a leaden sky at the heart of winter is well expressed here. Avercamp's observant depiction of the skaters – jaunty, hesitant and falling over – together with details such as the hole cut in the ice for fishing, or the children listening to an old woman while others go about their business, is both delightful and instructive of everyday Dutch life. The tradition of such scenes goes back to Pieter Brueghel the Elder, whose had taught Avercamp's principal master, Pieter Isaacsz.

Although Avercamp had lived in Kampen since 1613, that city's landmarks – its Gothic churches, city gates and Stadhuis, for instance – appear in none of his landscapes. Instead, venacular buildings and imaginary castles are the norm.

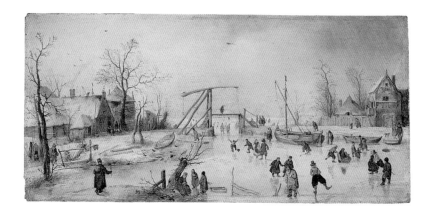

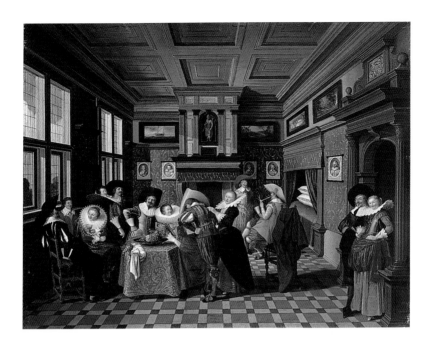

DIRCK VAN DELEN
Heusden 1605–71 Arnemuiden

and DIRCK HALS
Haarlem, 1591–1656

An Interior with Ladies and Cavaliers

1629
Oil on panel, 73 × 96.5 cm
Purchased 1889
NGI 119

The imaginary room suggests the height of wealth, with a marbled floor of three colours, a gilt doorcase, a wall bed set between pilasters, and a chimneypiece derived from a published design by the architect Sebastiano Serlio. Prints of imaginary portraits hang on embossed wallpaper below land and seascapes in ebony frames. The composition has an overall similarity to a plate by Hans Vredeman de Vries in his treatise on perspective of 1560 and, like other van Delen pictures, is strongly influenced by the Antwerp School.

Van Delen's master is unknown, but we do know that he had moved to Arnemuiden by 1626, where he maintained a fashion for painting ornate interiors and gardens. The figures in these works were supplied by a number of different artists, in this instance Dirck Hals (younger brother of Frans), whose bright colours and smiling faces are readily identifiable. The figures may demonstrate the Five Senses: the galantes touch and stare as they enjoy wine, fruit and tobacco, while a statue in the background with a horn may symbolize hearing.

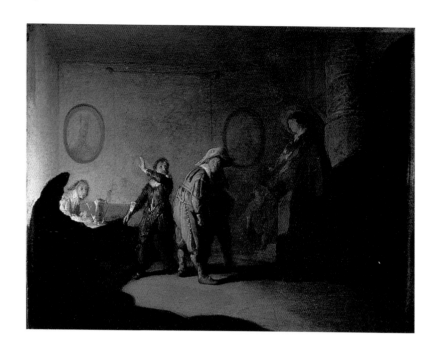

REMBRANDT and studio
Leiden 1606–69 Amsterdam

La Main Chaude

*c.*1628
Oil on canvas, 21 × 27 cm
Purchased, 1896
NGI 439

This painting depicts a lively game where one is smacked from behind and has to guess who has done it. It was played in Holland by both children and adults – here a group of men in a dramatically lit room. The main figure is actually cheating, as he turns to look at his assailant, while the references to drinking, smoking and playing the violin suggest a secondary theme of warning against time-wasting.

Rembrandt was first suggested as the artist nearly a century ago, but a definite attribution to him was only confirmed at the end of 2001. Long placed in his Leiden circle during the 1620s, when he was establishing himself as a history and portrait painter, the picture had been linked to other emerging artists such as Gerrit Dou and Jan Lievens. While it is the only known genre scene by Rembrandt, the quality of draughtsmanship and composition, the silhouetted foreground man and the oval portrait of a man on the back wall, plus the x-ray discovery that the scene was painted over a discarded portrait, are all pointers to his authorship.

WILLEM CORNELISZ. DUYSTER

Amsterdam, 1599–1635

Interior with Soldiers

1632
Oil on panel, diameter 48.2 cm
Purchased 1895
NGI 436

The portrayal of off-duty soldiers in a barn is typical of the artist. The main figure proudly displays a walking stick and gorget under his cloak. He is clearly an officer, and the finery of his slashed sleeves and lace cuffs is in stark contrast to the humble leggings of the seated figure, who has been wounded on the head. The two soldiers gambling and the hunting bag on the wall allude to non-military activities.

Duyster is known for his satirical pictures of soldiers brawling or over-dressed in satin and velvet, but here his attitude to the soldiers is ambiguous. He has devoted much care to the carefully lit interior, following the Dutch liking for tonal painting from the 1620s onwards. The finesse seen in areas such as the straw, and the work's unusual roundel composition, mark it out in his small *oeuvre*. This is Duyster's only dated painting, created a year after marrying the sister of the genre painter Simon Kick, and three years before dying of the plague.

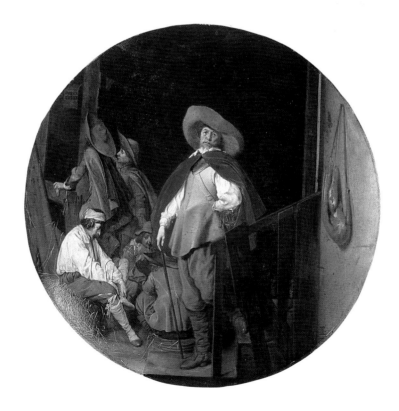

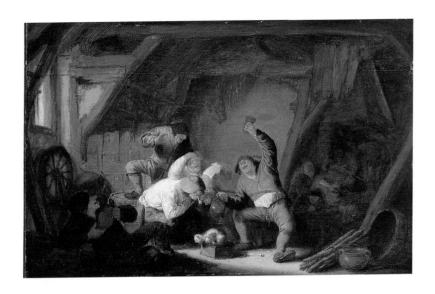

ADRIAEN VAN OSTADE

Haarlem, 1610–85

Boors Drinking and Singing

c.1635
Oil on panel, 32.4 × 50.9 cm
Purchased 1873
NGI 32

The scene of intoxicated abandon in a ramshackle interior centres on a group of men drinking, smoking and singing. A cat is seated on their heating brazier, next to a discarded pipe and some playing cards. The effects of intemperance are evident in the lined faces and bulbous noses of the figures, and they have a slightly grotesque quality. At the same time they are treated with a touch of humour which softens any sense of criticism.

Van Ostade was a fine draughts-man, as is shown by the treatment of the central man holding a glass and jug. Exaggerated gestures and the sketchy quality place this work early in a career which produced more than 800 paintings. Van Ostade is believed to have been a pupil of Frans Hals alongside Adriaen Brouwer, another exponent of 'low-life' subjects; unlike Brouwer, however, he places more emphasis on gesture than facial characteri-zation. In Van Ostade's later work the peasants exhibit more refined behaviour; he also widened his range with genre scenes and portraiture.

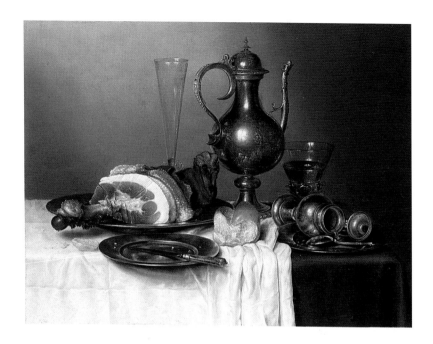

WILLEM CLAESZ. HEDA
Haarlem, 1593/94–1680/82

A Banquet-piece

c.1635
Oil on panel, 55.3 × 73.8 cm
Sir Henry Page Turner Barron bequest,
1901
NGI 514

Known as a *banketje* (banquet-piece),
the display comprises pewter plates –
one with a joint of ham, the other a
knife – a *façon de Venise* flute glass, a
pewter flagon, a Berkemeyer glass,
bread, a mustard pot and a spoon.
Apart from the costly flute glass,
which would have been made in
Venice or copied in Holland, these
are everyday objects observed with a
precision and order that continues to
fascinate.

Heda emerged as a still-life painter
in the early 1630s. He initially fol-
lowed earlier Haarlem painters in
employing simple table arrange-
ments, but in time he added increas-
ing richness and complexity to his
works. The highlighting of objects by
a crumpled white tablecloth, the over-
hanging knife to suggest depth, and
the play of reflections, all conveyed in
the restrained, silvery 'monochro-
matic' style of Haarlem artists, are
typical. Light sparkles across the
composition, in which the textures of
the ham and bread, and the carefully
judged spaces, are integral to the
effect.

WILLEM DE POORTER

Haarlem 1608 – after 1648 Haarlem(?)

The Robing of Esther

Late 1630s
Oil on panel, 39.4 × 30.8 cm
Sir Walter Armstrong gift, 1893
NGI 380

Esther is being dressed in royal apparel by attendants who hold up a mirror and golden chain. In secret a Jew, she risked her life by going unsummoned before her husband, the Persian King Ahasuerus, to prevent an intended massacre of the Jewish people. Her intercession was later seen by Christians as a prefiguration of the Virgin on Judgement Day.

De Poorter may have been a pupil of Rembrandt and was certainly influenced by him. His earliest dated work is from 1633 and depicts Esther's successful audience before King Ahasuerus. The subject here is used as an opportunity for a display of sumptuous textiles and metalwork in the detailed style of Leiden painters.

Sir Walter Armstrong, who donated the picture, was director of the Gallery from 1892 to 1914. He published widely on Old Master painting and was an acknowledged connoisseur of Dutch art.

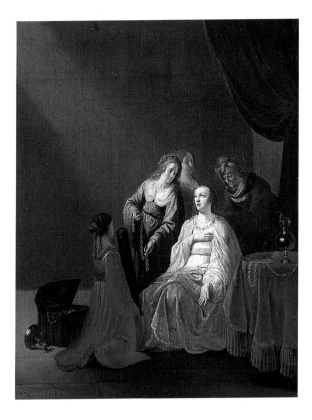

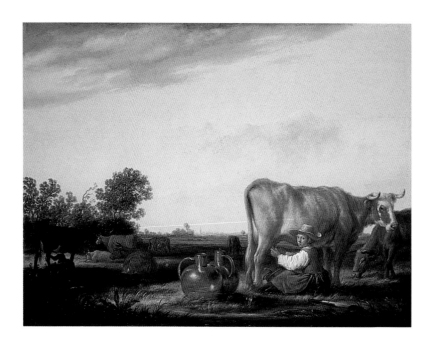

AELBERT CUYP
Dordrecht 1620–91

Milking Cows
1640s(?)
Oil on panel, 50.5 × 66.9 cm
Mr John Heugh gift, 1872
NGI 49

This particular grouping of a milk-maid at work occurs in several other canvases by Cuyp. The cattle and copper vessels are finely observed in a scene of warm sunlight that is typical of his work from this date. An extended sketching tour of Holland undertaken by Cuyp around 1642 led to an appreciation of the Utrecht School and the influence of Jan Both and Herman Saftleven, who worked in an Italianate landscape style. Cuyp was to blend these influences with the topography of his native Dordrecht, replacing an earlier, more tonal, style. Following his marriage to a rich widow in 1658, Cuyp took up public life and died one of Dordrecht's wealthiest citizens.

There have been suggestions that members of Cuyp's studio may have assisted on this picture, and that the artist's father, Jacob Gerritsz. Cuyp, may have worked on the landscape. Cleaning has revealed again Aelbert Cuyp's mastery of light and form, and strengthened the attribution to him.

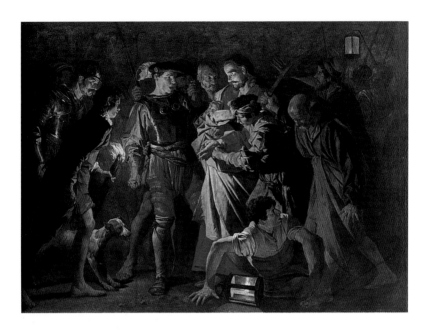

Matthias Stom

Amersfoort *c.*1600 – after 1650 Sicily(?)

The Arrest of Christ

*c.*1641
Oil on canvas, 201 × 279 cm
Sir George Donaldson gift, 1894
NGI 425

As the soldiers converge to arrest
Christ in the Garden of Gethsemane,
St Peter raises his sword to cut off
the ear of the High Priest's servant,
Malchus. Judas stands beside Christ
holding a bag of money. A burning
taper held by a servant intensely
illuminates the faces of the principal
figures, each presented as an indi-
vidual study. The leathery texture of
skin tones is a feature of this artist.
Painted some 40 years after
Caravaggio's version of the same
scene (see page 44), Stom's canvas
offers a more expansive view and
omits the fleeing figure. A prepara-
tory drawing shows that the composi-
tion was initially vertical and more
compressed.

Stom is amongst the third genera-
tion of Caravaggisti. He came from
near Utrecht, where he would logical-
ly have trained. By 1630 he was in
Rome and by 1641 he had moved to
Sicily, where he painted a number of
subjects related to this one.

GOVERT FLINCK

Kleve 1615–60
Amsterdam

Head of an Old Man

c.1642
Oil on panel,
64 × 47.4 cm
Purchased 1886
NGI 254

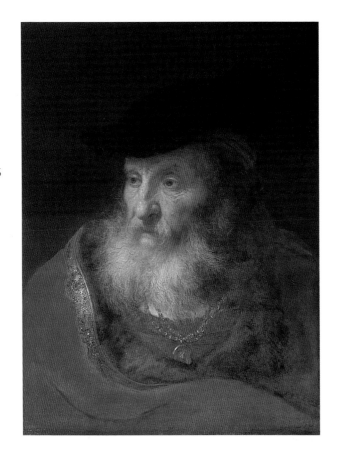

Like other such types by Rembrandt and his school, the subject was identified in the late nineteenth century as a Jewish rabbi. The title *Bust of a man with beret, cloak and necklace*, from an etching made of the painting in 1772, is closer to the truth, however. This is a study of a figure, whose venerable age, gilt-edged cloak and gold chain with medallion give visual interest. Warm colouring and a concentrated light source are features of this and other works by the artist.

Flinck completed his artist's training when he spent a year in Rembrandt's studio as an assistant around 1633. This experience left a lasting imprint. Flinck was able to sell some of his paintings as Rembrandt's own, and at the same time gained a reputation for Rembrandt-like portraits. By the 1640s, public taste was for a more elegant and naturalistic, Flemish style of portraiture and he gave up studies like this, which must be amongst the last of this type.

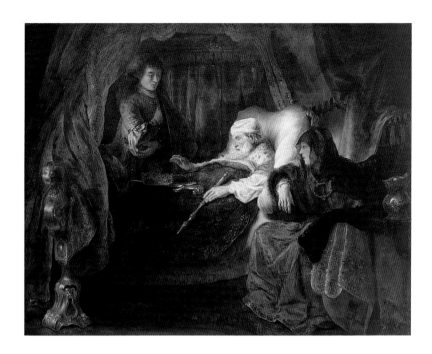

FERDINAND BOL
Dordrecht 1616–80 Amsterdam

David's Dying Charge to Solomon
1643
Oil on canvas, 171 × 230 cm
3rd Earl of St Germans gift, 1854
NGI 47

In accordance with the promise made to his mother, Bathsheba, who watches from the side, Solomon is named as King of Israel by his elderly father David. Both monarchs were renowned for their wisdom and seen as Old Testament prototypes for Christ, despite the illicit union that brought about Solomon's birth.

Bol had been a pupil of Rembrandt's from *c*.1634 to 1642, and both the detailing and the overall conception of this work derive from his master. The elaborate bed, one of whose gilt bedposts is visible, and the golden vessel on the table, have been identified as props in Rembrandt's studio, as also would have been the exotic clothes.

This substantial canvas may have been intended as proof of Bol's independent status. It was the first Dutch work acquired for the collection, having been deposited by the Lord Lieutenant with the Irish Institution, which had been established in 1853 to raise funds and donations of pictures for a future National Gallery.

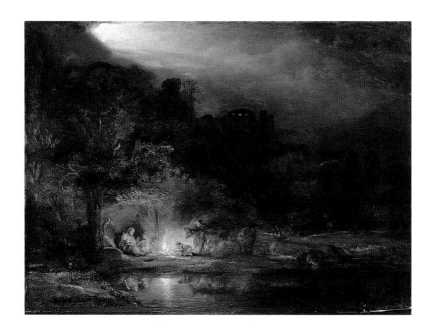

REMBRANDT

Leiden 1606–69 Amsterdam

Landscape with the Rest on the Flight into Egypt

1647
Oil on panel, 34 × 48 cm
Purchased 1883
NGI 215

After the birth of Christ, the Holy Family fled to Egypt to avoid the massacre of the newborn ordered by King Herod. The depiction of them resting at night is not described in the Bible, but became a popular subject from the fourteenth century onwards. In Rembrandt's only night landscape, the family is seated by a fire against a dense forest, partially illuminated by the fire and moonlight. The warm impasto of the flames and the reddish figures are perfectly balanced against the browns and greyish-black colours of the landscape.

Rembrandt was initially inspired by Adam Elsheimer's *Flight into Egypt*, engraved in 1614. Both works use a strong diagonal composition, but Rembrandt places the Holy Family at the centre, while the moonlight and candles in a distant castle increase the sense of mystery. The result is a work that is both poetic nocturne and narrative in equal parts – a fact that was recognized by J.M.W. Turner, who copied it at Stourhead, Wiltshire, and was the first in print to identify the subject.

SIMON KICK

Delft 1603–52
Amsterdam

An Artist Painting a Model

c.1648
Oil on panel,
92 × 69.5 cm
Purchased 1921
NGI 834

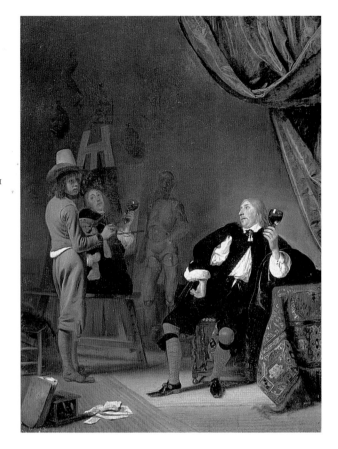

The artist depicted is too young for this to be a self-portrait. Somewhat formally, he wears a hat as he paints in a room of artist's props, including casts and a lifelike mannequin. It is rare to witness the actual creation of a genre subject, as here. The model leans back, in a pose used by Kick for various subjects, and holds up a *roemer* glass with languid abandon. (Interestingly, the same model recurs in two supposed group portraits of soldiers by Kick.) The Indo–Persian table carpet contrasts with the coarse matting on the floor. Life-size figures of drinkers, viewed at half length, were popularized in the 1620s by Utrecht artists such as Honthorst and Terbrugghen. Unlike this scene, however, they were usually shown in fancy costume.

Kick settled in Amsterdam and in 1631 married the sister of Willem Duyster, while his own sister married Duyster. His milieu took him from character studies in an early Rembrandt style to guardroom scenes and merry companies during the 1640s.

PIETER DE
HOOCH

Rotterdam
1629–84
Amsterdam

*Players at
Tric-trac*

*c.*1652–55
Oil on panel,
45 × 33.5 cm
Purchased 1892
NGI 322

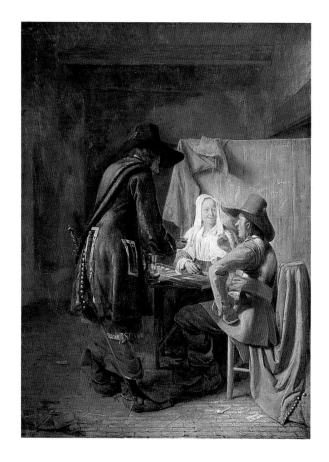

Two soldiers and a woman play tric-trac, or backgammon, a game then associated with idle time-wasters. There is a broken pipe and a card on the brick floor, and a flagon on the table. A wooden screen conceals part of a large fireplace. De Hooch was the son of a Rotterdam bricklayer and is said to have had some training under the landscapist Nicolaes Berchem before settling in Delft during the 1650s. His early paintings depict taverns and the military in a translucent tone of yellowish-brown, with stronger colour in the details.

The use of a vertical format for this picture may be derived from Gerard ter Borch. The soldiers are sensitively portrayed but do not have the surface finish of later figures. Although the background is unresolved, the painting does show the artist's interest in defining interior spaces and his close observation of domestic life, traits which were to blossom within a few years in his best-known, more luminous, works.

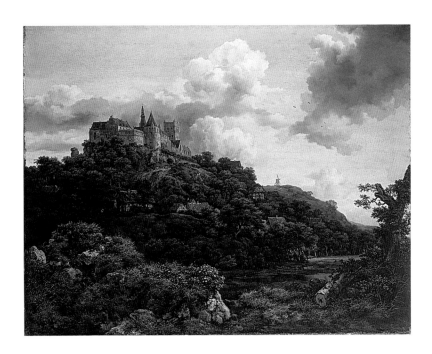

Jacob Isaacksz. van Ruisdael

Haarlem c.1628/29–82 Amsterdam

The Castle of Bentheim

1653
Oil on canvas, 110.5 × 144 cm
Sir Alfred and Lady Beit gift, 1987
(Beit Collection)
NGI 4531

The castle lies across the German border in Westphalia and was painted some 14 times by Ruisdael. He is thought to have travelled there around 1650 with his great friend Nicolaes Berchem, whose father was born nearby. Viewed from the south-west, the medieval fortress is more elevated than in reality and is set against a sweep of clouds that take up one-third of the canvas. Modern interpreters have suggested that it symbolizes the eternal city on Mount Zion, to which a few tiny figures progress through the forest, beyond sharp rocks covered by scrubby vegetation. The prominent felled and lacerated trees add a *vanitas* element.

In Ruisdael's landscapes humanity is always secondary to the power of nature, giving an added profundity. He had a precocious talent and may have been apprenticed to his uncle, Salomon. Painted when the artist was about 24 years old, this majestic landscape is acknowledged as one of his masterpieces.

JAN DAVIDSZ.
DE HEEM
Utrecht 1606–83
Antwerp

A Vanitas
Fruit-piece
1653
Oil on canvas,
85.5 × 65 cm
Purchased 1863
NGI 11

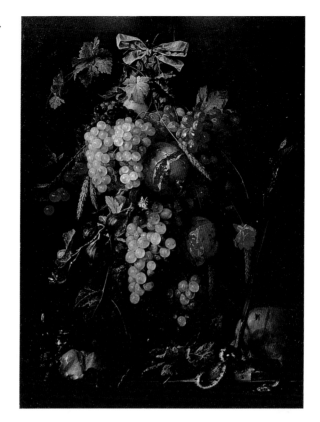

The outstanding rendition of ripe fruit, some on the point of bursting, has the secondary theme of man's short life and the possibility of Salvation through the Passion of Christ. Every item has a symbolic meaning. Man's life cycle – from the Fall of Grace (fig and snake), through childhood (relief of putti), to death (the skull) and Heaven (butterflies, cherries and blue ribbon) is entwined with the Church (pomegranate). The crucified Christ conquers death and the devil. The intercessionary communion wine derives from the grapes and corn above.

De Heem was initially a painter of sober *vanitas* groups in Leiden. It was after he moved to Antwerp in 1637 that he began to produce these elaborate garlands and hanging bouquets, in addition to banquet displays with rich tableware that carry no *memento mori* associations. In Antwerp he is said to have found it easier to acquire the variety of fruits needed for his paintings.

Willem Drost

Active Amsterdam 1652–80 Amsterdam

Bust of a Man Wearing a Large-brimmed Hat

*c.*1654
Oil on canvas, 64 × 55.7 cm
Purchased 1889
NGI 107

Another figure study from a member of the Rembrandt circle, the subject was wrongly described as a Jewish rabbi in early Gallery catalogues. His fur-lined cloak has similarities to one worn by Rembrandt in a self-portrait, as does the cap, here red with a pearl ornament. A chain with crucifixes enlivens the shirt. The modelling and lighting make it one of Drost's most accomplished works, with a great sense of presence and an individual interpretation of Rembrandt's style.

Exceptionally little is known of the artist's life. He is thought to have been with Rembrandt around 1650, and was in Italy by 1654 where he made an extended stay and worked on a commission with Johann Carl Loth in Venice. In 1663 he returned to Amsterdam. The discovery of his signature on this picture during cleaning in 1982 stimulated new attributions to the artist of a number of paintings from the early 1650s, which were formerly attributed to Rembrandt and unknown assistants.

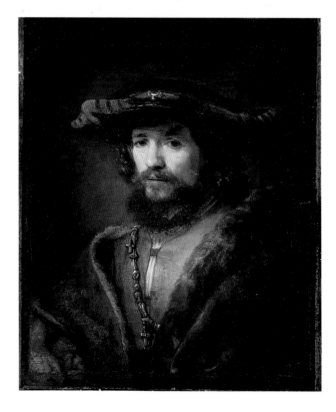

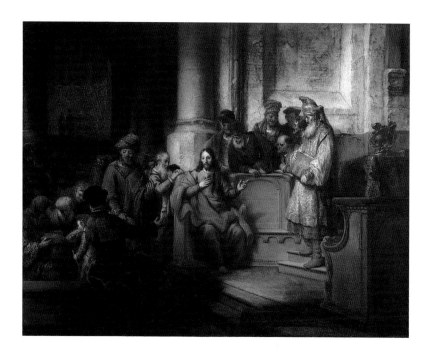

GERBRANDT VAN DEN EECKHOUT

Amsterdam 1621–74

Christ in the Synagogue at Nazareth

1658
Oil on canvas, 61 × 79 cm
Purchased 1885
NGI 253

On the Sabbath, Christ came to the synagogue and read from the book of Isaiah before announcing that the scripture was that day fulfilled. In this unusual subject, taken from the Gospel of St Luke, the prominent scribe in white, holding a folio volume, represents the server who handed him the text. The setting is a *sjoel*, or study room attached to a synagogue, separated by a typical seventeenth-century wooden partition with bench, on which Christ sits.

Van den Eeckhout had been a pupil of Rembrandt from 1635 to 1640/41 and became a versatile and successful artist. He was also a poet and a painting valuer. His conception is infused with borrowings from Rembrandt prints, but with his own characterization of the figures and a warm greyish colouring that marks it out as a major work. Although the signature and date were only found in 1981, the work has always been identified as by him.

Jan Baptist Weenix

Amsterdam 1621–60/61 Huis ter Mey, near Utrecht

The Sleeping Shepherdess

*c.*1658
Oil on canvas, 72.5 × 61.1 cm
Sir Henry Page Turner Barron bequest, 1901
NGI 511

A shepherdess asleep amongst the debris of a classical ruin is protected from the sun by her large hat, and from danger by a Dutch partridge gun dog (a type of spaniel). The soft fall of light across her face and the reflections on her clothes are delicately handled. Beyond two overgrown columns can be seen an open-air inn with figures by the seashore. In one of his most beautiful paintings, Weenix evokes the lethargic mood of Italy a decade after his return to Holland. By excluding any reference to work, he appears not to be commenting on the moral dangers of heavy sleep as pointed out by Dutch moralists of the time.

Weenix trained with various masters before spending the years 1642–47 in Rome, where he was in the service of Cardinal Pamphili. Settled in Utrecht, he painted genre and history subjects in Italianate settings, together with game pieces; as did his son Jan Weenix.

Nicolaes Berchem
Haarlem 1620–83 Amsterdam

An Italianate Landscape
1650s(?)
Oil on canvas, 61.4 × 65.3 cm
Sir Henry Page Turner Barron bequest, 1901
NGI 510

On the plain, lit by warm sun, a rock with a castle and ruined aqueduct evoke the landscape of Italy. They provide a carefully disposed backdrop to the cattle drovers who water their beasts in a stream. The crisp quality of the figures and animals, with their attractive colouring, reflect Berchem's specialization in this area. He provided them, on occasion, for at least seven other artists, including Ruisdael, Hobbema and J.B. Weenix. His ink and wash drawings were made into more than 50 etchings, most of which deal with animal subjects.

The son of the still-life painter Pieter Claesz., Berchem never travelled to Italy but absorbed the lessons of earlier Italianate landscapists. He was an adept painter of many landscape types and produced a wide variety of allegorical, religious and mythological subjects, perhaps over 800 in all. He was widely regarded in the eighteenth century as a result of the large number of engravings made from his paintings.

SALOMON VAN RUYSDAEL
Naarden *c.*1600–70 Haarlem

The Halt
1661
Oil on canvas, 99 × 153 cm
Sir Henry Page Turner Barron bequest,
1901
NGI 507

The arrival of travellers at an inn was one of the artist's favourite themes and more than 30 examples survive, the earliest dated 1635. This is the largest and deemed by many to be the finest. The season is summer. Well-dressed riders accompany three carriages, one of which displays the artist's monogram and date. A man is relieving himself against the wall, an indecorous detail later painted over and now restored to view. There are affinities with the late landscapes of Rubens in the way the curve of the land is echoed by the trees, and the inclusion of cattle by water.

This hilly landscape is in south Holland, a terrain that replaced the river bank as Ruysdael's principal subject. Ruysdael was the uncle of Jacob Ruisdael, deliberately spelling his name differently, and was based in Haarlem from where he travelled widely. This picture belonged to an Irish diplomat and collector out of whose estate the Gallery's Director, Sir Walter Armstrong, chose 10 paintings, nearly all Dutch.

FRANS POST
Haarlem, *c.*1612–80

A Brazilian Landscape
1660/65
Oil on panel, 48.3 × 62.2 cm
Robert Langton Douglas gift, 1923
NGI 847

Brazil was at this time a Dutch colony, its high rainfall suitable for growing sugar cane. Here several sugar plantations are viewed along a river, and the workings of one are shown in detail. On the right is a furnace house where a number of slaves fuel the wood-fired boilers. Others put out the cane on the drying platform in front of an unidentified building. The foreground includes a papaya tree next to macaúba and coco palms, and an alligator, armadillos, anteaters and a monkey.

Post was the younger brother of the painter and architect Pieter Post, and accompanied the expedition of Prince Jan Maurits to Brazil in 1637–44. His entire output is devoted to views of the country, both real and imaginary. Portrayed in a precise manner, without tonal perspective, they possess an immediacy and a naïve quality. In this he was influenced by his brother's work and that of Cornelis Vroom, combined with his own response to the intense light and colours he experienced.

ANTHONIE DE LORME

Tournai c.1610–73 Rotterdam

Interior of the St Laurenskerk, Rotterdam

c.1660–65
Oil on canvas, 87.1 × 73.5cm
Purchased 1903
NGI 558

The St Laurenskerk is a late Gothic church (built 1409–1525), of which only the walls were left standing after bombing in 1940. Restoration was completed in 1968, but most of the contents were lost. This view along the south ambulatory, with the choir to the left, shows several painted monuments, numerous tombs, and a glimpse of armorial glass.

De Lorme was in Rotterdam by 1627 but painted imaginary church interiors until about 1652, when he turned to real buildings, principally St Laurenskerk. This development must relate to the wave of Delft artists painting actual church and domestic interiors from this date.

The clarity and precise architectural detail show the impact of Pieter Saenredam, the well-known Harlaam painter of church interiors. De Lorme's response is less austere, however, as can be seen in the fall of light from the chapel windows and the animated, detailed figures. These may illustrate contemporary advice to visit tombs and ponder one's own mortality.

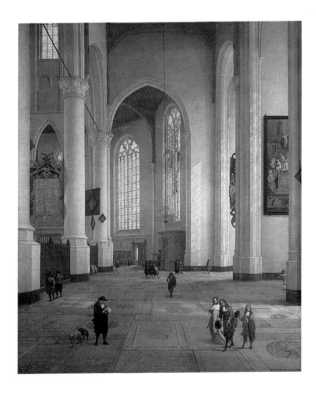

JAN MYTENS
The Hague *c*.1614–70

A Family Group
1661
Oil on canvas, 135.5 × 169.5 cm
Purchased 1873
NGI 62

Mytens was the leading portraitist
of his day in the capital city of The
Hague. On the evidence of other
sitters, this is probably either the
family of a noble, a government
official, or a newly rich burgher. It is
one of his most colourful and engag-
ing groups. The separation of the old
man, in a *robe-de-chambre*, and the
young boy, in semi-classical dress,
implies they are deceased. The other
family members are wearing fashion-
able dress, the boy's being the more
fanciful. Their dog may symbolize
fidelity, and the bunch of grapes, held
by the stem, chaste love in marriage;
however, they also serve to link an
awkward group and add interest, as
do the peaches and the corner group
of poppies and geranium leaves.

Mytens belonged to a family of
artists. He received an international
polish and knowledge of van Dyck
and Rubens from his uncle, Daniel
Mytens the Elder. He later taught
Daniel Mytens the Younger.

*Man Writing
a Letter*

c.1663
Oil on panel,
52.5 × 40.2 cm
Sir Alfred and
Lady Beit gift,
1987 (Beit
Collection)
NGI 4536

This painting and its pendant (NGI 4537) respectively show a man writing a letter and a woman reading it. Metsu presents the contrasting male and female surroundings of the Amsterdam middle classes, their objects revealing that this is a love letter. He is a 'man about town', in a satin suit and lace shirt with large cuffs. The silver inkstand indicates wealth, and the globe his worldly pursuits. Metsu's pastiche of an Italianate pastoral landscape on the wall is a further pointer. There is a dove on its gilt auricular frame, while the tree within it is a warning of transience and against excess. Even the bright light from the open window and the rumpled Turkish table carpet on which the man writes suggest a heated mind.

The theme of letter writing became increasingly popular in Dutch art during the 1650s. Metsu's paintings are two of the most accomplished examples, and are his most refined achievement.

GABRIEL METSU

Leiden 1629–67 Amsterdam

Woman Reading a Letter

c.1663
Oil on panel, 50.2 × 40.2 cm
Sir Alfred and Lady Beit gift, 1987 (Beit
Collection)
NGI 4537

A woman sits on a wooden *zoldertye*
platform in a marble-floored hall and
reads the letter that we see being
written in the pendant painting
(NGI 4536). The favourite curl on her
plucked forehead shows that she is
engaged. One senses disorder in a
calm domestic world. She has
stopped sewing and dropped her
thimble. The cast-off shoe has erotic
connotations, while the mirror in a
sober ebony frame is a warning of
vanity and against lasciviousness.
The excited spaniel, normally a
symbol of domestic fidelity, has
become a reminder of the lover.
A curious servant, who has another
letter to deliver on her way to market,
holds a bucket decorated by Cupid's
arrows and draws back the protective
curtain over a stormy seascape. This
was a frequent metaphor for the trials
of love and the hazards of separating
and meeting.

Metsu trained with Gerrit Dou,
but his brushwork is always freer
and his sources more numerous,
with a memorable feel for textures
and colours.

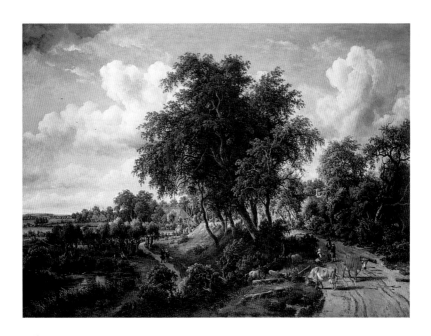

MEINDERT HOBBEMA
Amsterdam 1638–1709

*A Wooded Landscape –
The Path on the Dyke*
1663
Oil on canvas, 105.5 × 128 cm
Sir Alfred and Lady Beit gift, 1987 (Beit Collection)
NGI 4533

The main path leads behind trees, where sunlight picks out some cottages. A lower path, alongside a pond, offers an alternative viewpoint of trees, figures and buildings on the horizon that is typical of the artist. The figures and cattle have been attributed to Adriaen van de Velde. With simple elements, which come from no particular place, and a mastery of delineating foliage and effects of sunlight and shadow, Hobbema created a type of picturesque landscape that was to have a major influence and made him the most highly regarded Dutch landscapist for three centuries. The Beit Collection painting has maintained this reputation and is judged to be his masterpiece.

Hobbema was a pupil of Ruisdael from the late 1650s, and only a year before this work was painting similar themes with the slightly melancholy approach of his master. In 1668 he became a wine-gauger in Amsterdam and gave up painting almost entirely.

JAN STEEN
Leiden 1625/26–79

The Village School

c.1665
Oil on canvas, 110.5 × 80.2 cm
Purchased 1879
NGI 226

The boy is about to be punished with a ferrule for scribbling on his exercise, much to the delight of the girl and the apprehension of another boy waiting in line. This was an acceptable punishment at the time, if not administered in anger. Amongst the objects on the wall is a shelf of books and candle-boxes for bringing possessions to school, with an hourglass as warning against time-wasting. The bottles in a niche suggest a critique of schoolmasters, too. Badly paid, working long hours, and frequently dissolute, they had a low reputation.

Steen used his own children, Cornelis, Catherina, and Johannes, as models for the three principal children. Using a harmonious palette of greens and greys he demonstrates his skill at narrative, seen here on a large scale. Humour and a moral message are integral to Steen's work, and still enjoyed today.

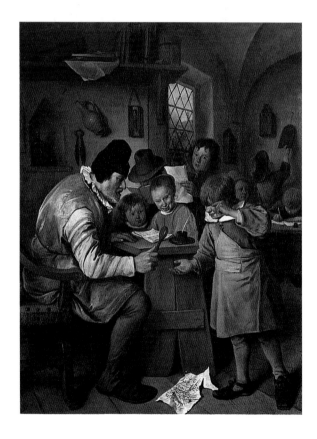

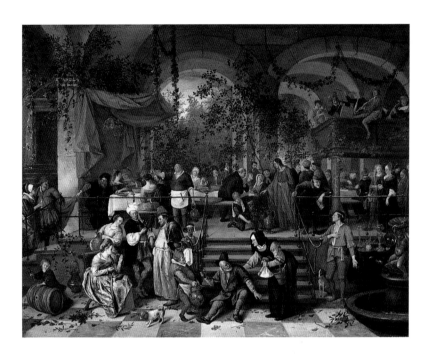

JAN STEEN
Leiden 1625/26–79

The Marriage Feast at Cana
1665–70
Oil on panel, 63.5 × 82.5 cm
Sir Alfred and Lady Beit gift, 1987 (Beit
Collection)
NGI 4534

The miracle of Christ turning water
into wine at the marriage feast, told
only in St John's Gospel, is here
submerged within a lively inn scene.
Steen includes a wealth of detail,
such as a drunkard encouraged to
return home by his long-suffering
wife, and the ornately dressed guests
and servants below the stairs. The
overall composition wittily derives
from Raphael's monumental *School*

of Athens fresco in the Vatican. The
young man in orange, who gestures
towards the fountain, or water of life,
and looks towards Christ, underlies
the true meaning of the miracle and
reminds us that wine should be
enjoyed in measure. The innkeeper
can be taken as an idealized self-
portrait, given Steen's ownership of
both an inn and a brewery during a
peripatetic life that took him to three
masters while he was training, and to
various cities to live.

The quality and finish of Steen's
pictures varies greatly. Some of his
best date from the period 1661–70,
when he lived near Haarlem.

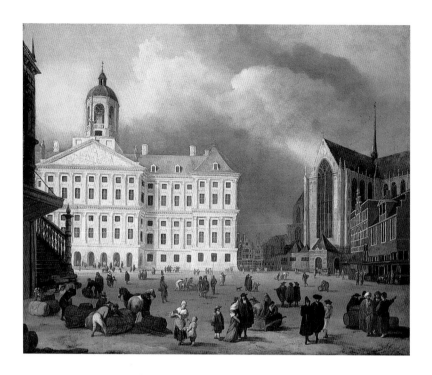

JAN VAN KESSEL
Amsterdam 1641/42–80

The Dam at Amsterdam
1669
Oil on canvas, 68 × 83.1 cm
Purchased 1939
NGI 933

The square depicted here has been the heart of Amsterdam since the first dam was laid across the Amstel about 1270. Flanked by the former weighhouse and the Nieuwe Kerk (begun in 1490 and still used to solemize royal investitures), the square is here dominated by the recently completed Town Hall (1648–*c*.1665) designed by Jacob van Campen. The building's small central entrance was designed to prevent a mob attack. On the pediment above is an allegory of Amsterdam being paid tribute by the sea, and statues of Prudence, Peace and Justice, all of which are schematically recorded. The building was later a royal palace for a time. The adjacent houses and shops seen here are long gone. Van Kessel depicts figures drawn from a wide range of social backgrounds and nationalities. The inclusion of sleighs used to move goods relates to city ordinances restricting carts and wagons.

A friend of Hobbema, van Kessel may have been a pupil of Ruisdael. He specialized in city and panoramic views.

GODFRIED SCHALCKEN

Made 1634–1706
The Hague

Preciosa Recognized

Late 1660s
Oil on panel,
44.2 × 31.2 cm
Purchased 1898
NGI 476

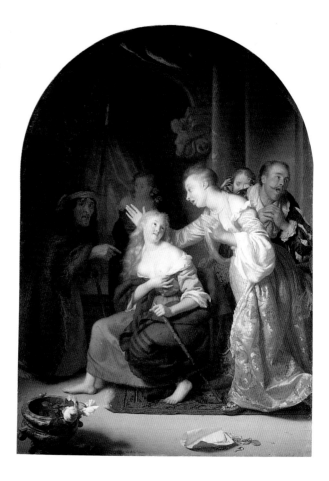

The true identity of Preciosa is revealed as she displays to her astounded parents a moon-shape birthmark on her left breast. She had been abducted as a child by the old gypsy woman, Majombe, who now confesses to save Preciosa's lover, Don Juan, from trial by her father, a magistrate. Her jewellery and notice of disappearance lie on the floor, the unblemished rose in a marble bowl being a metaphor for her innocence. The incident comes from Cervantes' short story *The Little Gypsy*, which was translated into Dutch and performed as a play. The picture is highly theatrical in terms of the facial reactions and the costumes, which range from plain drapes to satin, brocade and silk.

Schalcken paints with an exquisite touch and a porcelain smooth surface. He learnt his minute *fijnschilder* technique from Samuel van Hoogstraten and Gerrit Dou. Later in his career he gained fame and wealth from candlelit scenes and portraiture.

JOHANNES
VERMEER
Delft 1632–75

*Woman
writing a letter,
with her Maid*

c.1670
Oil on canvas,
71.1 × 60.5 cm
Sir Alfred and
Lady Beit gift, 1987
(Beit Collection)
NGI 4535

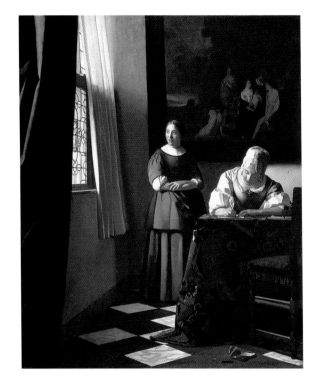

The earliest description of this painting, when it was left as security with the baker in 1676, is simply of two personages, one writing a letter. The lady appears to have thrown down a letter that she has received, as well as her letter-writing manual, which was something much used for personal correspondence. With such unexceptional content Vermeer has fashioned one of his most sublime works, whose qualities words can only inadequately express. Light filters through the window, giving a statuesque calm to the centrally placed maid and transforming the lady's dress into a blur that echoes her inner turmoil. Behind her hangs a painting of *The Finding of Moses*, a reminder to trust in Divine Will to resolve events and bring to-gether opposing factions. Muted colour contributes to the sense of a distilled moment.

Vermeer moved from Caravag-gesque subjects to interior scenes of Delft that give a concentrated image of everyday surroundings. This is one of only 35 accepted works by the artist.

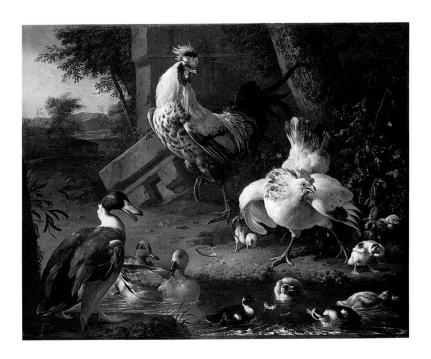

MELCHIOR DE HONDECOETER
Utrecht 1636–95 Amsterdam

Poultry

Date unknown
Oil on canvas, 101.5 × 130 cm
Sir Henry Page Turner Barron bequest,
1901
NGI 509

A domestic drake, drake teal, drake wigeon, and ducklings disport themselves in and around a pond; above are a domestic cock, hen, chicks and a duckling. The setting enhances the sense of realism, as do the birds' lively movements. A fragment of stone cornice and a glimpse of landscape add a decorative element, and help to make the painting more than simply a natural history study.

Hondecoeter had a good artistic grounding. His grandfather, based in Utrecht, was one of the first Dutch landscapists and his father painted landscapes and bird paintings. He trained with his uncle, J.B. Weenix. He worked in The Hague from 1649 to 1662, and then spent the rest of his life in Amsterdam. His style varied little over a long career, and he was much copied. His high posthumous reputation is demonstrated by the fact that François Boucher made drawings of the cock and hen from this work and used them in a number of his own pictures.

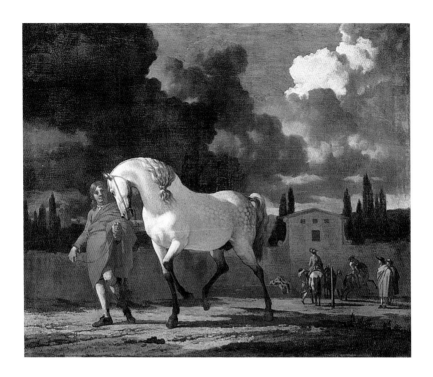

KAREL DUJARDIN
Amsterdam(?) c.1622–78 Venice

The Riding School
1678
Oil on canvas, 60.2 × 73.5 cm
Purchased 1903
NGI 544

A youth leads an Arabian stallion by the bridle. Since the picture's auction in 1895, the scene has been identified as an Italian riding school. The building with scroll volutes and cypresses beyond the walled enclosure support this. Dujardin's unusual composition and the dramatically lit red cloak and horse's head, set against low, brooding, clouds, makes this one of his most compelling later works. It is the last dated picture by the artist.

Dujardin is said to have studied with the landscape artist Nicolaes Berchem, and was certainly influenced by him. He may have visited Rome around 1650 before working mainly in Amsterdam.

His work encompasses Italianate landscapes, scenes with animals, portraits, religious works, and history paintings; he also executed about 50 engravings. He was in Italy from 1675 until his death. During this time his brilliant colouring and rich textures were replaced by more abrupt contrasts of light and forms, with heavier application of brushwork as on this heavy-weave canvas.

Jan Wijnants

Haarlem(?) 1631/32 –84 Amsterdam

A Wooded Landscape with a River

c.1679
Oil on canvas, 94 × 116 cm
Sir Henry Page Turner Barron bequest,
1901
NGI 508

Dominated by a gnarled oak tree above sharply lit fauna, this large imaginary landscape shows figures on a sandy road against a curving river and distant church. It reflects the change in Wijnants's style during the 1670s when there was a renewed taste for Italianate landscapes with broad panoramas and generalized details. The sunlit staffage would not be out of place in the *campagna*: a woman on a packhorse and a man talk to a woman with a water vessel on her back, while a boy plays with a dog and a man fishes.

Wijnants was a Haarlem painter and an unsuccessful innkeeper who was persistently in debt. Ruisdael and Philips Wouvermans had a lasting influence on him. Alongside decorative compositions such as this he painted many pictures of dunes and silver birches around Haarlem. The figures in his paintings were generally executed by Johannes Lingelbach.

DOMENICUS VAN WIJNEN
Amsterdam 1661–*c.*1700(?)

The Temptation of St Anthony
1680s
Oil on canvas, 72 × 72 cm
Arthur Kay gift, 1901
NGI 527

St Anthony (*c.*251–356), the hermit saint who withdrew to the Egyptian desert, is here assailed by the Seven Deadly Sins. He lies beside a book, a candle, and a skull, and recites his rosary, looking steadfastly at a crucifix as Lust appears and illuminates her breasts. Behind Lust are Avarice (chained with moneybags), Envy (a crone with snake hair), Pride (a naked woman raised up), Gluttony (drinkers), Sloth (the pig), and Anger (men fighting). Light bursting from a bubble causes the damned to fall, and will St Anthony's persecutors.

This fantasy is in the tradition of Hieronymus Bosch. He was a member of the 'Schildersbent' club of Dutch artists in Rome, between 1680 and 1690. Wan Wijnen was a pupil of Willem Doudyns, a minor history painter, in The Hague. There are few identified paintings by him.

Jan Weenix

Amsterdam 1642–1719

Game-piece: The Garden of a Château

1690s
Oil on canvas, 122 × 106 cm
Sir William Hutcheson Poë gift, 1931
NGI 947

A domestic cock and a brace of pigeons flank a brown hare with its leg pinioned on a branch above tulips and daisies. After experiencing the initial impact of these objects the eye is drawn to the accompanying fruit. The shrivelled marrow, the part-eaten pomegranate and plum, the peach with a fly crawling over it and the deteriorating grapes together give this painting a *memento mori* aspect. Game-pieces such as this, set before a park with statuary and a distant château at sunset, were a frequent device used by the artist and offered an idealized image to his patrons. Although hunting was restricted to the nobility and certain officers of state, such pictures were often acquired by the bourgeoisie for their houses. It the eighteenth century this picture was paired with *A Goose Attacked by a Spaniel*, now missing.

The artist was the son and pupil of Jan Baptist Weenix. Besides Italianate subjects his oeuvre comprises images of the hunt, portraits and genre paintings.

DIRCK VALKENBURG

Amsterdam
1675–1721

Birds with Urn in a Landscape

*c.*1700
Oil on canvas,
132 × 99 cm
W.S. Gubleton
bequest, 1911
NGI 625

Two domestic hens and a cock stand above a hill myna, a kingfisher, a drake wigeon, and a domestic drake. Perched on the urn is probably an exotic Alexandrine Parakeet. Valkenburg was the last major Dutch painter of animal and bird subjects, of which this is a large and colourful example. The work is elegantly signed on the urn below a relief of putti.

Valkenburg was trained by Jan Weenix and borrows the format of that painter here with the inclusion of a château in the distance. The realistic presentation of the birds comes from Weenix's cousin, Melchior de Hondecoeter. Some rare murals by that artist, where the park plays an equal role to that of the poultry and wildfowl, can be seen at Belton, Northamptonshire. Valkenburg bridges the two areas of the canvas with a statue of Ceres, directing the viewer's eye to a park with figures and a classical house under a suffuse sky. The rich palette and air of a graceful parade belong to the eighteenth century, when Valkenburg created some of his most elaborate compositions.

LUDOLF BAKHUIZEN

Emden 1631–1708 Amsterdam

The Arrival of the Kattendijk at the Texel, 22 July 1702

1702
Oil on canvas, 133 × 111 cm
Purchased 1883
NGI 173

The *Kattendijk* was a 759-tonne ship of the Dutch East India Fleet, built at Zeeland in 1694 and here identified by name on the stern of the largest ship. On 28 November 1701 she left Batavia with 90 sailors and 25 soldiers. After rounding the Cape of Good Hope in February 1702, she returned in a fleet of 19 ships, including the *Sion*, seen to the left. The vessels are depicted on the Marsdiep, a silt-free channel between the Dutch mainland and the island of Texel, formed from reclaimed land. For all the choppy water, the ships dominate the sea and constitute a display of Dutch naval strength. This work was painted not long after the event took place.

Bakhuizen had begun drawing ships while working as a merchant's clerk. Strongly influenced by the van de Velde family, he succeeded them as the leading Dutch maritime painter, in 1672 after their departure to London.

CORNELIS TROOST

Amsterdam 1696–1750

Jeronimus Tonneman and his son Jeronimus ('The Dilettanti')

1736
Oil on panel, 68 × 58 cm
Purchased 1909
NGI 497

Jeronimus Tonneman was an important patron of the artist and is portrayed here as a man of culture. He is accompanied by his son, who plays the flute. On the table is van Mander's history of Dutch artists, *Het Schilder-boeck*. The imaginary room would befit a townhouse on the Herengracht in Amsterdam. Troost owned the copy of François Duquesnoy's statue of St Susanna that can be seen in the niche. The stucco relief of *Time revealing truth and banishing slander*, however, is clearly included for a moral purpose, as is the partly-seen roundel over the mantelpiece depicting *Mercury killing Argus* (after he lulled him to sleep with pipes), a story linked by van Mander to the seeking of wealth and empty fame. Ironically, young Jeronimus was to stab his mistress and flee Holland a year after this picture was painted.

Troost trained with the portraitist Arnold Boonen. As well as being a narrative painter, portraitist and skilled pastellist he was also an actor. This is one of his most accomplished works.

Jacob Xavery

The Hague 1736 –
after 1779(?)

A Garland of Flowers hanging from a Bough

*c.*1760
Oil on canvas,
68.5 × 56.4 cm
Purchased 1864
NGI 50

There are no fewer than 24 flowers in this still-life, which must have been painted over a period of several months. The scarlet peony, the pink and yellow roses, the red Maltese Cross and the two varieties of tulip stand out against a ledge and an ill-defined space. The composition is unusual: the garland, suspended from the bough of an oak tree, seems initially to be upside down. The piece carries no moral lesson and is simply to be enjoyed for the floral palette and textures.

The painting was originally purchased as a work by Jan van Huysum, but the grouping and presentation of the flowers and the use of dense brushwork show marked differences with that artist's work. It has subsequently been attributed to Jacob Xavery, who trained partly with van Huysum. A number of works by Xavery have false van Huysum signatures. Xavery worked in Amsterdam until 1769, when he moved to Paris. As well as floral still lifes he also painted portraits and landscapes.

BRITISH AND AMERICAN PAINTING AND SCULPTURE

John Smibert

Edinburgh 1688–1751 Boston

The Bermuda Group

1729–30
Oil on canvas, 61 × 70 cm
Purchased 1897
NGI 465

The philosopher George Berkeley (1685–1753) was appointed Dean of Derry in 1724, and the following year published a proposal to establish a college on the island of Bermuda. He left Ireland with his wife and spent the years 1728–31 at Newport, Rhode Island, awaiting government funding, before returning. This small group portrait shows Berkeley (right); Smibert (left); Anne Berkeley with

their newly born son, Henry; her companion, Miss Handcock; and John Wainwright, a patron of the Dean, all seated at a table covered with a costly Turkish carpet of a medallion and split-leaf border pattern. The standing men are Richard Dalton and John James, who were also part of this circle.

Smibert was born in Scotland but spent most of his career in North America. Berkeley had offered him the post of Professor of Architecture at his proposed college, a fact perhaps alluded to by his scroll. He settled in Boston in 1729 and quickly became the city's leading portraitist. There is a larger version of this picture at Yale University, which was previously exhibited in his studio.

WILLIAM HOGARTH
London 1697–1764

The Western Family
c.1738
Oil on canvas, 72 × 84 cm
Sir Hugh Lane bequest, 1918
NGI 792

On his return from hunting, Thomas Western (1714–66), Squire of Rivenhall in Essex, is shown joining his family for tea while a servant in the background puts away his gun. While his daughter is entranced, Western touches the hand of his wife, Anne Callis (d.1776), and offers the dead game to his mother, Mary. She is seeking the attention of a visiting clergyman, who is being addressed by a richly liveried servant carrying a letter.

At this date tea drinking was still an expensive activity, as is reflected in the porcelain tea service laid on a silvered side table. Wealthy aspirations continue in the harpsichord, the painted screen, the gilt mirror, and the overdoor of game in the style of Jan Fyt. Hogarth began painting these popular but time-consuming conversation-piece groups in 1728. Within three years, however, he was refusing clients as he turned increasingly to satirical depictions of modern life such as The Rake's Progress, for which he is best known today.

Hogarth's painting is superbly handled and can be dated close to The Strode Family (Tate Britain, London).

WILLIAM
HOGARTH
London 1697–1764

*The Mackinen
Children*

1747
Oil on canvas,
180 × 143 cm
Sir Hugh Lane
bequest, 1918
NGI 791

Elizabeth (1730–80) and William
Mackinen (1733–1809) were the chil-
dren of a Scottish sugar plantation
owner living on Antigua in the West
Indies. Elizabeth later married a
doctor and died on Antigua, while
her brother served on the Island
Council until 1798, when he settled
in Berkshire with his wife. When
Hogarth painted this portrait they
were probably in England to com-
plete their education.

During the 1740s, in an attempt to
be taken seriously as an artist,
Hogarth carried out a series of large-
scale portraits. For this picture he is
likely to have completed only the
heads from life, before adding the

ancillary detail after his sitters had
left London. The ensemble forms
an elegiac tribute to the ending of
childhood. Dressed like adults, the
children are absorbed by the butterfly
on the sunflower rather than the
shells and book: the transient is thus
set against the permanent. The
sunflower is also a reminder of the
enclosed world of Eden. The imagi-
nary setting on a terrace, and the
elegant poses (even of the protective
spaniel), combine to give a French air
to the picture, whose delicate colour-
ing has been affected by bleaching in
tropical sunlight.

THOMAS GAINSBOROUGH
Sudbury 1727–88 London

A view in Suffolk

c.1746
Oil on canvas, 47 × 61 cm
Purchased 1883
NGI 191

The curving track, chalk pits, pool, and windswept trees under a great expanse of sky powerfully evoke Gainsborough's native Suffolk, on the exposed east coast of England. These features are equally found in the Dutch seventeenth-century masters whom Gainsborough was studying as a young artist, and whose vision he shared. Like other undated works of this period, the view is partly imaginary. A horse, a barking dog, and a distant church tower are some of the tiny detals.

When he painted this work, Gainsborough was in London training under the illustrator Hubert Gravelot and the painter Francis Hayman at the St Martin Lane's Academy. At the same time he was engaged in restoring and copying the works of Wijnants, Ruisdael, Berchem, Hobbema, and others.

The painting is composed of a series of patterns. Gainsborough takes the eye through a sweep of foreground detail, echoed in the cascade of clouds. The silvery-grey colouring over a light ground has echoes of Wijnants, who would also often include in his compositions a jutting tree or man with a pole. The rendering of space, the clarity of light, and the clearly delineated foliage are all Gainsborough's own, however.

THOMAS GAINSBOROUGH

Sudbury 1727–88
London

Mrs Christopher Horton (1743–1808), later Duchess of Cumberland

1766
Oil on canvas,
75 × 62 cm
Sir Hugh Lane bequest,
1918
NGI 795

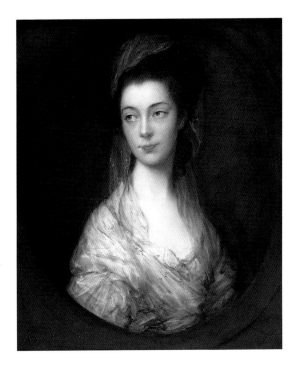

The elder daughter of Simon Luttrell of Luttrellstown, Co. Dublin, Anne Luttrell married Mr Horton of Catton Hall, Derbyshire, in 1765. Her portrait was painted a year later. The artist creates a radiant image, lending her turned head an air of nobility and placing the figure in a painted oval frame. There is ample testimony to her seductive charm in the delicate brushwork and the series of graceful curves on her face. The near diaphanous treatment of her veil and dress, with streaks of colour, adds a shimmering quality.

The sitter was memorably described in a letter by Horace Walpole as 'extremely pretty, very well made, with the most amorous eyes in the world, and eyelashes a yard long'. In 1771 she caused a royal storm with her marriage to Henry Frederick, Duke of Cumberland, George III's brother. He only informed his family of the union when the couple were *en route* to Calais, and this led to the Royal Marriage Act, which prevented royal marriages not approved by the sovereign.

Both Joshua Reynolds and Joseph Wright of Derby also painted the Countess; they reportedly found her a difficult sitter, but Gainsborough has left us a series of glamorous portraits.

THOMAS GAINSBOROUGH

Sudbury 1727–88
London

The Cottage Girl

1785
Oil on canvas,
174 × 124.5 cm
Sir Alfred and Lady
Beit gift, 1987 (Beit
Collection)
NGI 4529

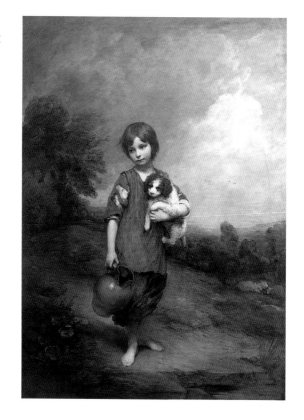

The ragged child standing forlornly by a stream with a broken pitcher is one of Gainsborough's most celebrated 'fancy pictures'. His landscapes, even for portrait backdrops, had long been idealized rural idylls conjured from the imagination and, during the 1780s, he painted a group of country subjects with touching sentiment. These were the artist's own genuine response to the activities and predicaments of children in a natural setting, and they struck a deep chord at the time. Unlike some of his contemporaries, Gainsborough makes no moral point in these pictures. A fashion for the picturesque, the poetry of Wordsworth and scenes of beggars by Murillo were all contributory factors.

A sense of Arcadia is accentuated by the indefinite location. The motif of holding a dog had earlier been used in Gainsborough's portraiture to engage the viewer. Cleaning has brought back the subtleties of the greens and purple in the landscape. The model here is actually thought to be a boy, Jack Hill, encountered by the artist while walking near Rich-mond Hill, although from the earliest references the subject is called a girl.

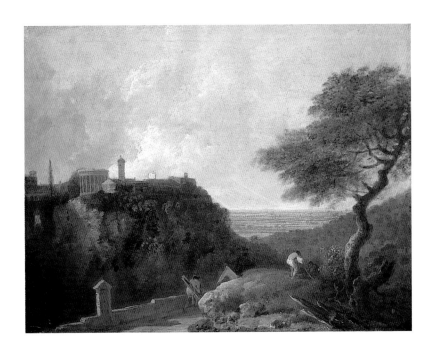

RICHARD WILSON
Penegoes 1713(?)–83 near Mold

The Temple of the Sibyl, Tivoli
1752
Oil on canvas, 50 × 66 cm
Milltown gift, 1902
NGI 747

A visit to Tivoli, north-east of Rome, was deemed essential for Grand Tourists in search of antiquities and for artists seeking dramatic views. One of the most recorded sites was the ruined temple dramatically placed on an outcrop near the town, then identified as that of the Sibyl. Built in the first century BC, 18 fluted Corinthian columns survive around a circular cella. It was converted into a church in the Middle Ages.

Wilson had only taken up landscape painting on his arrival at Rome in 1752, and he painted this and a pendant view of Tivoli that same year for Joseph Henry of Straffan, Co. Kildare. The scene is illuminated with sunlight, and the peasant figures on a knoll enhance the sense of idyll. He teasingly includes two men carrying away an easel and canvas.

While the freedom of painting in certain areas has suggested that he was working partly out of doors, the balanced composition is typical of eighteenth-century studio practice. Wilson was to repeat this subject on a number of occasions.

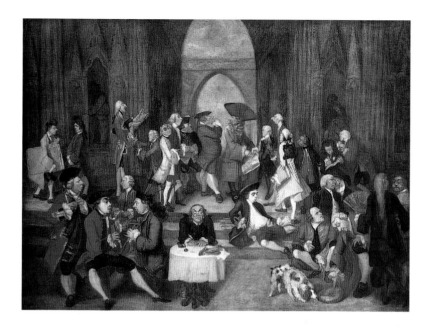

Joshua Reynolds
Plympton 1723–92 London

Parody of Raphael's 'School of Athens'

1751
Oil on canvas, 97 × 135 cm
Milltown gift, 1902
NGI 734

As a diversion from his study of Italian painting, Reynolds made a series of caricatures of Irish and British Grand Tourists visiting Rome in 1751, of which this is the largest and most elaborate. Its composition derives from Raphael's famous fresco in the Vatican Stanze, with the overall tone being set by the 'barbarous' Gothic architecture in place of a classical setting.

Discussion continues about who is portrayed: there is no key, and Reynolds is known to have included four imaginary figures. He shows an adeptness for exaggerating facial details and bandy legs, and observing details such as the oversize cuffs, wig-box and red-tipped shoes in the formal dress of the 'ideal' man on the steps. Joseph Henry, who commissioned the painting, was a scholar; he can be seen reclining on the steps in the guise of the cynic Diogenes. His uncle, the rich Joseph Leeson – the future Earl of Milltown – holds up an eyeglass at the centre, in the role of Plato, and looks across to his spindly son. The future Earl of Charlemont on recorder, and his three companions, demonstrate musical harmonics, in contrast to the pupils of Euclid trying to measure a pie.

JOSHUA
REYNOLDS

Plympton 1723–92
London

Charles Coote, 1st Earl of Bellamont (1738–1800), in robes of the Order of the Bath

1773–74
Oil on canvas,
245 × 162 cm
Purchased 1875
NGI 216

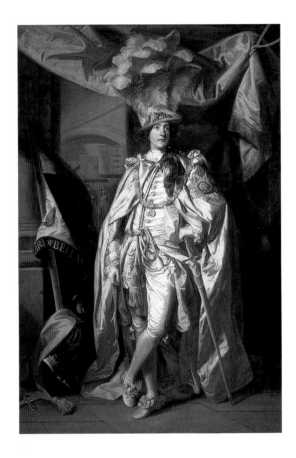

The Earl of Bellamont was a vain, pompous womanizer, who deserted his wife (a daughter of the Duke and Duchess of Leinster), and in his will acknowledged six illegitimate children by four different mothers. He was installed as a Knight of the Bath in 1764 after quelling a minor uprising, and created an Earl three years later. He married in 1774, and that same year Reynolds completed this flamboyant portrayal of him.

The Earl rests nonchalantly on his sword, dressed in ceremonial satin and lace and showing off his shoes with rosettes. No other Knight was ever immortalized in such a relaxed pose, or actually wearing the Order's oversize hat with ostrich feathers. Whereas the face is strongly painted with vermilion red, the fugitive carmine used for the robes has now turned to pink. The cross-legged pose from the Antique is a typical eighteenth-century formula and, allied to the loose costume, far-off gaze, undressed hair, and falling curtain, evokes the era of van Dyck. A family reminder is the coot on his banner and one standing below it.

JOSHUA
REYNOLDS

Plympton 1723–92
London

The Temple Family

1780–82
Oil on canvas,
241 × 183 cm
Milltown gift,
1902
NGI 733

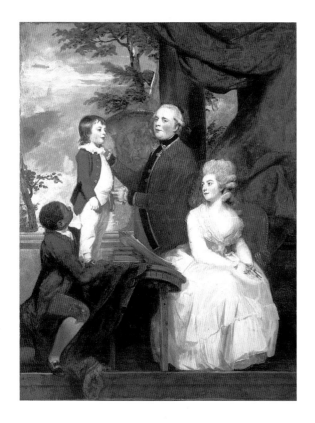

In an elaborate group, probably for the family portrait room at Stowe House in Buckinghamshire, Reynolds depicts George Grenville, Earl Temple (1753–1813) with his wife Mary (active 1775–1813), their son Richard, Lord Cobham (1776–1839), and an unnamed black servant. The Countess was the eldest daughter and heir of Earl Nugent; she was an amateur painter and supposedly a pupil of Reynolds. She looks up from her sketch of Richard on the table to check it against the original. Her husband twice served as Lord Lieutenant of Ireland, where he found himself pitted against Henry Grattan in the Irish parliament, and

was created 1st Marquess of Buckingham in 1788.

The inclusion of the Borghese Vase behind the family group is a reminder of the Italianate gardens at Stowe, while the boy is a skilful reworking of a young Christ Child presented to a supplicant donor, the type of borrowing found in Reynolds's noblest portraits. As with other paintings by Reynolds the surface has been affected by the artist's paint experiments, but the brilliant colouring re-emerged after the last cleaning. The picture left Stowe around 1849, being acquired by the Countess of Milltown only two years before the Milltown gift.

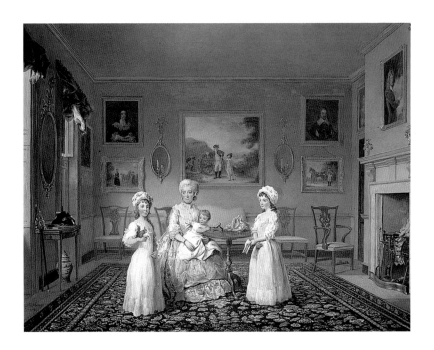

PHILIP REINAGLE
Edinburgh(?) 1749–1833 London

Mrs Congreve with her children
1782
Oil on canvas, 80.5 × 106 cm
Edmund Russborough Turton gift, 1914
NGI 676

Mrs Rebecca Congreve is shown with her children, Ann, Thomas, and Charlotte, in a drawing room thought to represent Eastcombe House, near Greenwich, where the family had moved in 1780. Over the mantelpiece is Godfrey Kneller's portrait of their illustrious ancestor, the playwright William Congreve. The survival of all the family portraits vouches for the authenticity of furnishings and their disposition in the room. Four of these portraits are now in the

Gallery's possession, including that of Captain William Congreve with his elder son William, again by Reinagle. The Captain was renowned for manoeuvring artillery across rough country, and is shown leaning on an eight-pounder canon.

Between the windows can be seen his sword, his tricorne hat and a leather pouch for orders, while a toy cannon is on the central table. The squirrel and the book held by the girls, the floral carpet (Axminster or Aubusson) and the pair of girandole mirrors (to a Hepplewhite pattern) are more feminine elements.

After years as Alan Ramsay's assistant Reinagle later turned against formal portraiture. He never repeated the quality of his Congreve family groups in other interior scene.

GILBERT STUART

Rhode Island
1755–1828 Boston

Bernard Shaw of Sandpitts, Co. Kilkenny (born c.1739)

*c.*1790
Oil on canvas,
76.3 × 63.2 cm
Purchased 1967
NGI 1829

Bernard Shaw was a great-great-uncle of the writer George Bernard Shaw. His brother Robert Shaw became Comptroller of the Post Office in Dublin and commissioned portraits of himself and his wife from Gilbert Stuart. This portrait must have been executed at the same time, remaining in the family collection at Bushy Park, Terenure, until the late nineteenth century. Although the sitter never achieved much in public life, the artist conveys a palpable sense of life through the working of the paint on the face and cravat.

Stuart enjoyed great success during his stay in Ireland from 1787 to 1793. Like his contemporary Francis Wheatley, his move to Ireland was occasioned by the need to escape debts in London, where he had worked independently for five years. Stuart returned to North America and is today known principally for his iconic images of George Washington. His pictures from that period show an increasingly sketchy finish, while the Irish pictures have a creamier texture and a more solid build-up of paint. He preferred to sketch in paint on the canvas and kept sitters at their ease with lively conversation and snuff-taking.

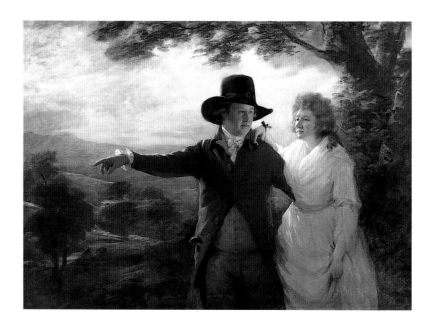

HENRY RAEBURN
Stockbridge 1756–1823 Edinburgh

Sir John and Lady Clerk of Penicuik

1791
Oil on canvas, 145 × 206 cm
Sir Alfred and Lady Beit gift, 1987 (Beit Collection)
NGI 4530

Sir John Clerk (*c.*1740–98), 5th Baronet, was descended from a rich merchant who had built Penicuik House, near Edinburgh. He followed intellectual pursuits typical of the Scottish Enlightenment, and married Rosemary Dacre from Cumberland in 1777. Their tender relationship is amply conveyed in this double portrait, judged to be one of Raeburn's finest paintings. While the device of couples promenanding before an imaginary landscape had been used

earlier by Gainsborough, Reynolds, and Romney, here there is a convincing rendering of the scrubby landscape found in the Pentland hills, and the two figures are fully integrated with it through gesture and back-lighting. Sunlight is the key factor as it catches a winding river, the tree, Sir John's coat, and his wife's cheek. It is reflected back from her muslin dress to him, underlining the bond between them.

Raeburn had spent two years studying in Rome. On opening his first studio in 1786 he strove to re-capture the mood of Italy in a series of full-size portraits set in landscape, unlike the technique of his more familiar later paintings.

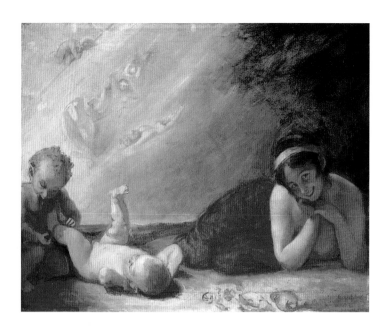

GEORGE ROMNEY
Beckside 1734–1802 Kendal

Titania, Puck and the Changeling, from Shakespeare's 'A Midsummer Night's Dream'
1793
Oil on canvas, 104 × 135 cm
Purchased 1894
NGI 381

At the opening of Shakespeare's play, Oberon, King of the Fairies, renews the argument with his Queen, Titania, over who should have custody of the changeling boy. She crowns with flowers the 'lovely boy stolen from an Indian King' and treats him as her actual son. The boy's birth on a beach may explain Romney's choice of setting here, with three characters placed against a sky full of fairies. Puck, a 'shrewd and knavish sprite', tries to 'bind his feet in flowery fetters' and is to bring about Titania's romantic love misadventure on jealous Oberon's orders.

Underlying the air of dalliance is Romney's choice of Emma Hamilton as the model for Titania. She had long been the artist's muse, having first sat to him for a portrait in 1782 while she was mistress of the Hon. Charles Grenville. An arranged marriage in 1791 to his uncle, Sir William Hamilton, the British Ambassador at Naples, gave her a European stage in society. She was later mistress of Admiral Nelson. The warm palette and sketchy technique, typical of Romney's later work, enhance the sense of allure.

THOMAS
LAWRENCE

Bristol 1769–1830 London

*Lady Elizabeth
Foster (1759–1824),
later Duchess of
Devonshire*

c.1805
Oil on canvas,
240 × 148 cm
Sir Hugh Lane bequest,
1918
NGI 788

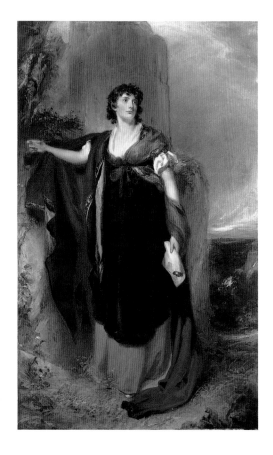

The second daughter of the Earl Bishop of Derry (see page 233), Lady Foster led an extraordinary life after separating from her first husband, John Foster of Co. Louth. She acted as paid companion to an illegitimate daughter of the 5th Duke of Devonshire on a tour to the Continent, and the following year returned to Italy secretly to bear the Duke a daughter. A son by him was later born at Rouen and (until she could marry him in 1809, upon the Duchess's death), Lady Foster, or 'Betty' as she was known, lived on equal terms with the couple.

Lawrence gives no hint of all this in his breathtaking and romanticized image of her as the Tiburtine Sibyl, a Roman prophetess who foretold the coming of Christ. Dressed in quasi-Antique costume, and looking younger than her 46 years, she stands in declamatory pose against a ruined column. Beneath a stormy sky is a distant generalized view of the Temple of the Sibyl at Tivoli, which her father had tried to buy but was prevented from exporting. She was to spend her last years in Rome, where she carried out excavations in the Forum.

Lawrence MacDonald

Gask 1799–1878 Rome

Eurydice

1837
Marble, heigth 140 cm
Purchased 1984 (Shaw Fund)
NGI 8303

As she dries herself after bathing, Eurydice receives the fatal snakebite that will send her to the Underworld, although her demeanor is still calm. The attempts by her Orpheus, her-husband, to rescue her are among the best-known Greek myths, related by the poets Ovid and Virgil. MacDonald trained in Scotland and lived principally in Rome from 1823, working in a neoclassical style. His subject here is an idealized nude, for which he has devised an intricate pose and fall of drapery; the result is a figure that should be seen in the round. MacDonald's subject pieces are fewer in number than his portrait busts, which are less innovative.

The statue was commissioned by the 6th Viscount Powerscourt and was originally displayed in the first floor Saloon of Powerscourt House, Co. Wicklow, where it stood alongside family portraits by MacDonald, subject pieces by his contemporaries and copies after the Antique. Subsequently it was for many years sited out of doors on the upper terrace of the famous gardens. Lichen and other blemishes were removed after acquisition to bring back the pristine whiteness of the marble.

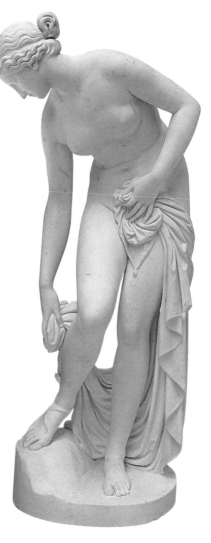

JOHN SINGER SARGENT
Florence 1856–1925 London

The bead stringers of Venice
1880–82
5th Baron Cloncurry bequest, 1929
NGI 921

Recording Venice in watercolour and oil provided Sargent with mental relaxation from the demands of portraiture in London. On visits to the narrow alleys or *calle* of the poorer areas of the city, he often made studies of girls at work. This scene retains a spontaneity that is lacking from some of the more carefully posed courtyard and interior oils. The secondary figures are only blocked in, and the work has the suggestive feeling of a sketch.

The process of stringing beads involved gathering them onto wires from a small wooden trough placed on the knees. This cannot precisely be seen here, however. One girl reaches into a pouch, and a second raises her hand. They face the open door of a shop and what would have been a third figure, now lost by the insertion of a piece of roughly painted canvas. Sargent was seemingly dissatisfied with this part and cut it out.

The painting is inscribed as a gift to the Hon. Valentine Lawless, who later became Baron Cloncurry. An intermittent sculptor and collector, he requested the canvas from Sargent and had it repaired.

STANLEY ROYLE

Stalybridge 1888–1961 Sheffield

The Goose Girl

c.1921
Oil on canvas, 72 × 91 cm
Purchased 1970
NGI 4009

A girl moves her geese through a bluebell wood in spring. This attractive image belongs to a series of pictures in woodland settings painted by Royle between 1913 and 1923 around his native Sheffield. The location survives today, despite the city's growth. The girl is placed within a frieze-like composition, and her lack of expression contributes to the sense of time stopped. The colours are particularly attractive: the green and purple in the wood are balanced against her orange dress, on which sunlight filters.

This subject and related rural scenes had been popular in England since the time of the nineteenth-century *plein-air* artists such as James Guthrie and Henry Clausen. Here the palette and presentation show the effect of Impressionism. The heavy impasto and Royle's habit of rolling canvases may have contributed to the marked cracking of the paint. The painter's wife, Lily, the daughter of a sweetshop owner, served as model for the girl here and in other genre paintings of the period. Royle subsequently moved to Canada, where he developed a more abstract landscape approach and had some influence on the next generation of artists.

FRANCIS WHEATLEY

London, 1747–1801

The Dublin Volunteers on College Green, 4th November 1779

1779–80
Oil on canvas, 175 × 323 cm
5th Duke of Leinster gift, 1891
NGI 125

The Volunteer Movement formed by the Protestant Ascendancy existed from 1778 to 1784, with the purpose of supporting the Irish parliament and gaining economic and legislative power from Britain. An army of local regiments was raised, ostensibly to defend the country. In 1779, the celebration of King William III's birthday by the Dublin Volunteers was a colourful occasion. One thousand armed men, from shop-keepers to the 2nd Duke of Leinster, their Colonel, gathered at the centre of Dublin in a square formation around the freshly repainted statue of the King on College Green, and volleys were fired by two cannons. (The bronze statue, by Grinling Gibbons, was subsequently much abused before being destroyed in 1929.)

Francis Wheatley was newly arrived from London after fleeing debt collectors and recorded the event with some licence to accommodate the figures. He was the first to paint contemporary Irish events since depictions of the Battle of the Boyne, but he found no buyer. A partial key names the Duke at the centre, Princess Daskov from Russia under a parasol at a window, and members of the Light Horse below. The houses on the left, one with Dutch Billy gables, were demolished when curved wings were added to the eighteenth-century Parliament House, the first purpose-built parliament building in modern Europe. It was later saved from destruction by conversion into a bank at the Act of Union. The 1750s façade of Trinity College survives, but the campanile beyond has gone.

Fold out
FRANCIS WHEATLEY
The Dublin Volunteers on College Green,
4th November 1779

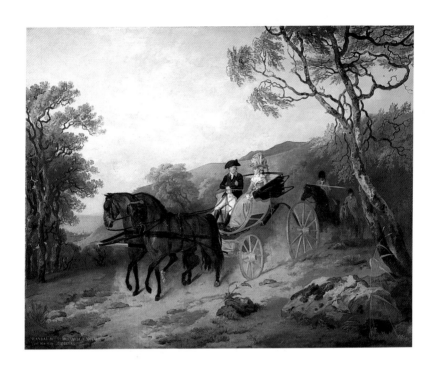

FRANCIS WHEATLEY

London, 1747–1801

The Marquess and Marchioness of Antrim

1782
Oil on canvas, 99.7 × 128.3 cm
Purchased 1980 (Shaw Fund)
NGI 4339

Randall William MacDonnell (1749–91), 1st Marquess of Antrim, wears the Order of the Bath. He is painted in a phaeton with his wife, Letitia (active 1774–1801), against a view of their northern home, Glenarm Park in Co. Antrim. She was the daughter of 1st Viscount Mountmorres, and her previous husband had died. Her fashionable riding outfit, with lapelled waistcoat and elaborate hat, was the type of detail in which Wheatley excelled. For his depiction of the Palladian house he would have had recourse to a painting or engraving, of which examples survive.

Wheatley found a ready market for these small conversation-piece portraits, where he blends sitters and landscape. Conversely, few Irish artists depicted conversation pieces, whether interior or exterior. The deft handling and colouring of the main group against the grey–green landscape make this one of the most successful compositions from the artist's Irish period. While his flight from London to avoid debts was acceptable, the discovery that the lady travelling as his wife was already married to his friend John Gresse hastened Wheatley's return to London.

IRISH
PAINTING AND
SCULPTURE

GARRET MORPHY

Flourished *c.*1655–1716

William, 4th Viscount Molyneux of Maryborough

*c.*1700
Oil on canvas, 76 × 64 cm
Purchased 1976
NGI 4151

In this half-length portrait Garret Morphy depicts the youngest son of the 3rd Viscount Molyneux, who succeeded to the title in 1700. He is wearing armour and holding a baton. A creamy white neckcloth, fringed with gold thread, is knotted at his throat and he sports a high, full wig made from real white hair in a style that was fashionable around 1700. The portrait is striking for the almost hyper-realism of the texture seen in the different materials: the hard sheen of the armour, the soft material of the scarf, the coarse texture of the wig.

Little is known about the early life of Garret Morphy. It is believed that he was in London in 1673, but it is unclear whether or not he had begun his artistic training in Ireland. Morphy's patrons and the circles in which he moved in England and Ireland were largely Jacobite. Later in his career he painted important English administrators and military leaders in Ireland.

JAMES LATHAM

Co. Tipperary 1696–1747 Dublin

Bishop Robert Clayton (1695–1758) and his wife Katherine (died 1766)

c.1740
Oil on canvas, 128 × 175 cm
Purchased 1983
NGI 4370

This double portrait of Bishop Clayton and his wife Katherine dates from the early years of their marriage, which took place in 1728. Clayton was successively Bishop of Killala, Bishop of Cork and Ross, and Bishop of Clogher. He travelled extensively on the Continent and was regarded by all who knew him as a man of culture and taste. His wife was the daughter of a former Lord Chief Justice of the Exchequer.

In this portrait the Bishop is seated at a table holding an open book. The figure is solidly painted in a realistic manner, distinguished by well-observed details such as the depiction of shadow under the nose and chin area. The billowing clerical robe is lavishly executed in flowing, swirling strokes of paint. In the manner of portraits of the eighteenth century, Katherine Clayton is presented as a less forceful personality than her husband: it is her elegance and femininity that are stressed. This is achieved by the carefully arranged, graceful pose.

It is known that the artist enrolled in the Guild of St Luke in Antwerp in 1724, remaining there for one term. He was working in Dublin from 1725 and enjoyed a successful career as a portrait painter in Ireland. The vast majority of Latham's portraits are bust-length, and very often are painted in oval format.

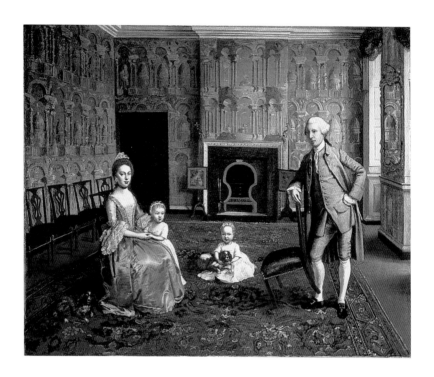

attrib. to STRICKLAND LOWRY

Whitehaven, Cumbria 1737 – c.1785
Worcester

An Interior Members of a Family

1770s
Oil on canvas, 63.4 × 75.8 cm
Purchased 1978
NGI 4304

It is not known what family is depicted in this portrait, the most likely candidates being either members of the Corbally family or their relatives by marriage. The picture is most informative about the interiors of wealthy Irish homes at that time. The key-hole or fiddle grate, associated with the burning of coal, was a feature peculiar to Ireland.

The firescreens featuring framed pictures supported on tripods were used to prevent women's white, lead-based make-up from melting before the heat. The chairs are of Irish Chippendale design. The silk loop-up curtains over the window recesses would also have been typical of the period.

Strickland Lowry was born in Whitehaven, Cumbria, where he was based for much of his early life. He left there in about 1762, and travelled across to Ireland. After a sojourn of a few years he came back to England, returning to Ireland on a number of occasions. As well as painting portraits Lowry engraved landscapes and also tried his hand at still-life paintings.

GEORGE BARRET

Dublin 1728/32–84 London

Powerscourt Waterfall, Co. Wicklow

c.1760
Oil on canvas, 101.9 × 127.5 cm
Purchased 1880
NGI 174

This portrayal of the waterfall at Powerscourt is one of a number of pictures by George Barret featuring the famous cascade with its impressive 116-metre falls. The artist spent several years painting at the Powerscourt estate. The composition stresses the 'sublime' in nature, a concept popularized by the noted philosopher, orator and writer, Edmund Burke. He maintained that what was sublime in nature was vast, awesome, terrible and uncontrollable, whereas the beautiful was denoted by smallness, tranquillity, gentleness and sweetness.

In order to impress the viewer with the sheer scale of the torrent of water, the artist places a group of tiny figures in the left foreground of the picture. Their size contrasts sharply with the huge trees – themselves planted to enhance the scene – while the high cliffs above reinforce the grandeur of this wonder of nature. Barret has chosen to depict the scene in midsummer, and the verdant trees, the lush growth on the cliffs and the Italianate golden light of evening that reflects on the foaming water are superbly handled in paint.

PATRICK CUNNINGHAM

Flourished 1750–74

Jonathan Swift (1667–1745), Satirist and Dean of St. Patrick's Cathedral, Dublin

*c.*1766
Marble, height 37 cm
Purchased 1901
NGI 8026

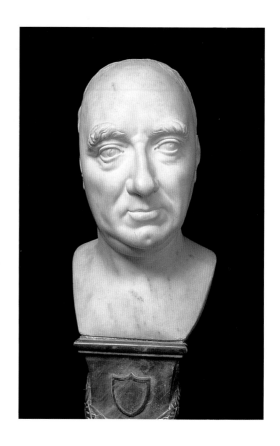

Dublin-born Jonathan Swift was the most celebrated dean of the city's St Patrick's Cathedral, but he is equally famous as a poet, satirist and political writer. He held highly controversial views on Irish issues, notably advocating, by means of pamphlets, a boycott of English goods. Other pamphlets attacked English misgovernment of Ireland and exploitative and absentee landlordism. His best-known publication remains *Gulliver's Travels* (1726), which is a broadly based satire on contemporary politics, religion and literature.

Patrick Cunningham's reputation rests on his realistic manner of portrayal, and this sculpted portrait is a superb example of that skill. The marble head and neck show a middle-aged man, with short curly hair, looking to one side. Swift's character and personality are conveyed in the ironic expression on his small, full mouth and in the alert eyes which denote a sharp observer of the human condition.

CHRISTOPHER HEWETSON

Thomastown, Co. Kilkenny 1739–98
Rome

Sir Watkin Williams-Wynn, Bt. (1749–89)

1769
Terracotta, height 53 cm
Purchased 1969
NGI 8063

Renowned as a great traveller and patron of the arts, Sir Watkin succeeded his father as 4th Baronet of Wymstay in Wales. On leaving Oxford University he set out on the Grand Tour in June 1768 with two companions. He remained abroad until February the following year. While in Rome he commissioned Christopher Hewestson to execute his portrait. The sculptor had arrived in the city by 1765 and lived there for the remainder of his life.

In this portrayal Sir Watkin is depicted in bust form with a drape open at the right shoulder and with curling hair and regular features. The head is turned slightly left, in a 'speaking' pose. The eyes are incised and convey a keen intelligent expression. The bust cost about 10 pounds and numerous casts were made from it, perhaps intended as gifts for the sitter's travelling companions.

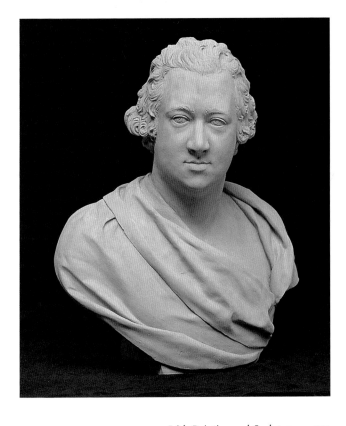

JAMES BARRY

Cork 1741–1806
London

The Temptation of Adam

1767–70
Oil on canvas,
199.8 × 152.9 cm
Presented by the Royal
Society of Arts, 1915
NGI 762

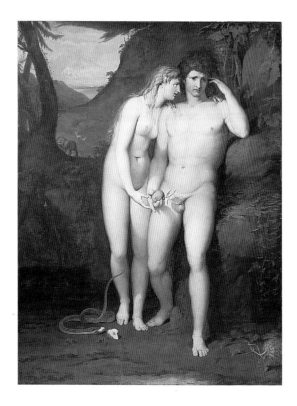

This painting is based on John Milton's ninth book of *Paradise Lost*. It represents the moment after Eve confesses to Adam that she has been tempted and has sinned. She leans towards him seductively, tempting him to eat the apple. Adam, in shocked dismay, collapses against the embankment behind. The leaves of the apple that Eve coaxes Adam to bite cover his genitals in anticipation of the shame they are both to experience after disobeying God's decree. The strikingly smooth, idealized forms of the figures are influenced by Hellenistic sculpture, which Barry had studied with great dedication while in Rome.

Barry briefly attended the Dublin Society's Drawing School. He left for London in 1764 and was in Rome two years later. During his time abroad he immersed himself in the study of antiquities and Old Master paintings. This work recalls the colour effects of Titian in the way he places the figures in full light and the peripheral elements in shadow. The use of symbolism reinforces the overall theme of the contrast between good and evil. To the left are images of evil: the serpent, the forbidden fruit and the lion seen in the distance. To the right are Christian images of hope: the bunch of grapes, a symbol of the Eucharist; and the gourd in the foreground, a reference to the Resurrection.

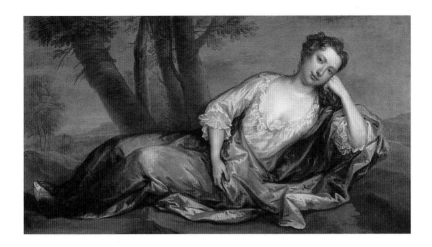

CHARLES JERVAS
Shinrone, Co. Offaly c.1675–1739 London

The Honorable Jane Seymour Conway (c.1711–49)

c.1735
Oil on canvas, 91.9 × 167.2 cm
Purchased 1974
NGI 4118

The sitter of this portrait was the fifth daughter of Baron Conway. She is shown full length, reclining in front of a wide landscape with a group of large trees on the left. She is wearing a blue wrapping gown and white chemise with red and white satin shoes. Although her pose is one traditionally used in art to convey melancholy, her expression, with its faint smile, is more evocative of seduction than of sorrow. It is thought that the canvas may originally have been intended for an overdoor. The broad handling of colour in large brush strokes suggests that the portrait was not intended to be viewed at close quarters.

Jervas went to London in 1694. He stayed there for at least a year, studying painting with Godfrey Kneller, one of the leading portrait painters of the day. From there he went to Italy, returning to London in 1709, where he enjoyed a successful career as a portraitist. During several visits to Ireland he carried out a number of portrait commissions. He is known to have painted at least 10 portraits of Jonathan Swift. After Kneller's death in 1723, Jervas was appointed principal painter to King George I, a position he retained under George II.

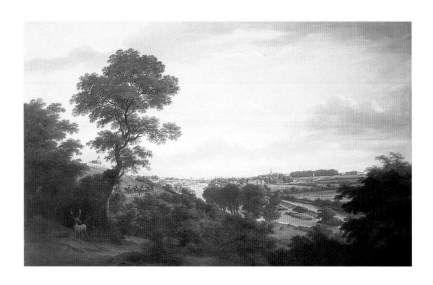

WILLIAM ASHFORD
Birmingham 1746–1824 Dublin

A View of Dublin from Chapelizod

1794–98
Oil on canvas, 113.4 × 184.5 cm
Purchased 1976
NGI 4138

William Ashford's panoramic view of Dublin from the Phoenix Park is one of two large views commissioned for Earl Camden, Viceroy of Ireland from 1795 to 1798. The chosen vantage point is a hill overlooking the man-made weir at Islandbridge. The composition has been carefully arranged in order to ensure that every aspect of the vista will be explored by the viewer. A solitary deer in a clearing to the left of the foreground leads the eye towards the magazine fort on the hill directly above. Below the fort, gun carriages drawn by horses are proceeding down the road leading to the Chapelizod Gate. Spanning the river Liffey is the Sarah Bridge, erected in the 1790s, with its single elliptical arch. On the far side of the river bank is the village of Kilmainham with the Royal Hospital (now the Irish Museum of Modern Art) and the Gaol clearly in view. In the far distance some spires and towers are silhouetted against the expanse of sky.

Ashford was an English artist who settled in Ireland. One of the foremost landscape painters of his time, he was elected first President of the Royal Hibernian Academy, Dublin, in 1823. In this splendid view of eighteenth-century Dublin he evokes the idyllic mood of a classical landscape.

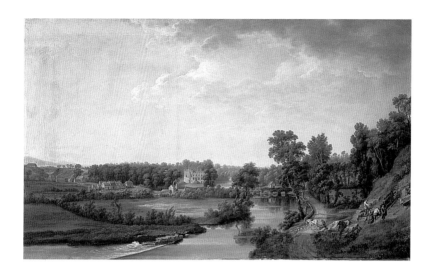

THOMAS ROBERTS
Waterford 1748–78 Lisbon

Lucan House and Desmesne, County Dublin

c.1773-75
Oil on canvas, 60.6 × 99.8 cm
Purchased 1983 (Shaw Fund)
NGI 4463

In this view the artist depicts old Lucan House and the tiny village of Lucan from the banks of the river Liffey on the road to Dublin. A castle had been built there in the late twelfth century but by 1772 the owner, Agmondisham Vesey, was designing a new house, very different from that seen in the picture. It was to be a villa of Palladian design, and is still standing. To create some human interest in the picture Roberts includes in the bottom corner a group of men quarrying stone. They also serve to give a sense of scale to the landscape. Roberts has depicted them with deft, quick brush strokes, which lend an air of life and energy to the composition. His handling of light imbues the scene with an Italianate feel, while the overall mood of tranquillity and serenity is in keeping with idealized classical landscape paintings of the period.

Roberts was an accomplished figure painter, but it was for his topographical views that he became justifiably renowned. His depiction of houses and their estates is highly realistic.

NATHANIEL HONE
Dublin 1718–84 London

The Conjurer

1775
Oil on canvas, 145 × 173 cm
Purchased 1966 (Shaw Fund)
NGI 1790

Nathaniel Hone established a successful career as a fashionable portrait and subject painter in London. This beautifully executed satirical painting (the full title of which is *The Pictorial Conjuror, Displaying the Whole Art of Optical Deception*) caused an outcry when it was submitted by the artist for exhibition at the Royal Academy, London, in 1775. The reason given was that included in the picture was a nude caricature of the Swiss painter Angelica Kauffman. This was subsequently painted over, but the original figure can still be seen in a sketch in the Tate Gallery. The true cause of offence, however, was that the picture was seen as an attack on Kauffman's friend Joshua Reynolds, president of the Royal Academy. His practice of borrowing poses from Old Master paintings to ennoble his portraits was seen by Hone as plagiarism.

The model used for the figure of the conjurer was often employed by Reynolds. With his long cane the conjurer summons up an abundance of Old Master prints, while in his hand is a print of Raphael's *Diadem Madonna*. The subject, 'Truth is revealed to Man', is a pointed reference to Reynolds's artistic practice. After a brief showing at the Academy it was requested that the painting be removed. Hone was furious, and promptly withdrew from the Royal Academy. Without delay he organized an independent display of his work, the first one-man show ever held in the British Isles.

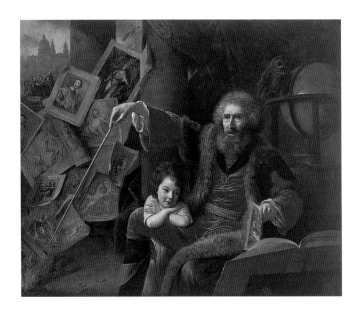

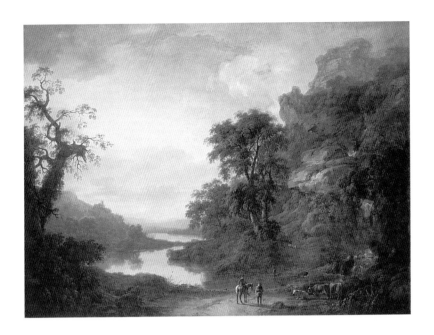

Thomas Roberts
Waterford 1748–78 Lisbon

A Landscape

c.1770
Oil on canvas, 112 × 153 cm
Purchased 1972
NGI 4052

Although Roberts is best known for his topographical views, his own preference was for the classical landscape. This type of painting does not illustrate anywhere in particular; instead it aims to produce a calm and harmonious effect through the careful arrangement of a compositional view. The French artist Claude, a century earlier, had established a series of rules for executing such views: the foreground area, painted in dark colours, should recede to the distant horizon by using colours that gradually become paler. Distance could be created by the device of placing trees or hills to either side of the picture. Human figures, animals, ruins, rivers, trees and shrubbery were placed carefully within the composition to lead the viewer through the landscape.

Roberts's composition is of the Claudian format. A large landscape, framed by trees, shrubbery and high craggy hill, is opened up to the left of centre by a serpentine river moving to distant hills beyond. The viewer is carefully led through this idyllic place, passing the figures and animals in the right foreground, towards the expanse of the still waters, on to the ruined Gothic church high overlooking the river, and finally to the horizon.

JAMES BARRY

Cork 1741–1806
London

Self-portrait as Timanthus

c.1780–1803
Oil on canvas,
77 × 63.5 cm
Purchased 1934
NGI 971

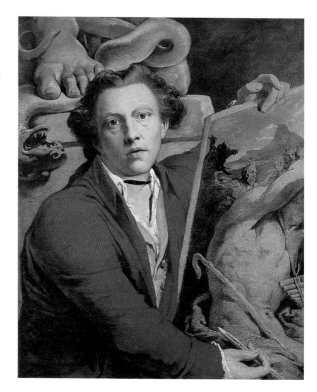

This half-length self-portrait is based on a description by Pliny the Elder of a lost painting by the ancient Greek artist Timanthes. It was begun around 1780; Barry initially used it for his representation of Timanthes in a painting for the Great Room at the Society of Arts in London. Later, in 1804, he was requested by the Society to provide a self-portrait, to be reproduced in engraved form for a published volume of the Society's Transactions for that year. In his reply to the Society Barry mentions that he had completed the portrait the summer before.

He represents himself wearing a red coat with a yellow waistcoat and white shirt underneath. His neck is adorned with a black ribbon. He holds aloft a painting of a Cyclops, the one-eyed giant who, according to Homer, devoured human flesh. In the background, satyrs gaze in fear at the giant. The windswept tree and active volcano silhouetted against the sky add to the sense of drama. Behind the artist is the base of the famous Hellenistic statue the *Laocöon*, a cast of which stood in Barry's studio. The artist's deliberate placement of himself between the statue and the painting was intended to reflect his ability to survive adversity.

Thomas Hickey
Dublin 1741–1824 Madras

An Actor between the Muses of Tragedy and Comedy
1781
Oil on canvas, 101 × 127.1 cm
Purchased 1925
NGI 862

An actor stands between female figures representing Tragedy and Comedy. With an outstretched arm he points to a pedestal surmounted by an urn and bearing the inscription 'Hence vain deluding joys', a line from John Milton's *Il Penseroso*. The figure of Comedy, in a diaphanous pink gown and grey shawl, attempts to pull the actor away from reading the message and from engaging with the more serious, thoughtful figure of Tragedy, suitably attired in black. The moral implication is that the actor would be choosing a frivolous path in life if he were to decide in favour of Comedy. This moral dilemma is a variation of another popular subject for artists, that of Hercules at the crossroads, standing between Vice and Virtue. The delicately painted composition owes a debt to Joshua Reynolds's famous picture of the actor David Garrick depicted between the muses of Tragedy and Comedy (1762).

Hickey painted this composition while in Lisbon. He had trained at the Dublin Society's Drawing School and had emerged a competent portraitist. He visited Italy in the early 1760s and set out for India in 1780. His ship was captured near Lisbon by the French and Spanish fleet. He received many commissions in Lisbon, but after three years was released and given permission to return to England. He then set sail again for India where he became a successful portraitist.

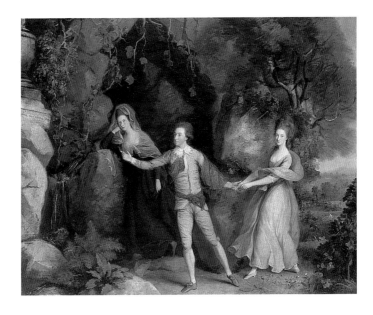

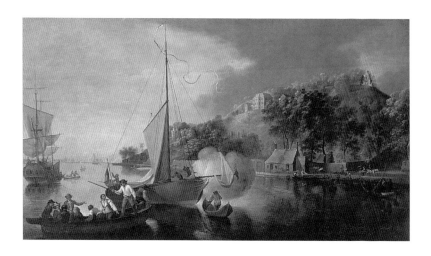

NATHANIEL GROGAN
Cork, *c.*1740–1807

Boats on the River Lee below Tivoli, County Cork

*c.*1785
Oil on canvas, 94.3 × 168 cm
Purchased 1973
NGI 4074

This is one of a number of view paintings that the artist executed around the city of Cork. It shows the estuary of the River Lee looking up towards the city. On the north bank is Tivoli, a house built in the Palladian manner for James Morrison, a wealthy merchant and Mayor of Cork. It was renowned for its garden temples, and the scene includes a temple of Gothic design located on the brow of the hill. In the far distance the city of Cork can be seen through a warm haze. Below on the water there is much activity. A yacht is about to enter a race, as signalled by the firing of a gun. In the left foreground passengers are being rowed out in a punt to take part. Behind the yacht is a large commercial boat with small rowing boats in attendance.

Grogan was born in Cork and was a largely self-taught painter. As a young man he longed to be an artist but received no encouragement from his family and so enlisted in the army, serving in America and the West Indies. When he returned to Cork he made an adequate living as a painter. He is best remembered for his humorous genre scenes of Irish

Hugh Douglas Hamilton

Dublin, 1740–1808

Frederick Hervey, Bishop of Derry and Fourth Earl of Bristol (1730–1803), with his Granddaughter Lady Caroline Crichton (1779–1856), in the Gardens of the Villa Borghese, Rome

*c.*1790
Oil on canvas, 224.4 × 199.5 cm
Purchased 1981 (Lane Fund)
NGI 4350

The Earl Bishop of Derry was a seasoned traveller and collector, visited in Rome in 1787 by his granddaughter, Caroline, and her mother, Lady Mary Erne. The young girl points to a relief of the Seasons on a Roman altar of the 12 gods. The Earl Bishop may have tried to purchase this antique sculpture, but he was outbid by Napoleon I (it is now in the Louvre).

Hamilton trained in Dublin, had a successful career in London, and from 1782 spent nine years in Rome. There his portraits included full lengths against ancient monuments.

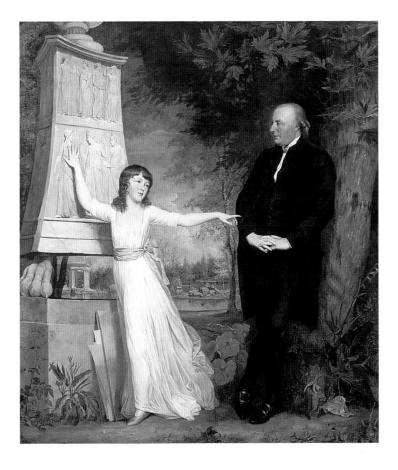

HUGH
DOUGLAS
HAMILTON
Dublin, 1740–1808

*Cupid and Psyche
in the Nuptial
Bower*

1792–93
Oil on canvas,
198.6 × 151.2 cm
Presented by the
Friends of the National
Collections of Ireland,
1956
NGI 1342

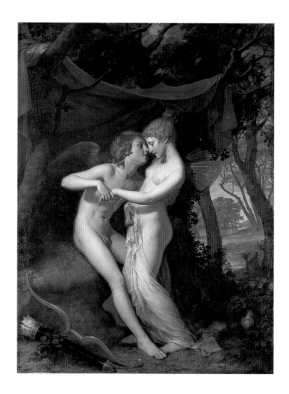

The classical myth of Cupid's love for Psyche stirred the imagination of many artists in the eighteenth century. In spite of the title Hamilton's interpretation seems to show an earlier episode in the story. The scene is a woodland setting at night. The figures are placed in front of a large tree over which is placed a red canopy. In the background is a lakeside. The youthful, handsome Cupid sits on the bank by the tree and gently draws Psyche towards him. In spite of her hesitancy the love of the two is evident. This work was inspired by a sculpture of the same subject by Antonio Canova, who was working in Rome during Hamilton's last years in that city. Canova's neoclassical forms are recalled in the smooth, idealized figures of the young lovers.

The mythological theme of the painting is reinforced with symbolism. Both figures are winged, Psyche's wings being those of a butterfly, symbol of both the soul and of Psyche in Greek art. A real butterfly rests on a rose in the right foreground of the composition, an attribute of Cupid. In the left foreground his other attributes, the bow and quiver, are laid on the ground. Silhouetted against the background on the left is ivy, symbolic of immortality.

The painting was exhibited in Dublin in 1800 to great critical acclaim.

JAMES ARTHUR O'CONNOR
Dublin 1792–1841 London

The Mill, Ballinrobe
*c.*1818
Oil on canvas, 42 × 71 cm
Purchased 1970
NGI 4011

The Mill is one a series of four
paintings commissioned around
1818 by Courtney Kenny, owner of
Bridge House in Ballinrobe, Co.
Mayo. One painting shows the
house, another the pleasure grounds,
the third a panoramic view of the
countryside at Lough Mask. This
painting depicts the mill located at
the edge of the river Robe, close
by a wooden footbridge. On the left
of the picture two men are pushing
a punt out onto the river. On the
far bank behind them are the
picturesque ruins of a Gothic church,
its shadow visible on the river
surface. In the centre of the
composition, a church spire can be
seen on the horizon.

The scene is remarkable for its
mood of serenity and tranquillity.
O'Connor achieves this by inter-
preting Ballinrobe less as a
topographical view and more as an
ideal place where time stands still.
The absolute stillness of the water,
the lack of movement in the tall trees
silhouetted against the sky, and the
almost total lack of human activity,
all combine to reinforce this notion.

This painting is a superb example
of the artist's early technique.
O'Connor is believed to have been
largely self-taught, and his initial
style is marked by a close attention to
detail and very precise brushwork.
This is in contrast to his later
paintings, which are more broadly
painted and more concerned with
depicting the awesome and sublime
aspects of nature.

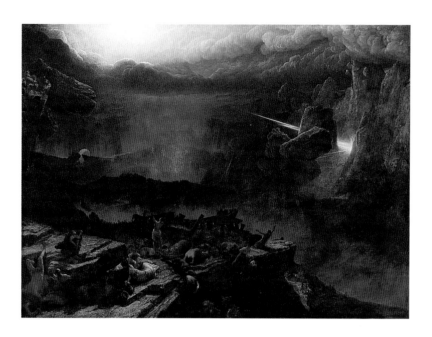

Francis Danby

Near Wexford 1793–1861 Exmouth

The Opening of the Sixth Seal

1828
Oil on canvas, 185 × 255 cm
Purchased 1871
NGI 162

The catastrophic event shown in this work is based on lines from the Book of Revelations (6: 12–17) whereby on the opening of the Sixth Seal the earth opens up and bursts into disarray. In the painting the sky is lit up unnaturally, a volcano has erupted violently, lava spills forth, and lighting strikes a mountain top with great force. Cities are collapsing and their inhabitants call upon the earth to fall on them and hide them from the wrath of God.

In order to convey the terror and drama of the apocalyptic event, Francis Danby paints his scene onto a very large canvas. He employs a palette of darkest browns, fiery reds, grey and vibrant whites to vividly conjure up what is happening. The puniness of the figures against the massive scale of the landscape forcefully conveys the idea that human beings are not in control of the world they inhabit. Nature has been unleashed, and they are powerless to prevent it. In dramatic works such as this one, Danby displays his awareness of the Romantic movement that was sweeping across Europe during the nineteenth century.

Danby was a master of spectacular scenes. Indeed this painting proved to be so popular when exhibited at the Royal Academy (London) Exhibition of 1828 that is was moved to a separate gallery because of the huge crowds it attracted.

James Arthur O'Connor

Dublin 1792–1841 London

A Thunderstorm: The Frightened Wagoner

1832
Oil on canvas, 65 × 76
Presented by Mr. F. McCormick, 1972
NGI 4041

Inspired by the sheer power of nature, the artist depicts the drama of a violent thunderstorm. The work provides an excellent example of a Romantic landscape painting. In this type of image the artist's personal response to the wonders of the natural world becomes part of the subject.

The mood of the scene is set immediately by the giant twisting tree in the left foreground. It strains to remain rooted to the ground against the ferocity of the wind whipping at the branches and leaves.

Close by a man struggles to keep on his hat as he surveys the bridge and the rushing torrent of water below. The horses are frightened and, in the way of animals, sense the danger in traversing the rather fragile-looking crossing. The heightened sense of movement in the trees and water, the contrasting areas of light and shadow, and the agitated brushwork, all contribute to this striking representation of a storm. It is thought that O'Connor's treatment of the subject may have been inspired by William Wordsworth's poem *The Wagoner* (1819).

O'Connor seems to have been largely self-taught. He went to London in 1813 but after some months was obliged to return home to support his orphaned sisters. He remained in Ireland for about 10 years, working as a landscape artist. In 1822 he returned to London.

Patrick MacDowell

Belfast 1799–1870 London

A Girl Reading

1838
Marble, height 141 cm
Purchased 1980
NGI 8250

The young girl portrayed in this charming sculpture is intent on her book; the loose robe she wears has fallen from her shoulders, in folds that reveal the graceful body beneath. Her naturally curling locks, held in place with braided ribbon in the classical style, cascade down the back of her swan-like neck. Her prettiness is evident in the perfection of the profile, her gently lowered eyes, and the soft curve of the mouth.

Rather than represent an individual, the sculptor has created a type, in which the grace and refinement of youth are celebrated in marble. The carving is sensitively executed; the diaphanous folds of drapery are lightly incised and provide an interesting contrast to the more deeply gouged coiling hair.

A popular sculptor in his own lifetime, MacDowell had a reputation for producing finely designed figures, full of touching sentiment, in the conventional neoclassical idiom.

John Hogan

Near Waterford 1800–58
Dublin

Hibernia with a Bust of Lord Cloncurry

1844
Marble, height 148 cm
On loan to the National
Gallery of Ireland
NGI 14,688

This marble group was sculpted while the artist was in Rome, where he lived from 1823 to 1848. It depicts the idealized form of Hibernia (Ireland), dressed in classical garb and wearing a coronet with laurel leaves. She is seated on a chair of antique design. Surrounding her are the appropriate attributes of her country. The fingers of her right hand rest on a harp, her right foot on an Irish wolfhound. An inverted crown decorated with a shamrock lies beneath the harp close to some scrolls and a book. Hibernia's left arm is casually draped around a Herm – a form taken from classical antiquity comprising a bust set on a tapering pillar.

The bust's sitter was Valentine Lawless, Lord Cloncurry (1773–1853). He had joined the United Irishmen and was several times imprisoned. He supported Catholic Emancipation and the abolition of tithes, and was active in attempts to provide relief during the Famine of 1845–50. He saw himself a patron of the arts, and travelled extensively on the Continent. Cloncurry commissioned Hogan to create the sculpture, which was originally to be presented to the Dublin Literary Society. It was subsequently moved to Cloncurry's country seat, Lyons House, in Co. Kildare. Stylistically the work combines the smooth idealism of classical sculpture with naturalism.

RICHARD ROTHWELL

Athlone, Co. Westmeath 1800–68 Rome

The Young Mother's Pastime

1844
Oil on canvas, 93 × 79 cm
Purchased 1942
NGI 1102

The joy and delight of the mother are
evident in this charming picture.
Seated, supposedly outdoors under
the shade of a tree, she holds her
bonny infant aloft with pride. The
fact that it may be a portrait of the
artist's wife and first child adds to the
picture's appeal. Rothwell had
married in 1842, and he exhibited the
picture two years later at the Royal
Academy in London.

Rothwell's early art training was at
the Dublin Society Schools. He
moved to London in 1829 where he
quickly established a successful
portrait practice. His work was much
admired by Edwin Landseer and
Thomas Lawrence, who prized the
richness of his palette and his ability
to paint flesh that equalled the skill
of the Old Masters. When Lawrence
died Rothwell inherited his practice.
He spent some time in Italy, and
on his return to London found it
difficult to regain his popularity as a
portraitist. The rest of his career
was one of disappointment and a
shortage of patronage.

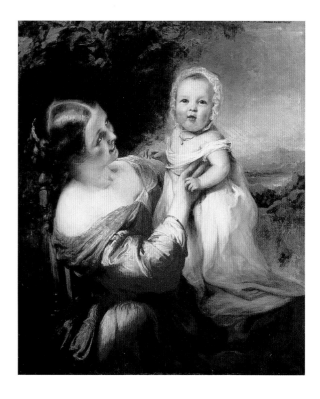

WILLIAM MULREADY
Ennis, Co. Clare 1786–1863 London

The Toy-seller
1857–63
Oil on canvas, 112 × 142 cm
Purchased 1891
NGI 387

This painting was left unfinished at the artist's death. It depicts a rather timid child, in his nurse's arms, making a strange face at a black toy-seller who attempts to engage its attention in a rattle. The scene is outdoors, close to a house in a wooded glade. In the far distance the landscape opens out to a brilliant blue expanse of sky and water. Mulready shows his talent for painting the human form in his handling of the three figures. Each one is convincingly portrayed in the round, the most striking figure being the dignified, muscular toy-seller silhouetted against the horizon. At the same time, the expressions on the faces of all three, ranging from fear to degrees of concern, help create a sense of psychological drama in the picture.

The artist's palette is rich in colour throughout the painting. Equally impressive are the precise, delicate brush strokes delineating the sunflowers and the leafy background beyond. It is not clear whether the flowers in the picture have a symbolic meaning. It has been suggested that they and the toy-seller may for the Victorian viewer have represented exotic elements of nature.

Although Mulready was born in Ireland, the family moved to London in 1792. He trained first with the sculptor Thomas Banks before enrolling at the Royal Academy in 1800; he subsequently became an extremely successful genre painter. While the style of Mulready's early genre scenes recalls those of seventeenth-century Dutch artists, later ones are influenced by the High Renaissance masters.

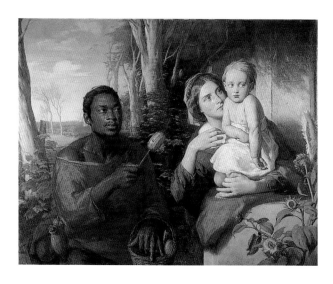

*Bathers
Surprised*

1852–53
Oil on panel,
59 × 44 cm
Purchased 1911
NGI 611

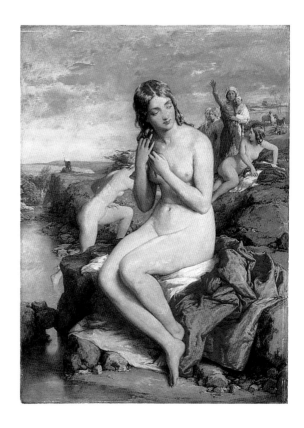

A group of young women are depicted nude, bathing from the rocky banks of a stream. Behind, a woman, holding a child in her arms, calls out urgently that someone is coming. The two women behind her appear to clutch each other in alarm. One of the naked figures has already begun to rise from her prone position on the rocks, while another springs from the water, her long hair streaming behind her as she does so. Their dramatic response suggests that it is a male stranger who is about to invade their privacy. Yet the foreground figure seems unperturbed by the news. She gazes dreamily in the middle distance, absent-mindedly fingering her hair as she does so.

This accomplished study of the nude as seen from several angles is a logical development of Mulready's superb academic drawings, which were greatly admired by Queen Victoria. He had trained at the Royal Academy in London but continued to take life-drawing classes until late in his career. His depiction of the nude links him to the traditions of Western European art – to the antique and the Italian School. The foreground figure owes a debt to Titian's *Venus Anadyomene* and the study of figures in different poses to Michaelangelo's *Bathers* cartoon.

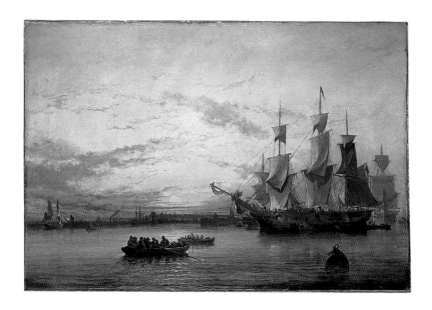

Edwin Hayes

Bristol 1820–1904 London

An Emigrant Ship, Dublin Bay, Sunset

1853
Oil on canvas, 58 × 86 cm
Miss Mary S. Kilgour gift, 1951
NGI 1209

Many Irish landscape painters also produced seascapes from time to time. Edwin Hayes, however, is remarkable in that his considerable body of work is exclusively confined to the sea, shipping and coastlines.

The subject of this painting is a very poignant one. The sailing ship at anchor at the mouth of the river Liffey waits for passengers who are migrating across the Atlantic. The painting was completed in 1853, just a few years after the Great Famine. Around this time over a million people left Ireland in order to seek a new life in England or North America. There is a note of hope in *An Emigrant Ship*, however, represented by the dramatic, flaming sunset. It symbolizes the better future that awaits those fleeing the results of famine. The ship is delicately painted and the artist gives a detailed description of the other ships and boats in the water.

Hayes spent long periods of his life at sea, at one stage sailing around Ireland in his father's yacht. The idyllic mood of the painting, in the tradition of the great classical landscapes of the seventeenth century, serves to present a potentially tragic theme in a less harrowing way for the viewer.

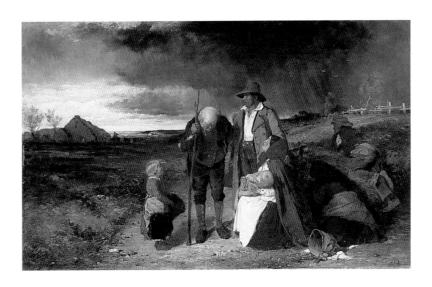

ERSKINE NICOL

Leith 1825–1904 Feltham

An Ejected Family

1853
Oil on canvas, 50 × 82 cm
Michael Shine gift, 1992
NGI 4577

The Scottish artist Erskine Nicol painted numerous Irish everyday scenes, of which this is a fine example. A young labourer, surrounded by his family, stares at the thatched cottage from which the family has just been evicted. His wife, holding a baby in her arms, looks up imploringly at her husband as if for guidance, but he appears to offer none. The elderly grandfather rests his hand on the man's shoulder in a gesture of support, while his granddaughter looks on in bewilderment. Two more children lie on a grassy bank watching their cattle being taken by the bailiff. The reason

for the eviction and the seizing of assets is non-payment of rent.

The scene is well composed, the figures carefully observed, and the landscape precisely rendered. The heavy downcast sky echoes the mood of the scene. Nicol spent four years in Ireland, from 1846, and thereafter returned each summer for many years. Most of his Irish scenes are amusing, if sometimes cruel, vignettes of Irish life. This picture is unusual for its sympathetic portrayal.

BARTHOLOMEW COLLES WATKINS

Dublin 1833–91 Upper Lauragh, Co. Kerry

Murlough Bay and Fair Head, Coast of Antrim

c.1870
Oil on canvas, 34 × 52 cm
Purchased 1999
NGI 4673

The coast of Antrim with its rugged and dramatic scenery was, and still is, a popular tourist spot. This painted view shows Murlough Bay. The eye is led into the picture by the strategic placing of stones and seaweed at the bottom left of the composition. In the middle distance craggy rocks line the shore, their impressive height emphasized by the small figure standing close by. Behind the rocks a house can be seen. Its scale also serves to impress on the viewer the vastness of the mountains dominating the horizon.

Watkins was a slow worker and his pictures were always very carefully painted. Each small portion was finished before he touched the rest, resulting in works that recall those of the English Pre-Raphaelite artists. This painting is meticulously crafted and demonstrates the artist's skill in rendering realistic detail. Having trained in Dublin, Watkins devoted his career to the painting of landscape. He died while on a sketching tour in Kerry.

Market Day, Finistère
1882
Oil on canvas, 201 × 132 cm
Purchased 1986
NGI 4513

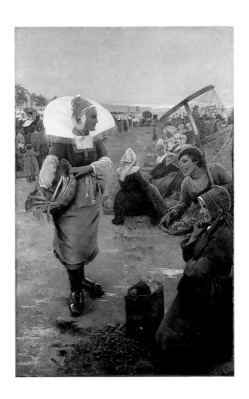

Painted in Concarneau during the winter of 1881–82, this is one of the most ambitious Breton canvases executed by the artist. It was exhibited at the Paris Salon of 1882. Thaddeus had studied in Paris in 1880–81 before coming to Brittany. Many artists were attracted to this picturesque part of France with its air of the exotic.

The painting shows the beach at Concarneau, where a young woman in typical Breton costume pauses to inspect the local shellfish and chestnuts. Resting on her hip is a basket of leeks. The artist pays great attention to the depiction of the clothes, lavishing attention on the wonderfully elaborate lace collar and fetching salmon pink and white bonnet. Her eye-catching apparel is in striking contrast to the plain garments of the old woman beside the brazier and the rather awkward youth intent on selling the local shellfish.

This is a masterly *plein-air* scene combining immense interest in detail with a very open composition, which leads the eye through the market to the flat expanse of coast beyond. In the manner of the realist painter Jules Breton, Thaddeus is likely to have posed the young woman in his studio. She is more crisply painted than the other figures in the picture, and the colours used to describe her contrast strongly with the more muted tones of the background.

WALTER OSBORNE

Dublin, 1859–1903

Apple Gathering, Quimperlé

1883
Oil on canvas, 58 × 46 cm
Patrick Sherlock bequest, 1940
NGI 1052

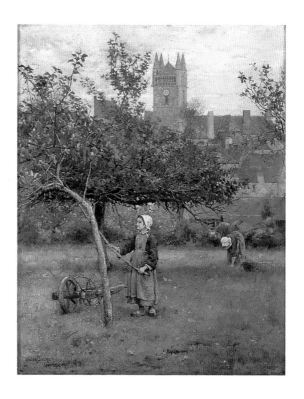

Walter Osborne was a pupil at the Royal Hibernian Academy Schools from 1876, and went to Antwerp in 1881 to continue his studies. From 1883 to 1884 he was in Brittany. It was a short stay, but proved to be a most productive one. The painting of children apple-picking in Quimperlé is one of a number of Breton rural scenes executed during this visit. In the foreground a young girl in peasant costume is shaking loose the apples from the tree with the aid of a long stick. Behind her, a second figure, bent low, picks the ripened fruit already scattered on the ground. Dominating the background is the local church. Several artists in the district painted the church as seen from the entrance, but Osborne

chooses the view facing the clock tower.

The picture, which quietly celebrates the dignity of rural labour, recalls the art of Millet. It is also influenced by the work of Bastien-Lepage in terms of the predominantly grey–green palette and the suggestion of the 'square brush' technique in the middle-distance of the composition.

SARAH PURSER
Dublin, 1848–1943

Le Petit Déjeuner
1881
Oil on canvas,
35 × 27 cm
Richard Irvine Best
bequest, 1959
NGI 1424

The subject of *Le Petit Déjeuner* is the dancer Maria Feller, who was the daughter of an Italian count and a dancer. Feller had been a voice and music student in Paris, and for a period shared an apartment with Sarah Purser and the Swiss artists, Louise Breslau and Sophie Schoppi. This portrait was executed during the summer of 1881, at a time when Feller was teaching music. She is shown seated on a bentwood chair wearing an outdoor dress, a green–grey jacket with a white lace jabot, blue skirt and brown bonnet tied with white ribbons.

Although full of detail, nothing in the picture distracts the viewer's attention from the woman's pensive expression. On the marble table her croissant and breakfast drink remain untouched. The theme of young women looking moody was tackled by other artists of the day. Feller's *ennui* is reminiscent of a number of genre portraits by Degas, an artist Purser greatly admired.

Purser studied in Paris at the Atelier Julian. On her return to Dublin she pursued a career as a portraitist. She also became involved in numerous cultural activities: she founded An Túr Gloine, a stained-glass co-operative workshop (1903 –43), and was a driving force behind the establishment of the Municipal Gallery of Modern Art and the Friends of the National Collections.

RODERIC
O'CONOR

Milton, Co.
Roscommon
1860–1940
Neuil-sur-Layon

*La Jeune
Bretonne*

*c.*1895
Oil on canvas,
65 × 50 cm
Purchased 1975
NGI 4134

This intimate, colourful portrait is one a series of peasants in traditional costume. It depicts a three-quarter-length figure of a young Breton girl in profile, facing right. The left half of the picture is in shadow and is painted in tones of green and brown; the right half is illuminated with brush strokes of pink and mauve, moving to blues and yellows at the top. The girl wears a cap with a chin strap, painted in green and violet strokes with white, and her hair is purple and navy blue in contrast to the flesh tones of golden and radiant red reflected from the red shawl about her shoulders. Around her hips is a deep blue green shawl. The unusual viewpoint adds to the intimacy of the portrait – it is as if she is unaware of the scrutiny of the artist.

Little is known about the O'Conor's early tutelage in painting but he is recorded as having visited Antwerp in 1881, and in 1883 was working under the direction of Carulus Duran in Paris. He was one of the significant members of the Pont-Aven group, which included

DANIEL MACLISE
Cork 1806–70 London

The Marriage of Strongbow and Aoife

*c.*1854
Oil on canvas, 309 × 505 cm
Presented by Sir Richard Wallace, 1879
NGI 205

This exceptionally large canvas depicts an event commonly regarded as pivotal in Ireland's history. The picture narrates the episode when the Normans, who had settled in England in 1066, were provided with the opportunity to invade Ireland. This was presented to them by Dermot McMurrough, the King of Leinster, who had been expelled from his kingdom. He sought assistance from the Norman leader, Richard de Clare, known as Strongbow. In return for his help McMurrough promised Strongbow the hand of his daughter, Aoife, in marriage, and pledged that subsequent to his death he would succeed to the title of King of Leinster. After Strongbow had captured the city of Waterford he married Aoife on the battlefield. Later generations saw this union as the first confirmation of Ireland's loss of freedom, a loss that was to endure for seven-and-a-half centuries.

The occupation of Ireland is symbolized by the figure of an old harp-player clutching his instrument with broken strings. It is reinforced in the proud stance of Strongbow, who tramples on an overthrown cross decorated with early Irish Christian art. The figures of the defeated Irish are adorned with a variety of ornaments, a reminder of their proud Celtic heritage. Prior to designing the picture, the artist consulted his Irish antiquarian friends in an attempt to ensure that the costumes and weaponry were correct in every detail. In this picture the artist's Romantic, nationalist sympathies are to the fore. It is thought that he may have intended that his painting should recall contemporary tragedies such as the unsuccessful 1848 Young Irelander Rebellion and the 1845–50 Famine, as well as recording an important episode of medieval history.

Maclise was one of the most successful history painters of his day. At the peak of his career he was commissioned to produce several paintings for the Houses of Parliament in London. This work, extremely accomplished and ambitious in terms of scale, design and execution, serves as apt testimony to his skill.

Fold out
Daniel Maclise
The Marriage of Strongbow and Aoife

RICHARD MOYNAN
Dublin, 1856–1906

'Military Manoeuvres'
1891
Oil on canvas, 148 × 240 cm
Purchased 1982
NGI 4364

The scene takes place in a village, thought to be Leixlip, in Co. Kildare. On the street, some ragged barefoot and mischievous-looking children are playing at being a military band. Their musical instruments are ordinary household objects: pots and pans, tin boxes, buckets and saucepan lids. Passers-by stop to watch the make-believe band, while the children pause to tease a soldier walking with his girlfriend on the pavement. The trooper has been identified as a member of the Fourth Royal Irish Dragoon Guards, a regiment based in Ireland during the 1880s. He wears the walking-out uniform of the cavalry regiment.

He recognizes that the leader of the children's musical 'ensemble' is wearing the regimental band helmet – and is clearly is not amused.

'Military Manoeuvres' is a superb example of a subject picture – a type of painting that emphasizes the element of storytelling. Moynan produced a number of beautifully painted subject pictures such as this. He first studied medicine but then decided to become an artist. After training in Dublin he went to Antwerp and was in Paris by 1884. He developed his reputation as a portrait painter, although his greatest strength arguably lies in his wittily observant scenes of everyday life.

HELEN MABEL TREVOR

Lisnagead, Co. Down
1831–1900 Paris

The Fisherman's Mother

c.1893
Oil on canvas,
65 × 53 cm
Presented by the
artist, 1892
NGI 500

Helen Trevor felt a great rapport with the mothers of the fishermen whom she met in Brittany. This painting presents a three-quarter-length figure of an old woman, seated, leaning on a stick and facing the spectator. The figure, which dominates the foreground of the canvas, is an imposing one. The piercing eyes with their direct, unflinching gaze immediately suggest the strength of character required of these women, whose husbands and sons faced constant danger at sea. The hands that rest on the cane, entwined with rosary beads, are witness to a life of hard work endured with the aid of a steadfast religious faith.

Trevor began her art training relatively late in life. She studied at the Royal Academy, London, then in Paris, and first visited Brittany in 1881. Her Breton subjects include sentimental pictures of schoolchildren, studies of elderly women and woodland scenes in the manner of the Barbizon School. She was especially interested in the lives of Breton fishing people, their customs and traditions. She exhibited a small number of Breton scenes in Dublin, London and Paris. This painting was shown at the Paris Salon in 1893, at the Royal Academy in 1895, and later the same year at the Royal Hibernian Academy, Dublin.

RODERIC O'CONOR
Milton, Co. Roscommon 1860–1940
Neuil-sur-Layon

The Farm at Lezaven, Finistère
1894
Oil on canvas, 72 × 93 cm
Purchased 1961
NGI 1642

Roderic O'Conor spent more than a decade at Pont-Aven, Brittany, from 1890 to 1904. Here artists were developing an advanced Post-Impressionist style of painting under the influence of Gauguin. O'Conor's readiness to experiment with new artistic ideas quickly secured him a position among this modernist vanguard. Whilst in Brittany he painted portraits of the Breton people, landscapes and seascapes.

Visible in the background of this landscape painting is a seventeenth-century farmhouse that was used as a studio by many artists. Paul Gauguin had rented the building in 1889 and O'Conor used it as his studio in 1893–94. The overlapping layers of flowers and fields lead the eye to the sunlit farmhouse. The varied palette of greens, pinks and red, and the freely applied paint, brings the lush summer landscape vividly to life. The striped brushwork evident in parts of the picture is typical of O'Conor's Breton work, although it is less heavily applied here than in earlier works.

Nathaniel Hone
Dublin, 1831–1917

Pastures at Malahide

c.1894–96
Oil on canvas, 82 × 124 cm
Presented by the artist, 1907
NGI 588

Generally regarded as Nathaniel Hone's masterpiece, this is one of several scenes of cattle in the meadows of north County Dublin executed by the artist. It depicts the relaxed but heavy bodies of resting cattle in the lush vegetation of the Malahide area. The composition is simple. The canvas is divided into zones of land and sky, the vast expanse of sky clearly dominating the scene. As the clouds roll overhead they cast dappled light on the landscape, while a burst of sunlight illuminates the gently rolling incline on the horizon line.

In order to capture the transient effects of Irish light the artist has worked rapidly. His brush strokes are quick and vigorous, the paint applied in thick layers of impasto. The palette is quite restricted: Hone limits himself to greys, blues and greens – colours which best describe the landscape of Ireland.

Although painted later in the artist's life, the picture reflects Hone's training in France. In 1853 he had gone to Paris to study art, and here he met artists working in the Barbizon area outside the city. Their concerns with recording the ephemeral effects of light and shadow in nature are reflected in this painting. The flecked brush strokes in the foreground indicate, too, his awareness of Impressionist techniques and their ability to impart a vivid sense of immediacy. Hone exhibited *Pastures at Malahide* several times during his lifetime.

WALTER FREDERICK OSBORNE
Dublin, 1859–1903

In a Dublin Park, Light and Shade
c.1895
Oil on canvas, 71 × 91cm
Purchased 1944
NGI 1121

Walter Osborne was a remarkably versatile artist, painting genre scenes, portraits and landscapes with equal skill. This scene, set in the Phoenix Park in Dublin, combines his interests in genre and landscape. It was painted after his return to Dublin from England where he had spent some years painting rural scenes.

Five people share a bench in a cool, leafy corner of the park. Shabbily dressed, they are clearly the poor of the city. Their ages range from baby-hood to old age. Osborne's decision to arrange them in a manner of a frieze suggests that the group may represent an allegory of life. With the exception of the infant lying asleep on his mother's lap, all of them seem to be preoccupied with their own thoughts. The artist's empathy with the working class of Dublin is evident in his treatment of the figures. The old man with the bowler hat and cane is accorded the dignity of an elder statesman, while the viewer's sympathy is evoked by the care-worn face of the young mother.

Osborne is also concerned with recording the filtering of light through the trees as it scatters rays of sunshine on the figures. In order to render a sense of immediacy to the scene he lays the paint thickly on the canvas with quick, confident brush strokes. Impasto is used to create the effect of dappled light throughout.

Osborne initially trained at the Royal Hibernian Academy Schools in Dublin and went on to further studies in Antwerp. He visited Brittany in 1883 and spend some years in England before returning to Ireland in 1892. He was influenced by *plein air* painters and the techniques of the Impressionists.

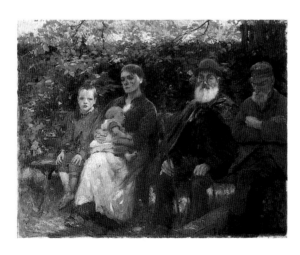

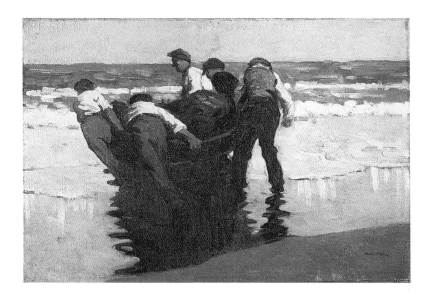

Paul Henry
Belfast 1876–1958 Bray

Launching the Currach
1910–11
Oil on canvas, 41 × 60 cm
Purchased 1968
NGI 1869

The picture portrays a common feature of life in the west of Ireland. Five men push their boat into the sea. The currach is a small boat of wickerwork and hide, materials used in this region because of the shortage of wood. The vessel is a versatile one: it is light enough to be carried by one man, and able to negotiate both shallow waters and rough seas.

Henry's record of the activity of fishermen on the island of Achill, off the coast of Co. Mayo, is an excellent example of his ability to convey the essence of life in this part of Ireland. The artist and his wife, Grace, also a painter, spent a month on the island in 1910; two years later they returned, and remained there on and off for the next seven years. Henry was attracted by the stark beauty of the place and the rugged existence of its inhabitants. His early paintings portray the activities of the islanders, but he soon realized that the residents were not altogether eager to be included in his sketching scenes. They felt that by drawing or painting their likeness, Henry was removing part of their souls. This painting, therefore, is likely to have been painted from memory or done furtively. Later Achill paintings concentrate on the landscape itself with its distinctive thatched cottages, mountains, bogs, lakes and cloud-filled skies.

It is Henry's images that, above all, have come to represent the quintessential essence of Ireland as seen on postcards and in various types of travel literature. Henry had initially trained in Belfast before going to Paris in 1898.

John Lavery

Belfast 1856–1941
Kilkenny

*The Artist's Studio:
Lady Hazel Lavery
with her Daughter
Alice and Step-
Daughter Eileen*

1909–13
Oil on canvas,
344 × 274 cm
Purchased 1959
NGI 1644

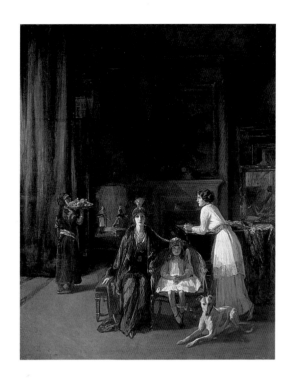

Born in Belfast and trained in
Glasgow, London and Paris, John
Lavery settled in London, where he
established himself as a celebrated
portraitist. His sitters included
leading figures of international
society as well as British royalty. This
impressively large portrait depicts the
artist's wife Hazel, her daughter
Alice from her first marriage and his
daughter Eileen by his first wife. The
painting was begun in his London
studio in 1909. Hazel Lavery is
fashionably dressed in a feathered
turban and richly coloured silk and
satin Paisley coat. Alice is seated in a
basket chair while Eileen leans
gracefully across the grand piano.
The family dog, Rodney Stone, lies
at the feet of the two girls. In the
background Ayisha, the black maid,

is seen entering the room bearing
a salver of fruits. Also visible in
the portrait is the artist himself.
Reflected in a mirror, his palette and
brush clearly visible, Lavery paints
himself studying the group of figures
he is portraying.

The painting is striking for its
sense of immense space, the
modelling of the figures in light and
shade, the fluid handling of paint and
its eye-catching colourful passages.
The composition is based on *Las
Meninas* by Velázquez, a painter
much admired by Lavery. The
grouping of the figures in the fore-
ground, the reflection of the artist in
the distant mirror, the position of
the dog and above all, the scale of
the interior, all recall Velázquez's
famous painting of 1656.

William Leech

Dublin 1881–1968
Surrey

*A Convent
Garden, Brittany*

c.1913
Oil on canvas,
132 × 106 cm
Presented by May
Botterell, 1952
NGI 1245

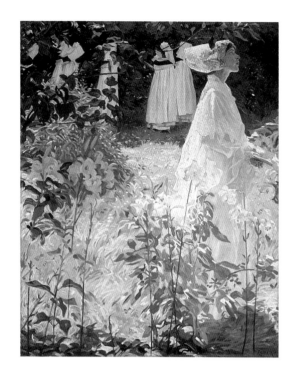

A novice is shown deep in spiritual meditation. With prayer book in hand she gazes upward as if in direct communication with Heaven itself. Behind, in the shadows of a tree-lined walled garden, are a group of nuns, walking in prayer. While they are dressed in plain religious garb, the novice is robed like a bride. Novices traditionally wore bridal costume on the day they took their final vows, as a symbol of becoming brides of Christ.

Sunlight streams into the garden. It falls on the lace habit and bonnet of the young novice, revealing the slim, elegant form beneath. The garment's delicate shades of mauve and lilac, as well as white and green, reflect the colour of the flowers and grass close by. The thick strokes of colour show Leech's interest in Impressionism,

and also suggest the influence of Van Gogh. This is offset, however, by the careful drawing and paintwork in the girl's figure. Her stillness set against the waving leaves and grass provides an interesting note of contrast in the picture.

The setting is Concarneau in Brittany. This picturesque part of France held a special attraction for Leech, as it did for many other artists. He visited the area frequently between 1903 and 1917. In 1904 Leech contracted typhoid and convalesced in a local hospital run by the Sisters of the Holy Ghost. It is this garden which is represented in the picture. The model for the novice is Elizabeth Saurine, the artist's first wife.

William Orpen

Dublin 1878–1931 London

The Holy Well

1916
Tempera on canvas,
234 × 186 cm
Purchased 1971
NGI 4030

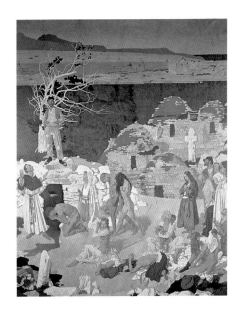

From 1913 to 1916 William Orpen painted several pictures which relate to the Celtic Revival. From the last decades of the nineteenth century, artists, writers and political ideologues had come to regard the west of the country as the 'real' Ireland, and those who lived there as the embodiment of a 'pure' Irish race. Orpen, however, did not wholeheartedly embrace this construct of national identity. The large canvas depicts Ireland's Celtic heritage with a sardonic eye and is an anti-romantic comment on the fanciful idealization of western peasant culture.

He bases his scene on the old practice when, on 'pattern days', people would gather to pray at a holy site associated with a local saint. The location is an island off the west shore of Ireland and the typically barren stony landscape of that region provides a backdrop for the those gathering at the well. They are in varying states of undress. A monk stands to one side of the well and blesses the naked figures. Above him stands an amused figure dressed in peasant costume, observing the scene below. It was not customary for people to undress as part of the ritual, especially in Ireland, a country noted for its sexual prurience. Thus Orpen is poking fun at the superstitious nature of these religious practices. Rather than symbolizing the nobility of the Irish he suggests instead that the Irish peasant is foolish and gullible.

Orpen was an exceptionally versatile and technically brilliant artist, and a major influence on the next generation of Irish artists. All the figures were painted in a new 'marble' medium, a technique developed at that time by Windsor & Newton, which gave to the canvas a flat, opaque quality something like tempera.

OLIVER
SHEPPARD

Cookstown 1865–1941
Dublin

*'In Mystery the
Soul Abides'*

1913
Marble, height 62 cm
Purchased 1942
NGI 8091

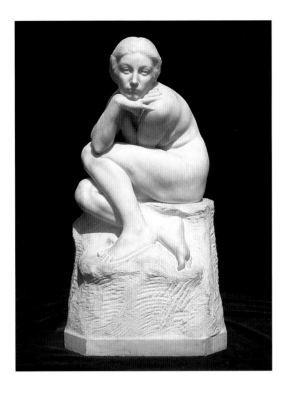

This marble statue is striking for its meditative qualities, both in pose and expression. The young girl, with legs crossed to one side, leans her chin on one hand, while the other is placed across her breasts. Gazing into the distance, the eyes are dreamy yet reflective. She seems totally unaware of the viewer, so deeply absorbed is she in her thoughts. The title of the sculpture offers a clue as to the subject of her meditation. The line is freely taken from a poem by the English poet, Matthew Arnold, entitled 'Morality'. In the opening lines the poet reminds the reader:
*'We cannot kindle when we will/
The fire which in the heart resides./
The spirit bloweth and is still./
In mystery our soul abides.'* Sheppard's small, quiet, thoughtful figure is perhaps pondering on the enigma of the life force of the spirit.

The quality of the carving – from the delicately wrought strands of hair and the careful delineation of every finger and toe-nail, to the naturalistic treatment of the torso – is indicative of the artist's talent. Having trained in Dublin and London, Sheppard was later to become Professor of Sculpture at the Royal Hibernian Academy, Dublin. His work consists mainly of sculpted portraits and romantic subjects, often of a Celtic flavour. He also designed a number of monuments including the well-known *The Death of Cuchulain*, on display in the General Post Office, Dublin.

Sean Keating
Limerick 1889–1977 Dublin

An Allegory
*c.*1922
Oil on canvas, 102 × 130 cm
Presented by the Friends of the National
Collections, 1952
NGI 1236

An Allegory was painted towards the
end of 1922, at a time when civil war
was raging in Ireland. It depicts
disparate groups of people connected
with this event but who, to all intents
and purposes, seem to be unaware of
each other's presence. The setting is
in a parkland before a large gutted
house. In the foreground, which is
dominated by the gnarled trunk of a
tree, members of the regular and
irregular armies dig a grave. A coffin
draped in the tricolour flag of Ireland
lies on the ground beside them. Close
by, a clergyman converses with a man
in business attire. Two more figures
are seated at the base of the great oak
tree, a mother holding a child to her
breast and a man reclining on the
ground, full of brooding intensity.

The painting obliquely conveys
two messages: the loss of ideals for
Ireland as a consequence of the Civil
War, and the artist's personal
response to this. After the valiant
fight to gain independence, national-
istic ideals were ruthlessly sacrificed
for radically different visions of
freedom. The reference to the dead,
and the ruined house behind, are
reminders of the destructive force of
conflict. The two figures who dig the
grave, symbolically turned away from
each other, indicate the internecine
horror of civil war. The other figures
in the painting are representative of
the tragedy that engulfed all sections
of Irish society. The glowering,
sprawling figure in the foreground is
a self-portrait of the artist, registering
his bitter disillusionment at this turn
of events.

Sean Keating is best known for his
treatment of contemporary Irish
themes, and also for his portrayal of
rugged Irish types.

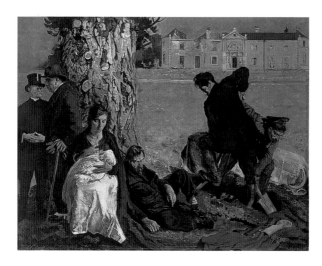

Mainie Jellett
Dublin, 1897–1944

Decoration
1923
Tempera on panel, 89 × 53 cm
Evie Hone bequest, 1955
NGI 1326

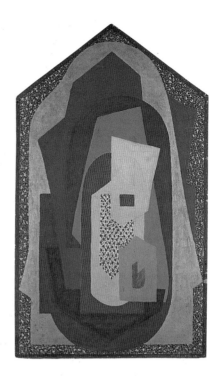

A number of coloured shapes are superimposed on one another, creating a sense of depth on the flat surface of the panel. The relationship between the angles of the different shapes encourages the eye to explore the work in a circular movement, thus suggesting an internal motion and rhythm. Although abstract, the picture strongly recalls icon painting through the shape of the panel, the use of gold paint and the choice of tempera (colour pigment mixed with egg yolk rather than oil) as a medium.

This painting, along with a similar abstract work, created a sensation when it was first exhibited at the Society of Dublin Painters Group Show in 1923. The reviewer from the *Irish Times* wrote that he could not understand the works: 'They are in squares, cubes, odd shapes and clashing colours. They may, to the man who understands the most up-to-date modern art, mean something; but to me they presented an insoluble puzzle.' Another reviewer of the same exhibition talked of the 'sub-human art of Miss Jellett'. This fierce onslaught on the first abstract work to be exhibited in Dublin sparked off a controversy about modern art that was to last for the rest of the artist's life.

Having trained initially in Dublin and in London, Maine Jellett went to Paris in 1921. There she studied under André Lhote and Albert Gleizes. Enriched by her contact with modern art, her own work is marked by its focus on rhythm and movement, colour and form.

Grace Henry

Peterhead 1868–1953
Dublin

*Still Life with
Marble Torso*

1920s
Oil on canvas,
59.7 × 49.5 cm
Signed: *G. Henry*
NGI 4664

Although Grace Henry is best remembered for her paintings of the west of Ireland, she also produced many still-life and flower subjects. *Still Life with Torso* offers an interesting variation on the still-life theme. The collection of objects placed close to each other include a truncated marble torso, a book, a framed picture and some heavy draperies of varying hues and patterns. The whole ensemble is sharply lit from the left, resulting in interesting light and shade effects on the surface of the marble. The bright white of the stone is softened by a series of subtle shadows emanating from the blue and deep purple of the draperies and the yellow cover of the book. Light catches also on the lower edge of the picture frame, which is painted in a striking red.

Aside from her interest in the reflective qualities of light, the artist is clearly fascinated by unconventional viewpoints. There is no single perspective in the composition. Instead, the objects of still life are seen from a variety of perspectives. The torso is viewed from below, while the framed picture hanging suspended in mid-air is viewed at a slightly different angle. The draperies behind and on the table, falling in a haphazard way, prevent any sense of the composition being grounded in a definite horizon line.

Grace Henry travelled and studied art in Belgium and France. In 1900 she was in Paris where she met her future husband, the painter Paul Henry. Her interest in modern art is evident in this work with its unusual colouring and viewpoints.

MARY SWANZY
Dublin 1882–1978 London

A Clown by Candlelight
1942–43
Oil on panel, 14 × 9 cm
R. Best bequest, 1959
NGI 1415

This tiny picture was painted in Dublin during the Second World War. Swanzy's home in London had been bombed, and she moved back to Ireland for a time. The clown sits at a table, head in hands, gazing thoughtfully at a candle, whose flickering light casts shadows on the wall behind. He seems lonely and withdrawn. The subject of the clown as a sad figure had already been used by artists such as Watteau, Rouault and Picasso. Swanzy's clown is her visual response to the troubled mid-war period, and to her own hopes and uncertainty about the future. During the war years her works were full of foreboding and disaster. She filled canvases with tortured figures, in attitudes of despair, which represent the effects of war on the psyche.

The art of Mary Swanzy is original and unconventional. Like a number of other gifted women artists, she was a champion of modernism in Irish art. After training in Dublin, she visited Paris where she was influenced by Post-Impressionism and Cubism. During her long career she travelled widely throughout central Europe and later to the South Pacific.

ALBERT POWER

Dublin, 1881–1945

Connemara Trout

1944
Marble, height 48 cm
Purchased 1949
NGI 8090

This striking sculpture of fish emerging from foaming waters was carved from a piece of Connemara marble, a stone distinctive for its green hues. While the large fish seem to rise victoriously from the rushing torrents of water, the smaller fish twist and struggle to survive the swift current. The artist cleverly exploits the different shades of colour in the block to suggest floating grasses and weeds. The tiny, naturally formed blemishes in the stone help create the illusion of small bubbles of foam, and the irregular shape of the marble piece evokes that of water and rocks. The theme, which represents the struggle for life, relates to the sculptor's great love of fishing.

The work was first displayed at the 1944 Royal Hibernian Academy Exhibition, where it met with critical acclaim. Much of the artist's work is distinguished by his deliberate choice of Irish stone. He believed passionately in an Irish art and in the use of native materials wherever possible.

Gerard Dillon

Belfast 1916–1971 Dublin

The Little Green Fields

c.1945
Oil on canvas, 40.5 × 89 cm
Máire MacNeill Sweeny Bequest, 1987
NGI 4520

From the Second World War onwards Gerard Dillon made regular visits to Connemara in the west of Ireland. Like many Irish artists before him, he was inspired by the stark but beautiful landscape of mountains, sea and lakes. He was also captivated by the simple and innocent lifestyle he found there. The pace of country life was slow, in marked contrast to that of urban towns and cities elsewhere in Ireland. This scene contains elements typically associated with the western seaboard: the distinctive dry-stone walls marking out each plot of land, the thatched cottages, the activities of the people, their farm animals. The present is united to the past by the inclusion of a small graveyard, the figure of the sculpted monk, the abbey ruins, the dolmen and the high cross. Dillon employs simple outlines, flattened forms and sharp colour contrasts that recall the art of the Celtic Christian period. In this way the notion of a timeless place is further reinforced.

Dillon's unsophisticated, naïve style is particularly suited to the subject matter. It also reflects the fact that he did not begin to paint seriously until he was aged 30. He was an active member of many art groups and represented Ireland at several international exhibitions.

YEATS
COLLECTION

JACK B. YEATS

London 1871–Dublin 1957

The Liffey Swim

1923
Oil on canvas, 61 × 91 cm
Presented by the Trustees of the Haverty
Bequest, 1931
NGI 941

The Liffey Swim had been instituted as an annual city event in Dublin in 1920 and was important during the early years of the Free State. It was one of several Dublin scenes that Yeats decided to paint.

Perspective is interpreted freely in order to include every element of excitement. We see not only the spectators crowding the riverside on Bachelor's Walk, in the foreground, and those with a grandstand view on the trams passing behind them, but also the throngs on O'Connell Bridge in mid-distance and on the opposite quay. There is a wide range of types of every age and of every standing in society. The man in the brown hat, picked out to left of centre, may be the artist taking notes – not the first

time he had appeared in his own work. If so it would underline the active association of the painter with what he paints, a theme that was to become very important to Yeats in his later, subjective, work.

The graduated posture of the spectators as they lean forward to watch the swimmers progressing down the river produces an illusion of group movement in the classical manner. Despite this, the style is modern and confident. Brushstrokes are broad and free. Colours are rich, and the whole gives the impression of having been painted with great rapidity. Emotion is now implemental in the composition, expressed in the actual application of paint and in colour that is deliberately intrusive. Thus red – positive and aggressive – tints the water around the desperate striving of the nearest contestant. The spectators, by contrast, are painted in passive greens and blues, and pink in the clouds reflects the general mood of optimism.

The Liffey Swim was awarded a silver medal at the Paris Olympic exhibition in 1924.

Jack B. Yeats
London 1871–Dublin 1957

A Morning in a City
1937
Oil on canvas, 61 × 91 cm
Presented by the Trustees of the Haverty
Bequest, 1941
NGI 1050

Yeats lived in Fitzwilliam Square from 1929, in the centre of Georgian Dublin. His city subjects assumed a romantic mood, especially in the last years of the 1930s, and reminiscence became an important element of his compositions.

A Morning in a City depicts the artist strolling in a place of past and present memories. The classical houses that line the street in which he walks glow a dull red in the early morning light, and the warm colour of the brickwork stains the light and mood of the city. Dim figures hurry, or walk collectedly, through the streets: an efficient girl going towards the office, a man bent over his barrow, the postman with his sack, a businessman and, beyond him, a newspaper boy (a favourite subject with Yeats). From a lighted doorway in the house to the left another vague figure emerges. All are ghosts, elements of a continuously fluctuating life beneath the distant sky, whose pink fingers of light are breaking through to the blue of daytime.

The artist joins the busy procession of the various professions – some lowly, others more privileged – but he is also separate. He can contemplate the mass around him, and soak in the scene from his cocoon of loneliness as he wanders in isolation through the indigo shadow of the old houses beyond and the green of the trees in the square. In some paintings Yeats's manner of reminiscence is more personal and idiosyncratic, but here his mood is Wordsworthian, quickened to the spirit of the city itself and of the people who inhabit it. He is endorsing his identification with city life and, at the same time, making his artistic detachment evident.

Jack B. Yeats

London 1871–Dublin 1957

Four Scenes in Search of Characters: Scene One – Beginning with Naples

1942
Oil on panel, 23 × 35.5 cm
Purchased 1992
NGI 4581

Four Scenes in Search of Characters are four stage sets without figures painted in 1942 and first exhibited at a theatrical exhibition held in the Contemporary Picture Galleries, Dublin, in November of that year. They were originally framed together. The fact that the title echoes that of Pirandello's play *Six Characters in Search of an Author* (1921) not only indicates Yeats's fascination for modern drama but is also a reminder of his personal association with the Theatre of the Absurd.

Yeats had always enjoyed drama, particularly the melodrama of the early years of the twentieth century, which he imitated in his own plays

for miniature stage. During the 1930s he returned to playwriting. In 1939 *Harlequin's Positions* was produced at the Abbey Theatre. In 1942 *La La Noo* appeared, with *In Sand* in 1949. In these he knitted together a love of music hall theatre with a deeper, more contemporary approach that was influenced by cinema – which also had its effect on paintings of this period.

Scene One of the *Four Scenes in Search of Characters*, set in Naples, recalls the adventures of Yeats's early heroes, although none of his juvenile dramas is set in Italy. Vesuvius can be seen jettisoning flames into the dark blue sky. In the foreground is a terrace looking on to the sea. The buildings to each side have coloured awnings and inviting entrances, and the scattered chairs, the grotto-like arch, and the opening in the balustrade where there must be a path up from the sea, are ready for action. The choppy sea and the volcanic mountain are the only signs of life so far, awaiting the characters to make their entrance.

JACK B. YEATS

London 1871–Dublin 1957

Grief

1951
Oil on canvas, 102 × 153 cm
Purchased 1965
NGI 1769

Grief is undoubtedly one of Yeats's greatest paintings. Around 1951 Yeats was exploring particular human emotions in his pictures. *Grief* seems to originate from a sketch he made in his last workbook, which he entitled *Let there be no more war*. In the centre of the drawing two figures are indicated as '2 old men tattered with old wounds', and women and children lie among weapons near them. There is a snake, and further armour, and mist. The sketch was an initial thought, and has little to do with the final picture; but, like other notes in the same book, it seems to have been an essential means of holding on to the germ of an idea until there was time to paint it. Yeats's mind, especially during the last years, was ceaselessly inventive.

The theme is projected powerfully in oil. Through the simplest images, with the iconic power of Picasso's *Guernica*, Yeats conveys his utter abhorrence of war. Two rows of houses, indicating a typical Irish country town, are laconically described. Between them pours a crowd of angry fighting men, painted in a tossing indigo which is broken only by the green of a figure in the left foreground, who is perhaps fleeing from the soldiers. The leader, an apocalyptic phantom on a white horse framed between the houses, gestures aggressively. The destroyer is surrounded with brilliant red, giving the effect of flames.

In the foreground, an old man with white hair and face crouches, dazed, looking at the blood dropping into his hands. Isolated to the right of the picture's centre in a cocoon of empty canvas, a mother, in a typical Yeatsian pose of feminine protectiveness, puts her arm around a small child. He has yellow hair, and is in some ways the dominant image in the painting, the prototype of vulnerable innocence. His hands, and the lower part of his body, are red with blood.

JOHN BUTLER YEATS
Tullylish 1839–New York 1922

John O'Leary

1904
Oil on canvas, 112 × 87
Presented 1926
NGI 869

John O'Leary was arrested for high treason during the Fenian campaign in 1865. He was sentenced to 20 years penal servitude, five of which were spent in Mountjoy Jail and in England, and 15 in exile in France. This portrait, painted for the American collector John Quinn, is undoubtedly the masterpiece of John Butler Yeats's career. Yeats had known O'Leary well in Dublin and London, and numerous sketches indicate that O'Leary was of great interest to him artistically. The artist's son, W.B. Yeats, in his memoirs judged O'Leary's head 'worthy of a Roman coin'.

Yeats had painted O'Leary's portrait twice before; both works are in the national collection. In the 1887 portrait (NGI 1963) he has the alertness of a man let out from the dark, while that of 1891 (NGI 595) casts him as a thinker. This last portrait, painted three years before O'Leary's death, resembles an amalgamation of the previous two. A photograph of him, taken at prison only hours after receiving his sentence, has the same aspect of thoughtful suffering as that seen here, with deep furrows under the eyes.

The artist conceived the portrait in Venetian style, with a swathe of curtain behind the patriarchal image, the sitter's compelling blue eyes evocative of ageless wisdom. He is seated quite casually in a library chair, and looks straight at the viewer, his slender fingered hand lying on the broad brim of the voyageur's hat perched on his knee. He is illuminated from the left, in a golden brown background that complements the grey of his garments. The portrait is painted in the artist's most flowing 'impressionist' manner; Yeats is obviously inspired and exhilarated by this further visual encounter with a man for whom he and his poet son had such admiration.

The portrait was exhibited in Lane's exhibition of Irish art at the London Guildhall in spring 1904. After he moved to New York, in 1907, Yeats exhibited with the Independents, borrowing the *John O'Leary* from Quinn; and the portrait was exhibited again in New York in November 1910.

GREEK AND
RUSSIAN
PAINTING

CONSTANTINOPLE SCHOOL

First quarter of the 14th century

Virgin and Child, St John the Baptist and Prophets

c.1325
Egg tempera and gold leaf on wood,
132.7 × 111 cm
Purchased 1968
NGI 1858

The Virgin is in the pose known in the Byzantine tradition as *Hodegetria or Indicator of the Way, that is, holding the blessing Child and pointing to him.* Of all the images of the Mother and Child this is the most frequently represented by the Eastern Church because the prototype of this composition was once held in Constantinople and, according to legend, was depicted by St Luke.

In our case the icon appears to have been painted during the Palaeologan dynasty (1261–1453) when the Byzantine capital became once again a supreme artistic centre.

The Virgin wears the purple maphorion, decorated with gold rosettes, and the Child a gold tunic. On the originally gilt background are the red letters M P Φ Y (Mother of God) and on the corners are two small archangels. The small busts of St John the Baptist, at the top, and 12 prophets, around the sides, are a later addition, probably carried out in the fifteenth century.

Constantinople School

Late 11th century

Crucifixion with the Virgin and St John the Evangelist

1390s
Egg tempera and gold leaf on wood,
37 × 31 cm
Purchased 1968
NGI 1843

A calm and rhythmic composition expresses the dramatic event in the classical manner. After death, Christ's body hangs limply on the cross. On his left his Mother points towards him indicating his sacrifice. To the right St John is plunged into grief while two angels are weeping in the sky. Behind the figures are the walls of Jerusalem. Ingeniously, the artist has tried to give some sort of perspective to the cross, but the overall scene remains two-dimensional.

Byzantine icons are sometimes difficult to date because of their frequent repetition of canonical images. This is the case of our panel, which may be presumed to have been painted at the end of the fourteenth century.

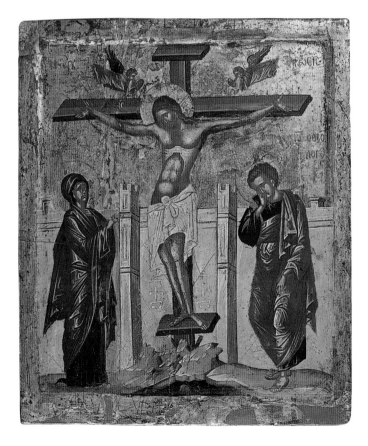

Novgorod School

First half of the 15th century

St George and the Dragon

1400s
Egg tempera on wood,
73.5 × 63 cm
Purchased 1968
NGI 1857

According to legend, St George was born in Cappadocia at the time of the Emperor Diocletian. Of Christian faith, he was a tribune in the Roman army. One day, when his legion reached the town of Selene in Libya, he was met by local people who entreated him to help them in their struggle against a horrible dragon. The fearless George, protected by God, confronted the monster and after a long combat killed it, thus saving the next victim, the young daughter of the king.

St George was greatly venerated in Eastern Europe and particularly in Novgorod, where he was considered the patron saint of the reigning princes. In our panel the saint is represented astride a beautiful white horse and spearing the winged dragon that has emerged from the neighbouring marsh. At the top right corner the blessing hand of God appears, while on the left a bust of St Nicholas is depicted. This an elegant composition, with its lively imagery, is a good example of the level of quality achieved by the Novgorod School at this time.

DECORATIVE
ARTS

ROMAN

1st century AD

Cinerary urn

Inscribed: D[IS] M[ANIBUS] / PHILOCALO /
C ☉ S / VLPIA·ATTICLIA / CONIUGE
M[ERENTI]F[ECIT]
White marble, no lid, 43 × 37.3 × 27.3 cm
Milltown gift, 1902
NGI 8279

Designed in the shape of a house,
according to a tradition of the ancient
Italic people, this urn is elegantly
decorated on the front only. A framed
tablet at the centre carries a funerary
inscription. Loaded festoons of fruits
are suspended from palm trunks at
the corners. Along the top a garland
supports the head of a gorgon,
flanked by two lively pelicans and two
goat heads. The door at the bottom
indicates the entrance to the house of
the departed spirits, the kingdom
of Pluto. Unfortunately, the lid is
missing, which normally would have
been shaped as a roof.

We do not know where the urn was
found but it is recorded that James
Russell, an English painter who was
active as an agent of art works for
many Grand Tourists, exported it
from Rome in 1751. In this case he
was acting on behalf of Joseph
Leeson, a wealthy Irish collector, who
built Russborough House and later
became the 1st Earl of Milltown.

SPANISH

14th century

Processional cross

Gilt copper and
bronze with rock
crystal cabochons
and coloured glass,
height 79.9 cm
Mr J. Hunt bequest,
1977
NGI 8324

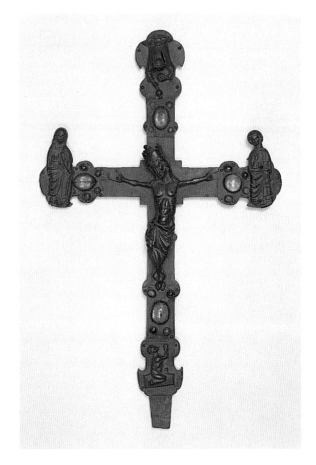

A beautiful example of medieval
Spanish craftsmanship, this proces-
sional cross is stylistically related to
contemporary production in Aragon.
This type of cross was normally
fixed at the top of a wooden shaft
and carried by a clerk during
religious processions. Because of
this exposure, such crosses were
decorated on both sides. Here, the
figures are decorated in gilt copper
both on the front and on the verso.
At the terminals copper trefoil sheets
have been applied, decorated with

cabochon glass stones on the front
and small pieces of coloured glass on
the verso.

Christ is represented on both sides
of the cross. On the front he is seen
hanging dead from the cross; at the
terminals are respectively the Virgin,
St John, a kneeling Adam and an
angel emerging from the clouds with
a thurible (incense burner). The verso
shows the enthroned blessing Christ
at the centre, and the symbols of the
four Evangelists.

ROMAN
17th century

Altar crucifix

*c.*1630s
Gilt bronze and lapis lazuli, height 108 cm
Purchased 1966
NGI 8014

This splendidly decorated crucifix is
typical of art in Rome during the
early Baroque period. The dead
Christ hangs limply from the cross
with his head falling heavily to one
side. His figure is modelled in classic
form in the manner of an earlier
example created by Giambologna and
possibly adapted by Alessandro
Algardi. The crucifix is very elegant,
and the contrasting combination of
blue and gold gives it a precious
appearance.

The figure of Christ, alongside the
cherubs, the skull and cross bones
and the 'INRI' cartouche are all made
of gilt bronze, while the cross and
stand are covered with lapis lazuli.
Everything seems to suggest that this
highly prized crucifix would have
been destined for an important
religious institution in one of the
major European centres.

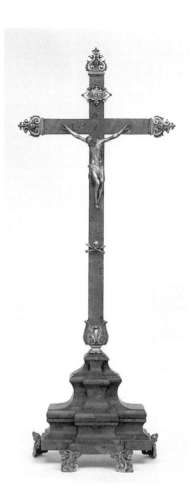

South German School

17th century

Mars and Venus discovered by Vulcan

Late 17th century
Boxwood, 13.6 × 24 cm
Milltown gift, 1902
NGI 8213

This small carved bas-relief is one of a pair of mythological scenes, probably acquired by the 2nd Earl of Milltown during one of his numerous Grand Tours around Europe. The incident shown here represents the embarrassing episode of Venus and Mars surprised during their lovemaking. According to legend, Venus was forced by Jupiter to marry the unattractive Vulcan but the goddess, repelled by her deformed husband, soon started to betray him with other gods. One day, while she was lying with Mars, the sun (Apollo) revealed the adulterous relationship with his rays. Enraged by the discovery, Vulcan imprisoned the two lovers with a metal net that he appositely forged, thus exposing the lovers to the laughter of the other gods on Mount Olympus.

A tradition of fine carving in every sort of wood had existed in Germany and Austria since the Middle Ages. This skill is well displayed in this remarkable work, which is executed in boxwood, one of the hardest woods that exists.

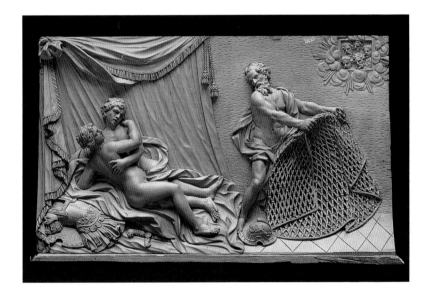

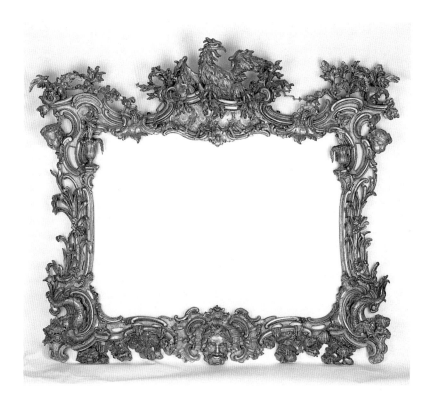

IRISH

18th century

Overmantel

Late 1740s
Gold leaf on carved wood, 210 × 234 cm
Milltown gift, 1902
NGI 12,158

This spectacular Irish mirror frame
comes from Russborough in Co.
Wicklow, the country house of the
Earls of Milltown. The overmantel
was certainly made during the late
1740s, while the house was under
construction. At this time, over a
period of nearly 10 years, craftsmen
from many parts of Europe
contributed to the creation of one
of Ireland's most magnificent
mansions. This extraordinary work
can be seen as significant proof of an
indigenous Irish rococo style. The
rococo initially developed in Ireland
most probably due to the presence of
Italian stucco-workers and French
Huguenot wood-carvers; soon,
however, a skilful and imaginative
local school was firmly established.

The mirror frame is decorated with
great fantasy with scrolls, *rocailles*,
water plants, fish, shells, vases and
putti heads. The centrepiece at the
top is an eagle with open wings and
thunderbolts, the symbol of Jupiter,
while at the bottom a classical head of
a river god is framed in a cartouche.

Gaetano Gallella

Italian, active second half of the 18th century

Fan with a bacchanal

Signed: *Gae / Gallella*

Mother-of-pearl fan with 19 sticks, carved, pierced, gilt and silver appliqués, painted and the guards similarly worked.
Length of guard 26 cm, span 47.5 cm
Milltown gift, 1902
NGI 12,042

Fans have been used from very early times, but during the eighteenth century they became particularly fashionable all over Europe. Topographical scenes and classical subjects were the most typical images of the Italian repertoire.

The scene depicted on the span of this fan is apparently a bacchanal. Seated at the centre is Silenus, the son of Pan, portrayed as a fat, jolly old man, while behind him two satyrs are providing wine for his cup.
A bacchante is kneeling in front of him with a bunch of grapes in her hand. To the left are two more revellers, one of whom is lying on the ground inebriated, and on the far

right a group of young people are conversing near a fountain. Almost all the figures are copied from the ceiling of the salon of the Palazzo Barberini in Rome, painted by Pietro da Cortona during the previous century. On the verso, a less important subject is painted: a picturesque ancient arch called the Arco Oscuro, located near Villa Giulia, also in Rome. Yet another classical theme, the Triumph of Galatea, is represented on the front of the mother-of-pearl sticks, carved within *rocaille* motifs.

Harry Clarke

Dublin 1889–1931 Coire

The Song of the Mad Prince

Signed: *HARRY CLARKE.1917*
Stained glass panel,
34.3 × 17.7 cm
Purchased 1987
NGI 12,074

Clarke was a leading exponent of the Celtic Revival and of the Irish Arts and Crafts movement at the beginning of the twentieth century. Attracted by the artistic language of the Symbolists, he created in that style innumerable beautiful images derived from literature, medieval legends and religious sources. Extremely talented, his ability was equally impressive in different media but his greatest success was achieved as an illustrator of books and as a designer and maker of stained-glass panels.

This miniature panel was inspired by a moving poem written by Walter de la Mare. In it Clarke explored some new technical solutions, aciding and plating together two double pieces of glass of different colours to achieve his desired combination of hues. Once polished, the stained glass was inserted in a walnut cabinet created by James Hicks of Dublin.

WATERCOLOURS, DRAWINGS AND PRINTS

Andrea Mantegna
(attributed to)

Isola di Carturo c.1431–1506 Padua

Portrait of Francesco Gonzaga

Black chalk and grey wash with white
highlights, 34.8 × 23.8 cm
Purchased 1866
NGI 2019

In 1484, Francesco Gonzaga
succeeded his father and became 4th
Marquis of Mantua. His distinctive
features, which were recorded on a
number of medals at that time, are
easily recognizable in this drawing.
Although Francesco did not have a
reputation as an intellectual – he
was more interested in horses and
chivalric romances – he was a
considerate patron to Mantegna.
Francesco's wife, Isabella d'Este,
however, was a notable patron of the
leading artists of Renaissance Italy,
and commissioned from them
paintings on learned subjects for her
studiolo (study).

This highly finished drawing is of
a type that was popular in Italy during
the Renaissance. Drawings such as
this provided a cheaper and more
easily transportable alternative to
painted portraits; they could be given
to visiting dignitaries or sent to other
important figures.

Andrea Mantegna moved to
Mantua in 1459 to work for
Francesco's grandfather, Ludovico
Gonzaga (1412–78). He remained
there for the rest of his life, with the
exception of a two-year stay in Rome.
He first depicted Francesco at the age
of six in the *Camera degli Sposi*
frescoes in the Ducal Palace.
Although Mantua was not politically
very important during Mantegna's

lifetime, it was close to the centres of
recent artistic developments based
around a revival of interest in the
classical past. Mantegna's works,
especially the later ones, dating from
after his visit to Rome in 1488–90,
are strongly influenced by these new
currents.

Other artists worked in Mantua at
the same time as Mantegna and it has
been suggested that this portrait is
the work of one of them, Bonsignori.
It is, however, is of better quality than
most drawings by that artist.

CLAUDE VIGNON
Tours 1593–1670 Paris

Porcia

1630
Red and black chalk,
32.1 × 21.4 cm
Former RDS schools
collection, transferred from
the National Museum of
Ireland in 1966
NGI 3837

Porcia was the wife of Brutus, the chief conspirator in the assassination of Julius Caesar which took place in 44 BC. After her husband committed suicide Porcia killed herself by eating burning coals, and this was seen as the ultimate act of loyalty. During the seventeenth century artists in France and Italy produced a number of series of works depicting heroic women of history, and Porcia was often included. This drawing is one of 20 by Vignon destined to be reproduced in prints for one such series; only five of the drawings survive today. The drawing for *Paulina*, and an impression of the print of *Porcia*, are also in the Gallery's collection.

Claude Vignon, like many European artists of the time, spent several years in Rome early in his career, where he was partially influenced by the followers of Caravaggio. After the artist's return to France in 1622 King Louis XIII and his minister Cardinal Richelieu commissioned paintings from him. A prolific artist, Vignon also provided designs for the leading print publishers in Paris, although few of his drawings survive.

Porcia is typical of the compositions for the series. The foreground is dominated by the monumental figure of the heroine, while visible in the distant background, on a very different scale, is the scene of her suicide. The facial features are characteristic of all of Vignon's female figures.

JAN BOTH

Utrecht, *c*.1615–1652

The Wooden Bridge

Pencil, brown ink and grey wash,
18.4 × 26.4 cm
Purchased 1887
NGI 2020

Jan Both spent some years in Rome in the late 1630s and early 1640s, where a number of artists, including Claude, Poussin and Herman van Swanevelt, were devising new forms of landscape. They went into the hills outside Rome to sketch, and would later use these drawings as sources for paintings. Although no paintings can be dated to Both's Roman period, he continued to produce Italianate landscapes after his return to Utrecht. Evocations of Rome were highly prized by the seventeenth-century imagination, and paintings of Italianate landscapes were popular all over Europe. Because he returned to the Netherlands and worked there, Both was particularly important in bringing Italianate art into northern Europe. As early as the seventeenth century, English collections, for example, contained paintings by him.

Few drawings today can be identified as being definitely by Both, and this is one of an even smaller number that can be directly linked to his activity as a printmaker. It is a preparatory drawing used to make an etching, entitled *The Wooden Bridge, Sulmona, Tivoli*. Indentations can be seen on the paper. These were made when the drawing was placed directly on the copper printing plate and the design transferred by making incisions along the outlines. In all, Both produced only 10 original etchings, after his own drawings, which underlines the rarity of this work.

ROBERT HEALY

Dublin 1743–71
Dangan

Self-Portrait

Signed and dated:
R.Healy 1765
Black and white
chalk,
57.5 × 42 cm
Purchased 1901
NGI 2438

This portrait shows the artist in a relaxed pose against a dark background, which is typical of his bust-length portraits. In his full-length portraits, Healy generally depicted his models in a natural setting. Because he never used colours, it has been suggested that Healy was colour-blind.

Robert Healy was the son of a successful Dublin architect and decorator. He studied at the Dublin Society Schools, where he learned the techniques of chalk and pastel. Healy's work is influenced by the portrait mezzotints of his slightly older compatriot, Thomas Frye, and the effect of Healy's grisaille chalks has been likened to that of mezzotint prints.

Healy was based in Dublin, but stayed frequently at the country houses of his patrons in order to make his portraits *in situ*. His masterpiece is a series of pastels he drew for Lady Louisa Conolly while staying at Castletown in 1765. He died a relatively young man, apparently from a cold he had caught while sketching in the park of another of his patrons, Lord Moira. During his lifetime Healy was particularly respected for his depictions of horses; however, few of these are known today.

James Malton

London c.1760–1803

The Custom House

Aquatint and etching,
36.5 × 52 (plate 31.5 × 43.3) cm
Purchased 1904
NGI 11569

James Malton is today best known for his 25 aquatint *Picturesque and descriptive Views of the City of Dublin*, which were first issued in sets of six between 1792 and 1799. In the announcement of the series, Malton, who was English, wrote that he was 'struck with admiration at the beauty of the capital of Ireland and was anxious to make a display of it to the world'. Although this was not the first set of views of Dublin, Malton's was the most popular and was reissued and copied several times. They show an idealized view, omitting the crowds and dirt typical of a late eighteenth-century city.

Most of Malton's depictions of Dublin's architecture were very accurate, but since the late eighteenth century a number of the city's landmarks have been restored and architectural details changed.
The Custom House was designed by James Gandon, the architect of a number of the city's most important buildings such as the Four Courts and the old Parliament House, which were also illustrated by Malton.

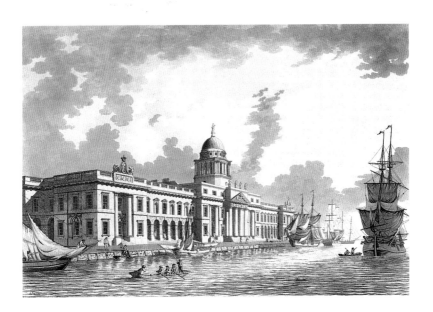

JOHN COMERFORD

Kilkenny *c.*1770–1832 Dublin

Portrait of Robert Emmet

Watercolour on ivory,
6.9 × 4.7 cm
Presented to the state by
R. Emmet, 1969;
transferred to the National
Gallery of Ireland in 1970
NGI 7341

This miniature, based on a sketch drawn from life, is perhaps the definitive image of Robert Emmet and is the source of many other portraits of him. The profile view and somber treatment of the patriot derives from French Republican portraiture.

Emmet joined the United Irishmen, an association that aimed to free Ireland from British rule, while he was a student at Trinity College Dublin and as a result was forced to give up his studies. He moved to France where he lobbied for support for an invasion to free Ireland. Emmet returned to Dublin in October 1802 and began to gather arms and recruits for an uprising. An explosion at one of his secret arms depots on 23 July 1803 forced him to call an early rising. Leading a small band of supporters he marched on Dublin Castle, where the Lord Chief

Justice and his nephew were killed. Emmet was arrested on 25 August, tried for treason and hanged on 20 September 1803, in front of St Catherine's Church on Dublin's Thomas Street.

In Ireland, miniature portraits of patriots and politicians were worn or displayed as an expression of political allegiance. Such portraits were especially popular after the unsuccessful rebellions of 1798 and 1803. John Comerford was the most successful miniaturist based in Ireland. He had studied at the Dublin Society Schools in the early 1790s and was influenced by the British miniaturist George Chinnery, who worked in Dublin from 1796 to 1802. He worked for the leading members of society in the city and exhibited regularly in Dublin as well as at the Royal Academy in London.

JEAN-ANTOINE WATTEAU

Valenciennes 1684 –1721
Nogent-sur-Marne

Woman seen from the back

Pencil and red chalk,
14 × 9.5 cm
Purchased 1891
NGI 2299.

Watteau is one of the greatest drafts-men in the history of European art. Most of his drawings are figure studies. Instead of preparing a composition and then making sketches of the poses he would need for it, which was the normal process, Watteau would draw a model in a number of poses without any specific composition in mind. When he was devising a painting, he would then turn to his drawings and pick out those that suited. In some cases he used sketches he had drawn a number of years earlier. Watteau was a master of the technique known as *aux trois crayons*, a combination of red, black and white chalks, usually on tinted paper. Under his influence, this technique was to become very popular in eighteenth-century France.

Rather than depicting subjects from ancient history or mythology, Watteau preferred to paint groups of young lovers in idyllic settings. He was criticized for portraying such frivolous subjects, which were known as *fêtes galantes*. Watteau seems to have been especially intrigued by the mysterious form of figures seen from the back: these occur frequently in his paintings, often as solitary figures detached from the main group. This drawing was engraved by Laurent Cars for a volume of engravings reproducing all of Watteau's known drawings, called *Figures de différents caractères*, published by the artist's friend Jean de Jullienne.

Joseph Mallord William Turner

London 1775–1851

Fishing Boats on Folkestone Beach

Pencil and watercolour, 18 × 26 cm
Bequeathed by Henry Vaughan, 1900
NGI 2415

Turner was the most important
British painter of the first half of the
nineteenth century and one of the
greatest landscape painters of all
time. The National Gallery of Ireland
has an excellent collection of water-
colours by this master, covering
almost his entire career.

Not only was Turner a consum-
mate interpreter of landscape but he
was also a master in the technique of
watercolour painting. This mastery
can be observed in the precise execu-
tion of this work, and the skill with
which the entire composition is

bathed in light from the sun. Turner
was very interested in the works of
the Old Masters, especially the
paintings of Claude, many of which
were in English collections by the
early nineteenth century. The treat-
ment of this view, with the sun near
the centre framed by objects to the
sides, is strongly reminiscent of
Claude's compositions.

Although this watercolour was not
included in the published version of
Ports of England, a collection of land-
scape prints, it is similar to those
made by Turner for this series and
may originally have been intended
for it. In the early nineteenth century,
such collections of views of England
became popular and Turner realized
early on that working for publishers
in the production of compositions
which could then be engraved
would be lucrative. Later, this allowed
him the freedom not to sell his oil
paintings.

DANTE GABRIEL ROSSETTI

London 1828–82
Birchington-on-Sea

Jane Burden as Queen Guinevere

Pen and brown ink,
19 × 15 cm

Signed with
monogram and dated
Oxford, 1858
Purchased 1883
NGI 2259

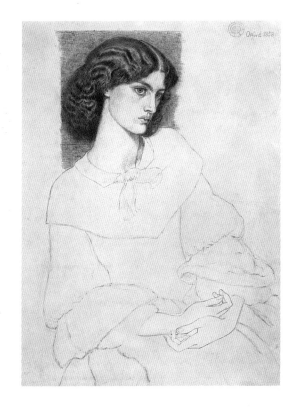

Jane Burden, who was 18 years old when she sat for this portrait, married the author and designer William Morris the following year, in 1859. The daughter of a groom, she is said to have met Rossetti at a matinee performance at the theatre. Later on, around 1870, she became the model and mistress of Rossetti, who portrayed her numerous times. This is perhaps the first portrait of one of the most important women in his life. With two friends, William Holman Hunt and John Everett Millais, Rossetti founded the Pre-Raphaelite Brotherhood in 1848. The critic John Ruskin championed this group and was a close friend and patron of Rossetti, buying and commissioning several works from him.

The Pre-Raphaelites, who wished to revert to a tradition of simplicity and realism like that found in early Italian art, aimed for a high degree of fidelity in reproducing nature and detail. Encouraged by Ruskin, Rossetti, with William Morris and Edward Burne-Jones, who were undergraduates at Oxford at the time, began in the summer of 1857 to paint scenes from Malory's *Morte D'Arthur* on the walls of the Oxford Union Debating Society. This drawing was a preparatory study for Queen Guinevere, intended for one of these murals which, however, was never executed.

SIR FREDERIC WILLIAM BURTON

Corofin, Co. Clare 1816–1900
London

Hellelil and Hildebrand, the Meeting on the Turret Stairs, 1864

Watercolour and gouache,
95.5 × 60.8 cm
Signed and dated lower left:
FWB 1864
Bequeathed by Miss M. Stokes,
1900
NGI 2358

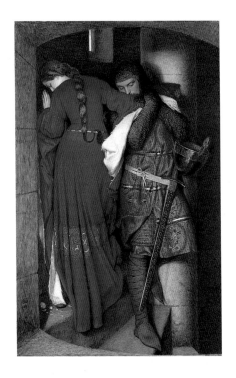

This is one of the most famous images in the collection of the National Gallery of Ireland. The subject is taken from a medieval Danish ballad which was translated into English and published in 1855. It tells the story of Hellelil, who falls in love with one of her personal guards, Hildebrand, Prince of Engelland. Her father is angered by this and sends his seven sons to kill the young prince. Rather than directly showing an episode from the story, Burton has chosen to depict the final meeting of the two lovers. The image has been given added poignancy and strength by the obscured faces of the figures, who look away from each other, and the tender touch between them. The rose petals on the step next to

Hellelil symbolize the transience of beauty.

Burton's interest in medieval imagery was not unusual in the mid-nineteenth century. The Pre-Raphaelites, with whom he was friendly, were taking a similar interest, and Gothic architecture was being studied seriously for the first time. However, Burton's attention to detail is almost scientific in its precision. He was a close friend of the Irish antiquary and artist, George Petrie, and often travelled with him, becoming knowledgeable in these matters.

Although Burton never worked in oils, the intensity and precise layering of colour in this watercolour give an effect similar to an oil painting.

JAMES ABBOTT MACNEILL WHISTLER

Lowell, Mass. 1834–1903 London

Nocturne in grey and gold – Piccadilly, 1881–83

Watercolour, 22.2 × 29.2 cm
Bequeathed by Rt. Hon. Jonathan Hogg, 1930
NGI 2915

Piccadilly is shown at night, bathed in the thick pea-soup fog with which London was associated until the mid-twentieth century. Whistler has used the technique of watercolour very effectively to suggest the hackneys, street lighting and crowds of people hurrying home and to convey the atmosphere of a busy city street. This watercolour is one of a series of *Nocturnes* or night scenes painted in oil or watercolour from the 1870s, in which the artist's personal response to the subject matter and the mood it evokes become the theme of the work.

Before settling in London Whistler had lived and studied in Paris, where he came into contact with Courbet and the Realists. While there, he became fascinated with the idea of the artist as being apart from the rest of society, a view which had been popularized by Henri Murger in his book *Scènes de la vie de bohème*, published in 1848. After moving to London, Whistler was among the artists who introduced the ideas of Aestheticism to England. This concept emphasized the autonomous value of art: in other words, art for art's sake.

From the 1860s onwards Whistler increasingly adopted non-specific titles for his work, which emphasized his interest in the manipulation of colour and mood for their own sake rather than for the conventional depiction of subject. Although a specific location is depicted in this watercolour, it is simply a pretext for conveying a certain mood.

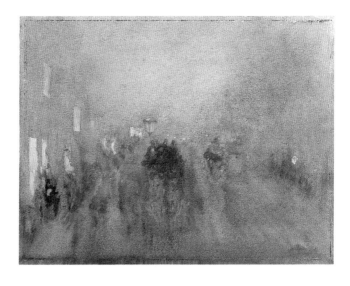

Edgar Degas
Paris, 1834–1917

Two Ballet Dancers in a Dressing Room

Pastel, 48.5 × 64 cm
Signed: *degas*
Bequeathed by Sir Edward Martyn, 1924
NGI 2740

From the late 1870s, Degas became interested in themes of women working. Ballet dancers were among his favourite subjects. In all there are over 600 works by the artist depicting them in a wide variety of media ranging from oil painting to photography. At first, Degas showed them on stage performing, but later he was allowed access to rehearsals and the backstage of the Opéra, and began to represent dancers in less public contexts.

In this pastel, two dancers are making final preparations in the dressing room and waiting to go on stage. He has captured the moment of waiting, but rather than showing any anticipation or sense of occasion, these dancers are simply in a routine work situation. They are also completely unaware that they are being watched. As spectators we are kept at a distance by the slightly elevated viewpoint used by the artist.

Although he was a founder member of the Impressionists and organized some of their exhibitions, Degas disliked this appellation and preferred to be called a 'Realist' or 'Naturalist'. He was not particularly interested in landscape, the favourite subject of his Impressionist colleagues, but preferred urban subjects and artificial light.

For most of his career Degas, who was from a wealthy family, did not need to sell his works in order to survive. From the 1880s he stopped sending works to major exhibitions, but sold his works through a number of dealers. It is possible that Edward Martyn, who was in Paris with the writer George Moore in 1886, bought this pastel directly from the artist.

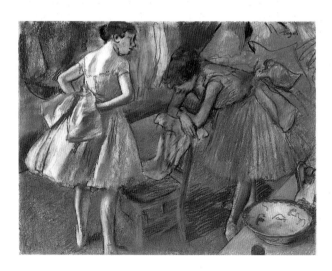

Pablo Ruíz Picasso

Malaga 1881–1973
Mougins

Two Dancers

Charcoal,
51 × 41 cm
Signed and dated,
upper right: *12 13
avril 1925 Picasso.*
Presented by Sir
Alfred Chester
Beatty, 1953
NGI 3271

In April 1925 Picasso was staying in Monte Carlo at the invitation of Serge Diaghilev, director of the Ballets Russes. Although in the past Picasso had designed a number of productions for the ballet company, by spring 1925 he was no longer working for them. Nevertheless, he remained in close contact with Diaghilev. This drawing of two dancers reading a paper during a break is one of a series which shows the same pair in a similar pose, using various different types of line and shading.

Picasso was one of the greatest artists of the twentieth century and a master of many styles. During the first years of the century Picasso and Braque together developed Cubism, which was characterized by the use of a limited range of colours and the division of the object or figure into fragments. Later, in the early 1920s, Picasso turned to the more classical and figurative style seen in this drawing. Throughout his career Picasso drew inspiration from his female companions, often changing his style and subject matter at the beginning of a new relationship. It is therefore not surprising that at this time, during his marriage to the ballet dancer Olga Kokhlova, he should produce a number of works based on this theme.